779

This book is due for return on or before the last date shown below.

Don Gresswell Ltd., London, N.21 Cat. No. 1208 DG 02242/71

383

PHOTOGRAPHY YEARBOOK 1995

SIXTIETH ANNIVERSARY EDITION 1935-1995

INTERNATIONALES JAHRBUCH DER FOTOGRAPHIE

EDITED BY
PETER WILKINSON FRPS

CONSULTANT EDITOR JOSEPH MEEHAN

DESIGNER GRANT BRADFORD

FOUNTAIN PRESS

FOUNTAIN PRESS LIMITED
FOUNTAIN HOUSE
2 GLADSTONE ROAD
KINGSTON-UPON-THAMES
SURREY KT1 3HD

© FOUNTAIN PRESS 1994
ISBN 0 86343 361 8

DESIGNED BY
GRANT BRADFORD

DIGITAL PLANNING
THE KASHDAN BROTHERS

ADDITIONAL TYPESETTING
DENNIS SHEARMAN
GRAHAM EHRET

REPRODUCTION & PRINTING
REGENT PUBLISHING
SERVICES LTD

Deutsche Ausgabe
© 1994 WILHELM KNAPP VERLAG,
Niederlassung der Droste Verlag GmbH,
Düsseldorf

CONTENTS

INTRODUCTION

There is truth in the old adage that the 'camera does not lie'. Certainly the use of very long or short focal length lenses, the use of lenses with perspective control or very long or ultra short exposure times, will record images which the eye does not normally perceive but basically what the camera records is a reality.

But since its conception there have been photographers who by manipulating the images produced by the camera have produced contrived 'artistic' pictures. As far back as 1857 O.G. Rejlander used over thirty negatives to produce his famous picture 'The Two Ways of Life'. 'The Gate of Goodbye' by F.J. Mortimer, another master of combination printing shows British troops going off to war in 1914 was also made from a number of negatives. Molly Mortimer told me not long ago, that her father sometimes on wet days used to photograph her and the family dressed in oilskins sitting in an old boat in their garden, for later combining into his famous shipwreck pictures!

These pictures, which were very successful in the pictorial exhibitions of their day, were not made to deceive and can be considered as photographic paintings. Interestingly a copy of the 'Two Ways Of Life' was purchased by Queen Victoria for her collection.

Today there are number of photographic printers who are capable of turning a dull and tonally uninteresting black and white picture into an outstanding image by skilful control when making the enlarged print, with landscapes even adding the sky from another negative if necessary. There are some superb monochrome landscapes in this edition of PHOTOGRAPHY YEARBOOK where I know that considerable control has been exercised in their making but it is so skilfully done that it is not obvious.

The same thing can be done in colour but it is extremely difficult and it is often more satisfactory to resort to retouching dyes or airbrushing. But the situation is changing rapidly, for it is now possible electronically to alter, retouch and combine photographs and to produce a result, which unlike in the past, shows no sign of such manipulation.

In this book there are two outstanding pictures by Paul Wenham-Clarke which illustrate how good camera originated images can be electronically combined and manipulated to produce unique technically perfect fantasy pictures. Using the latest lighting techniques the cage in the 'Cat and the Fiddle' shot was lit using a 'lightbrush' with a diffuser over the camera lens to give a soft image whilst the fiddle was 'lightbrushed' without a diffuser, for a hard image. Finally three 5 x 4" transparencies were electronically combined using the Quantel Graphic Paintbox. Paul Wenham-Clarke's other picture 'The Fireguard' was produced from five transparencies again combined electronically.

Whilst some traditionalists will consider that such pictures are not photographs, it is inevitable that we will be seeing many more manipulated images in the future especially as more still cameras become electronically rather than silver orientated. The present cost of the equipment required for electronic manipulation or hybridisation of the silver and electronic image means that it is beyond the means of the average photographer, but the prices are dropping rapidly so soon it could be little more than the cost of a high class photographic enlarger.

What are the ethics relating the manipulation of the silver or electronic image? One can only trust that the media will never use it to distort news or sport pictures - but what of a group picture of say two Prime Ministers meeting, surrounded by their entourage, is it permissible to remove any distracting figures for the sake of emphasising the important aspect? But not only

can figures be removed, provided there is a suitable image available, it is now possible to insert a person into a picture - perhaps that person is dead or in prison - so that we now have a picture of a group that never existed!

In the past, when selecting natural history photographs, I have endeavoured not to publish pictures which were not 'natural'. Pictures where the moon was recorded on the same negative but at a different time, or with a different lens, seems to me to be unethical in this type of work. Unfortunately I have already seen natural history photographs where it is impossible to detect that they have been electronically manipulated.

There are many involved in photography and publishing who feel strongly that there are certain areas where the substance of a picture should not be manipulated electronically or by any other means. Chris Dickie, when editor of the *British Journal of Photography*, advocated that hybrid images should be known as photronics. Perhaps in future all viewers and users of images should have the right to know if they are photographs or photronics.

Photographers from many countries are represented in *PHOTOGRAPHY YEARBOOK 1995* and the book has been enlivened by more images from Asian photographers than in past editions. I am indebted to the magazine *Photo Asia* for their assistance in making many of these pictures available; hopefully we will see more work from this part of the world in future. I also express my thanks to Chris Hinterobermaier for organizing an excellent submission from Austrian photographers.

Peter Wilkinson FRPS
Editor

Fountain Press are always pleased to receive pictures for possible inclusion in future editions of the PHOTOGRAPHY YEARBOOK and to retain the international character of the book, entries from outside the U.K. countries are especially welcome.

Although material can be sent at any time throughout the year the closing date for receiving material at the publishers for possible inclusion in the next edition is the end of January 1995 and this date will apply in subsequent years.

Colour transparencies may be of any size but should not be glass mounted. If a colour picture is available both as a print and as a transparency, the transparency is preferred. Prints, both black and white and colour, should be unmounted and not smaller than 18x24cm or larger than 30x40cm. Prints should always be packed flat not rolled. All work submitted must carry the author's name, and information is required as to the location or subject and any points of interest relating to the picture as well as to the make of camera, lens and film used. If packing is suitable, and adequate postage in stamps is included work will be returned after the book has been finalized. Non-UK submissions should be accompanied by a cheque in pounds Sterling drawn on a London bank or 12 (twelve) International Reply Coupons to cover the cost of return. Such entries will be returned by surface mail unless there is sufficient remittance to cover airmailing costs.

All possible care will be taken by Fountain Press but they cannot be held responsible for any loss or damage that might occur to material submitted. Although the copyright of any work accepted remains with the author, the publisher reserves the right to use accepted pictures to publicise PHOTOGRAPHY YEARBOOK.

As well as the prestige of having their work published, successful contributors will also receive a copy of the PHOTOGRAPHY YEARBOOK and a reproduction fee. Upon request the Publisher will, where possible, put prospective picture buyers in touch with the authors of published pictures.

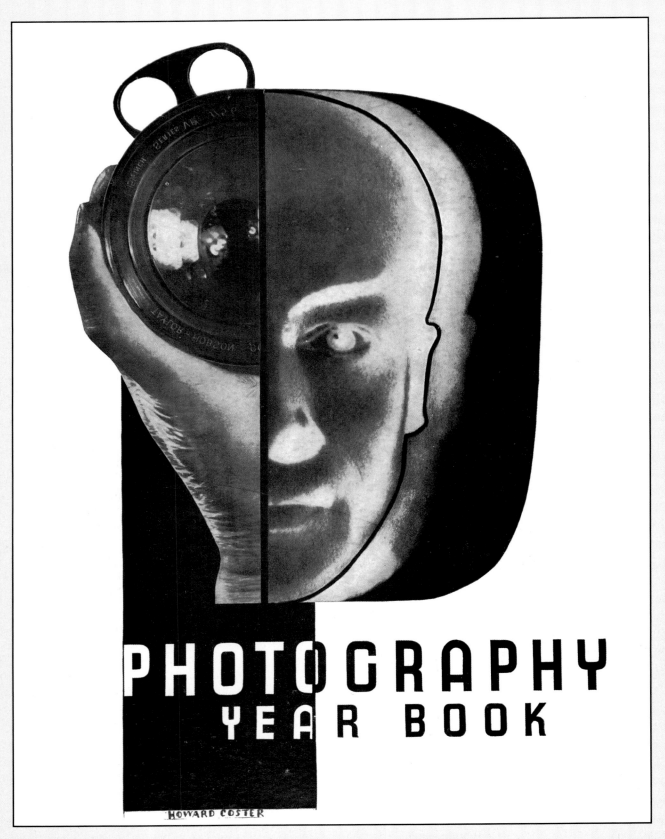

PHOTOGRAPHY
YEAR BOOK

HOWARD COSTER

THE COVER OF THE FIRST EDITION – 1935

THE SIXTIETH ANNIVERSARY
OF THE PHOTOGRAPHY YEARBOOK
1935-1995
A Brief Retrospective

'This first Year Book published by Photography *is intended as an annual survey of every branch and aspect of photography. In selecting the illustrations our guiding factor has been to cover every field; to present hundreds of specimens demonstrating the many applications of photography.'*

FROM THE INTRODUCTION OF PHOTOGRAPHY YEAR BOOK, FIRST EDITION, 1935

By any measure of historical significance or artistic achievement, the PHOTOGRAPHY YEARBOOK is a unique publication even within the genre of photographic annuals. Since its introduction in 1935 and for the 60 years since, it has displayed a remarkable degree of vitality and diversity in both the type of photography within its pages and the way those pictures have been presented. In fact, the Yearbook has really remained the same in only two respects: it has contained mostly photographs and it has been published nearly every year apart from the war years. Otherwise, it has undergone a significant metamorphosis over its 60 year history, passing through discernible periods of change. This evolution reflects the changing approaches photographers have taken toward their subject matter, the impact of the different equipment and films available to them, and finally, the different views of editors who struggled with their selections to indicate what photography meant to their Age.

The PHOTOGRAPHY YEARBOOK was the brainchild and subsequent offspring of *Photography Magazine* which, at the time, was one of Britain's most popular professional photographic journals, ceasing publication in 1992. Since the parent publication served primarily working photographers, the initial purpose of the Yearbook was to showcase not only the quality of that type of work, but also the range of professional photography on an international scale. The first volume was, indeed, a major effort in that regard and by the second volume the editors were able to claim a list of contributors 'working in practically every country of the world.'

Volumes 1, 2 and 3 issued in the years 1935-38 (1937-38 was combined in volume 3) just prior to World War II, averaged more than 20 specific categories bound in a large 12 x 9 1/2 inch book averaging 450 pages with more than 1,700 pictures per volume. This grand style of presentation ended abruptly with the onset of the Second World War. The War caused the suspension of publication of the Yearbook for the years 1939 to 1946 with original production materials for all the pre-war books and accompanying records being destroyed in the bombing of London.

The range of subject matter covered in the pre-war volumes was nothing short of extraordinary. As one might expect, there were sections concerned with more or less standard categories such as Portraits, Fashion, Architecture and Scientific Photography. Each of these was literally crammed with four, five and more pictures per page as opposed to the single print/page practice of today. These 'standard' categories were heavily supplemented by such special groupings as, The Photography of Hands, 'Trick' Photography and sections devoted to book covers, photo murals and other forms of mass market photo displays. In the second volume, a separate section printed on newsprint quality paper was added which featured the work of amateur photographers. It took

this paper form 'so as to repeat the photographs under approximately the same conditions as at the time of original publication in the *Sunday Referee* (newspaper).'

In addition to the wealth of photographic material, there was substantial space given over to text covering topics of perpetual interest such as lighting, posing and camera and lens selection. There was also no lack of name photographers represented in these pre-war issues with everyone from Man Ray to Cecil Beaton, Horst P. Horst, Andre Kertesz and even a small still life by Ansel Adams scattered throughout the hundreds of photographs in each edition. In terms of content, variety and sheer volume of imagery, there has not been anything quite like these early issues of the *PHOTOGRAPHY YEARBOOK* before or since.

Shortly after the Second World War, the Yearbook resumed publication under the new title of *Photography To-day* covering the years 1947-48. Then, in the second post-war issue of 1949 it declared that it was 'now reverting to its original title,' *Photography Year-Book*, eventually losing its hyphen in the 1950s and finally adapting the modern form of 'Yearbook' in the 1980s. The immediate post-war volumes representing the beginning of the second period in its development were, understandably, rather spartan in size and content. They are, in fact, the smallest formats of the whole 60 year series measuring approximately 10 x 7 inches and holding about 200 pictures in the earliest post-war volumes. The range of subject matter also decreased and would never again approach the 20 plus sections of the 1930s, even as the Yearbook and its publisher recovered from the War. For example, the areas of concentration for the '49 issue were limited to nine: Human Expression, Nature, Still Life, Speedlight, Press & Magazine, Colour, Industrial & Commercial, Work of Six Nations and Trends. Thus another characteristic of the post-war era was a steady reduction in such categories with more and more emphasis on a general display of photographs. Still, even if the size of the representation had been reduced in the post-war era, the mission of presenting the best certainly had not. Thus, the Editor of the 1949 edition, Harold Lewis, declared that their purpose was, 'to inform the reader of the progress of photography in its various paths and the lines of thought of the world's masters'. So, the practice of defining photography mainly through well established photographers continued as standard form. Furthermore, as Lewis points out, the over 10,000 photographs received 'seemed to be evidence of a new, wholesome spirit invading photography through

its pre-war shroud.' So while the Yearbook was still ostensibly a showcase of professional photography in this second period, there was no longer the single emphasis on including work that was the stock and trade of pre-war photographers; namely images for magazines and various forms of mass publications. There was now the beginnings of a wider net being cast as the editors looked for images that reflected a more complete picture of the world.

By the late 1950s, this new spirit had manifested itself in a book that displayed a gradual and overall improvement in the quality of the printed reproduction and an enlargement of its size to the proportions we are most familiar with today. Among the other notable changes in this post-war period was the inclusion of color, appearing initially in the 1949 version as a sixteen-page insert with no other significant representation until much later in the 1950s. It is worth noting that color photographs did not become a major feature of the Yearbook until the 1980s. There were also French and German versions of the text appearing in the '49 volume and in later years, especially in the 1970s and 1980s. This was expanded, at times, to the separate production of French, German and Spanish language editions.

The practice of having 'features' by or about name photographers was a prominent practice throughout the '40s and the '50s as, for example, 'Hands in Portraiture', by Yousuf Karsh (1949); 'The Telephoto Lens in Architecture', by Andreas Feininger (1950) and 'The Evolution of Pictorial Photography', by Helmut Gernsheim (1953). The list of contributing photographers during this period reads like a 'Who's Who' of post-war photography, particularly to western readers, with such names as Alfred Eisenstaedt, Robert Doisneau, Bill Brandt, Henri Cartier-Bresson, W. Eugene Smith, Edward Weston, Berenice Abbott and Paul Strand. Their work was often grouped under the appellation 'Star Photographers' or 'Honored Guests' and clearly a good portion of the appeal of the Yearbook was built around such key figures and articles about them or photographic techniques in general. By the end of the 1950s, however, this began to change with more emphasis on running large sections of photographs from all over the world.

The '40s and the '50s was also the period in which many more of the photographs appeared full page as opposed to multiple images per page and the beginning of their segregation by the national origin of the photographer under such section titles as 'Photographs by Nations', or simply organizing work by countries. There were even features focusing on the state of photography in a particular country as in

'The Italians' (1953), 'Modern American Pictorialism' (1953) and 'Vision Francaise' (1956) as well as themes such as 'The World at Work' (1950) and 'Photo-Reportage with the Miniature [Camera]' (1956).

The editors also tried a number of different approaches to picture presentation in layout and design as in juxtaposing two pictures of similar themes for comparison, a practice that continues to this day. Other experiments were mercifully shortlived like the use of captions with a play on words such as a photograph of washing hands entitled 'on the other hand' or a uniform line of chairs noted as being 'ready for action!'

There are also puzzling aspects first noted in this second era, especially in the earliest post-war books where there is a decided lack of any comprehensive treatment of war photography, a practice that seems to have generally continued throughout most of the Yearbook's history. The appearance of color images is inconsistent and does not follow, as one might expect, a steady and noticeable growth to its eventual major role in the 1980s. This observation extends into the next era, bridging the years 1960-79 where, for example, in the 1962 issue, just a single color image appears in an advertisement for Perutz film. A partial explanation of sorts comes in 1961 from Editor Norman Hall who oversaw the Yearbook for a decade; 'Good creative colour is not easy to find and it is also costly to show. Most of the true masters of colour photography produce almost exclusively for purposes of publicity [commercial photography], and even where their work is available it is usually not what is required for this book.'

Editors also talked during the post-war years, as they have right up until today, about weaknesses and disappointments in some of the work they received. One of the most outspoken Yearbook editors was Harold Lewis who, for example, commented in 1949, 'We had assumed that with the marketing of various good speedlight appliances would come a new and inspired type of picture. So far this hope has not materialized.' He also bemoaned the 'decline in orthodox portraiture, much of which shows a stilted artificiality more pronounced than in any other branch of photography. It seems obvious that the amateur becomes increasingly influenced by the commercial practitioner, instead of retaining subjective and personal vision.' Four years later, he noted another decline, this time when commenting on an approach that had been tried for three years where they put out the call among youthful photographers for a separate section called 'Young Britain.' According to the disappointed Editor, this

section 'had been a success for two years, but although the third invitation resulted in the largest entry of the three years, the freshness and promise of previous years was absent.'

Attempting to showcase the pictures of young photographers is just one of those many ways in which editors tried, throughout the history of the Yearbook, to introduce new and effective ways of sampling and presenting the wealth of their subject matter. Other examples of different approaches include the odd gatefold, for example, in 1964; the circulation of a readers' questionnaire as to what type of subject matter they wanted to see more of with the results printed in the 1968 book; wraparound covers beginning in the 1960s; occasional articles about photography of the last century as in the 1969 feature, 'The Studio Portraits of 1880'; and a sixteen-page photogravure section of Paul Strand's work beautifully produced in the 1963 book.

The end of the 1950s saw a marked and steady increase in what we would call action type photography with many spectacular shots from sports to great public events right down to pictures of everyday people and their activities. Certainly, the emerging camera technology of the 1940s and 1950s had much to do with this. We have only to recall the popularity of the 35mm Leica and Contax cameras of that period followed by similar designs from Nikon and Canon. The late 1950s also saw the beginning of what eventually became the dominance of the SLR with its interchangeable lenses, initially in the guise of the early Asahi Pentax SLR, followed by one of modern photography's most important cameras, the Nikon F with all its interchangeable lenses and accessories such as motor drives, to say nothing of faster and sharper films. Thus, the days of depending entirely on cumbersome, large format, sheet film cameras for much of one's work as in the 1930s, had given way after the Second World War to the more mobile hand-held cameras that came to be first personified by the seemingly countless models of twin lens Rolleiflexes followed by the rangefinder 35mm models already mentioned and finally perfected by the modern SLR.

All these changes in camera technology were paralleled by significant cultural changes often marked by challenges to established order and custom in the 1960s and 1970s. These events formed the subject matter, if not the stimulus, for much of the photographs of these two decades that together make up the third era in the evolution of the Yearbook. This was a period in which experimentation and 'anything goes' were the bywords for many photographers,

established names or otherwise. It is here, fox example, that very wide-angle lenses mounted on SLR cameras, were used to distort faces and subjects, or be used to place emphasis on the long, lean line of the fashions of the time so epitomized by that popular fashion model, Twiggy. It was a period to experiment with such darkroom processes as solarization and the Sabattier Effect well beyond the early images of Man Ray; of high contrast treatments, photocollage, photomontage, extreme high and low angles, the dramatic results of portable high speed flash and all the other approaches that could now be carried out much more easily because of new or improved photographic technology. There is also a 'grittier', more realistic look to the photographs of this third period, especially in the monochrome images, as faster films and more mobile, quicker operating handheld equipment allows the photographer to go places and do things that were not possible before. This is when tighter compositions (mostly with telephotos) became popular and many more examples of what is today loosely called macro or close-up photography became a mainstay of the Yearbook's selection process.

Viewed in retrospect, there seems to be divided opinion as to the final outcome of this third period; is it 'a time of great and rich experimentation in which photographers had new tools and great freedom to try new forms of expressions'; or, is it 'a time when many methods and approaches were quickly played out to their limited potential such that we now think of much of this type of photography as hackneyed and done to death.' Whatever the final analysis, few would deny that the Yearbooks of the 1960s and 1970s contained a richness of imagery and a range of treatment not seen since the 1930s though the nature of these images were, obviously, quite different.

The '60s and '70s also marked a change in ownership of the Yearbook. In 1963, it became part of Fountain Press Limited with the 1964 edition marking the first appearance under the Fountain Press imprint. Harry Ricketts who has served as Fountain Press's publisher since 1964 acquired the Fountain Press book list in 1982 ensuring that the Yearbook would continue to be published and it has largely been through his commitment to the Yearbook that it remains the viable publication it is today.

1963 also saw the end of Norman Hall's long and important editorship and the declaration of a new trend which had actually been manifesting itself in a limited way since the early '60s. In the words of the new Editor Ian James: 'I [have] therefore decided to devote more space to new photographers at the expense of a few established names.' John Sanders

continued the trend in the 1970s and by the 1980s, the PHOTOGRAPHY YEARBOOK had shed the last of its professional photography bias in picture selection as well as a dependence on features about star photographers and photographic trends by dropping all such approaches. Instead, the books of this last phase have been devoted only to photography, usually one print per page, from people whose dedication obviously matches the commercial fervour of the previous years. These changes were accompanied by the end of advertisements for equipment and films in 1986 which had been a major part of the Yearbook since Volume One. The evolution of the Yearbook's advertisements over the years between 1935 and 1986 in terms of changes in technical specifications and what the advertisements actually promised for the photographer represents a separate and interesting history as to how the field of photography was changing.

With the appointment of Peter Wilkinson as Editor in 1984 the emergence of work from the serious amateur became the dominant picture source, with only limited professionally motivated work, which brings us into the present. Today, the Yearbook clearly has shown a propensity for people photography, landscape work and outstanding natural history photography with a very high volume of color (although the monochromatic image is still well represented) taken primarily by people who are not employed as photographers. Some have criticized this last era as 'too given to camera club photography and limited to typical club themes' while others have supported it as 'representing the last bastion of high quality photography in a world ever more given to fads and degradation of pure photography.'

Whatever the eventual place the '80s and '90s find within an historical context, there is little doubt that the PHOTOGRAPHY YEARBOOK has been a truly unique publication for its entire 60 years. Indeed, it retains a singular position in the modern photographic world by opening its pages to all photographers, regardless of their commercial status and does not set any limitation on picture eligibility with such artificial standards as requiring that pictures must have been (or may not have ever been) published. The spirit of international photography, though somewhat diminished in the '80s with the dominance of images from the United Kingdom, is still very much alive and there are plans to expand this aspect of the Yearbook. Some thought is also being given to re-introducing features that will give Yearbook readers an idea of the trends that are moving through the photographic world as well as looking at the style of photography produced in various national regions.

In sum, after 60 years of publication, it is time to take stock of what has been done in the past as we look to the next 60 years. We hope that our readers will continue their loyal support and that we may continue to follow the path first set down some 60 years ago by our founders, summarized in the second volume of the 1936 book with these words: 'the maiden volume of the *Photography Year Book* was acclaimed because it gave, as had never been previously done, a complete picture of the world's camera art.'

A Visual Look Back at the First Issue

As part of our short discussion here of the evolution of the *Photography Yearbook*, we are displaying images only from the 'maiden volume' of 1935 because of the restrictions of copyright that are in effect for later volumes. In short, it would have been a task beyond our resources to track down the hundreds of photographers or their heirs in order to be granted permission to use their pictures for a complete visual retrospective of 60 years. Instead, we are showing as large a sample as possible of the premiere edition, which is outside any copyright restriction, to give our readers a sample of what these grand pre-war volumes were like.

It is certainly tempting to flip through these facsimile pages of the 1935 volume and just see 'old pictures' of bygone fashions, outmoded social practices and places that no longer exist. But such a superficial approach means that their real value to the modern photographer will be missed; namely, that these photographs were made perhaps, in some cases, literally, by our grandparents. Furthermore, what they produced is really an album of the world as they knew it; a world that, like the frozen moments of time captured on film, existed only for that time and never again.

That is worth thinking about as you raise your camera to your eye and take a picture in today's world. Indeed, what is the worth of that picture you are taking for now and for tomorrow? It is possible that by looking at these 'ancient' pages you may, in fact, become aware of other reasons for taking other pictures. Or perhaps, do you see something in the way these pictures were taken that can be used today? Lest we forget, the images in this first volume of the *Photography Yearbook* are really the result of the feelings, prejudices, limitations, and genius of people who, like us, took the time to learn how to take pictures and then proceeded to record what was important to them.

So in the end, this first issue of the *Photography Yearbook* and all those volumes that came after, are more than just photographic recordings of the past. Rather, they are really the perceptions of our kindred spirits who had to work with the same basic ingredients that we struggle with today: namely light, content and opportunity. It is certainly worthwhile for us to ponder what it was in that moment, in that pose or from that camera position that made the photographer take the picture. For it is this individual process of selection that separates us as photographers and the more we are able to see through the eyes of others, the richer our points of reference become for our own photographs.

The eternal themes such as beauty, mystery, motion and time are there for us to consider in these pages from the first Yearbook. And it may be that we will conclude that our predecessors were actually more attuned to the purpose of photography. A purpose that Edward Steichen so simply but eloquently said was beyond capturing just a moment of beauty or of time, but to be 'the major force in explaining man to man.' If that be the case, then every issue of the *Photography Yearbook* can teach us so much about who we were and what we are becoming. I can think of no greater purpose for an annual book of photographs.

Joseph Meehan
SEPTEMBER 1994

Joseph Meehan has been a photographer for more than 25 years and is the Technical Editor of Photo District News, *the première magazine for commercial and advertising photographers in the United States. He is also a columnist for the US publication* Darkroom and Camera *magazine and has frequently written for the* British Journal of Photography *and its annual,* Photo. *Meehan is the author of eight books on photography and has taught photography in the US as well as at the School of Art at Ealing College of Higher Education, London and Taiwan's National Academy of Art. An honor's graduate of Columbia University, he holds undergraduate and graduate degrees in European History.*

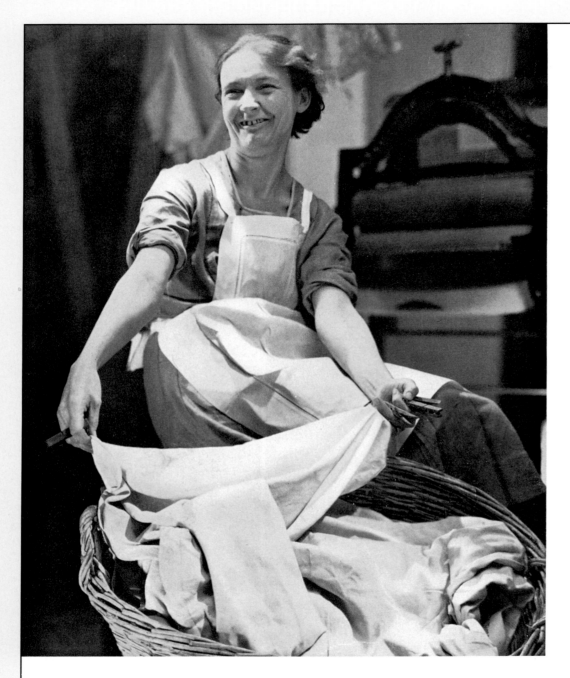

STUDIO SUN

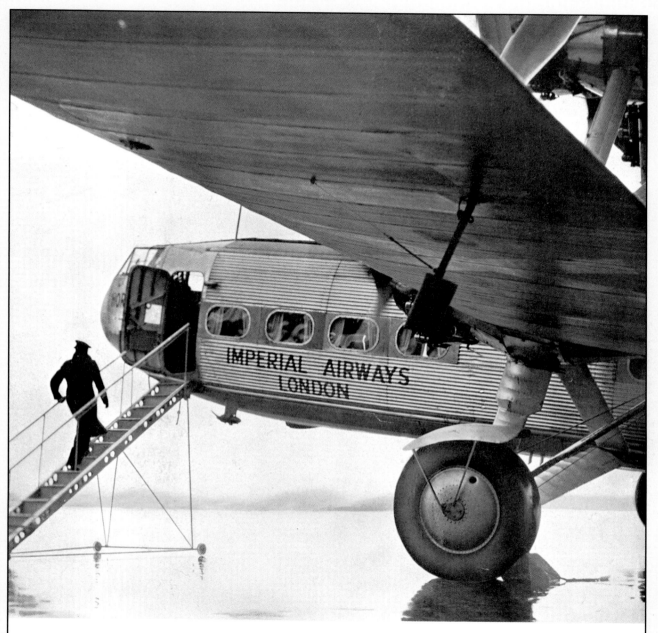

ALFRED CRASKE LTD.

(*Right*) CHARLES WORMALD.
By Courtesy Imperial Chemical Industries Ltd.

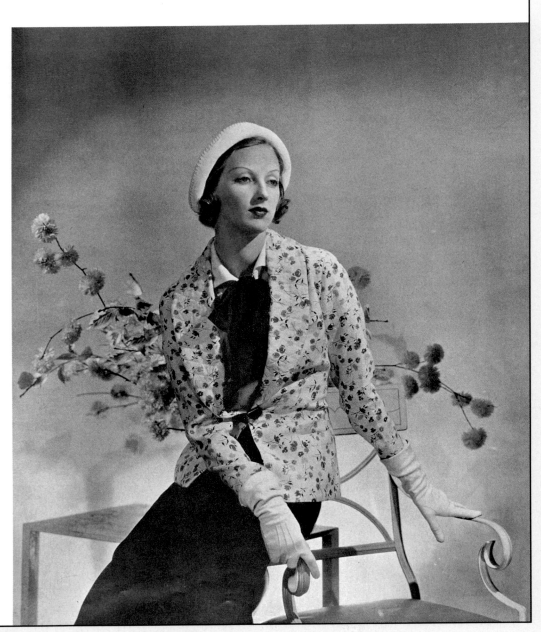

(*Right*) HORST (*Pari*
(for First International Agency Ltd
By Courtesy Matt

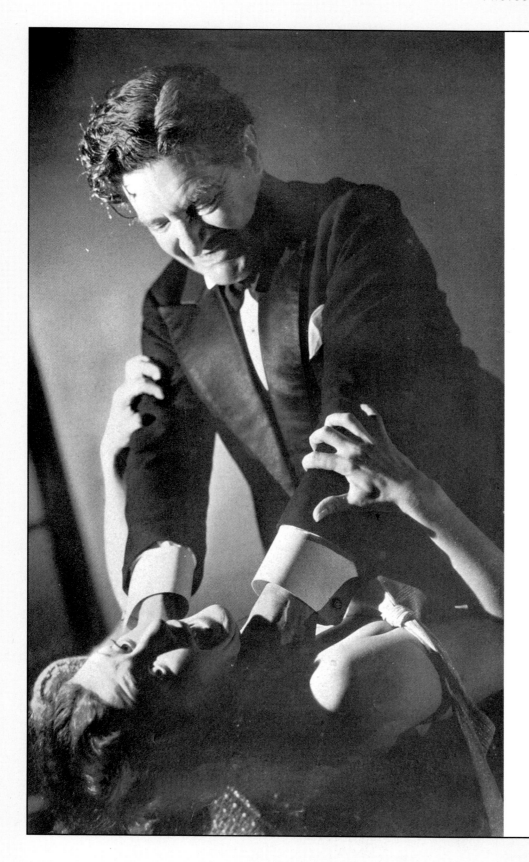

FOX PHOTOS

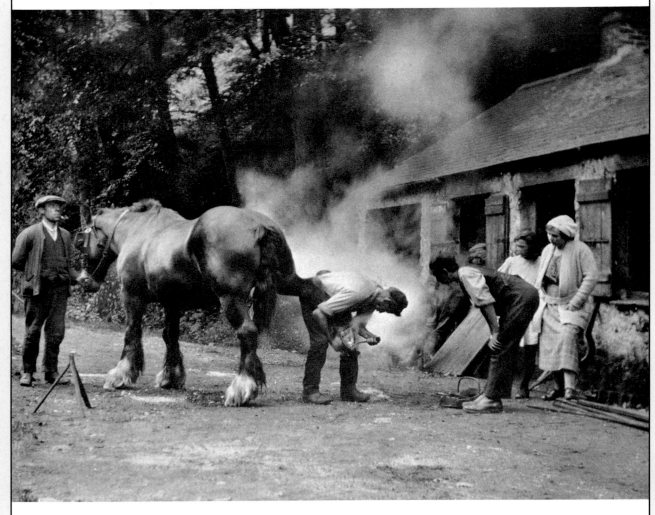

By Courtesy " Kodak Magazine "

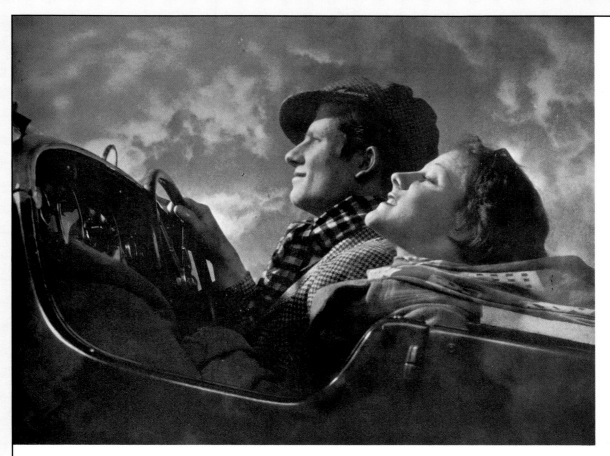

STUDIO SUN

UNDERWOOD & UNDERWOOD (*U.S.A.*)

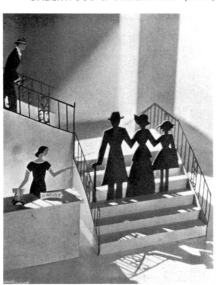

WALTER NURNBERG

143

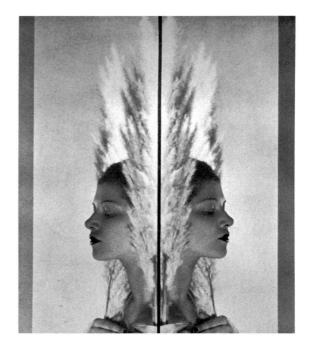

JAMES MAYCOCK (*Odhams Studio*)

YEVONDE

CANNONS

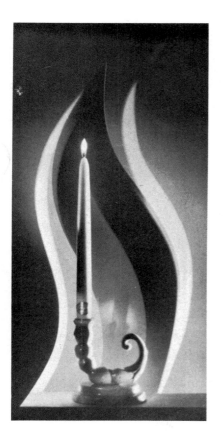

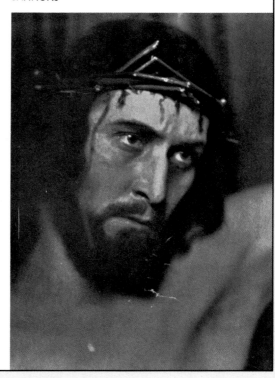

JOHN HAVINDEN (for W. S. Crawford Ltd.)

162

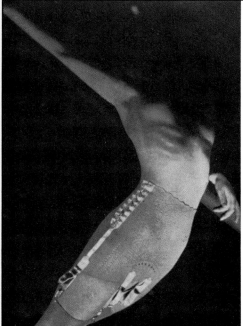

MAURICE BECK (for Charnaux Corsets)

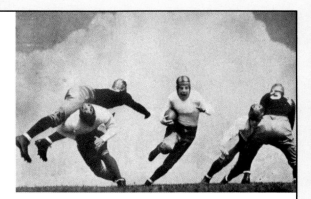

W. M. RITTASE (*U.S.A.*)

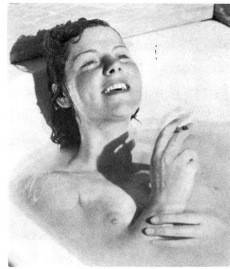

STUDIO SUN

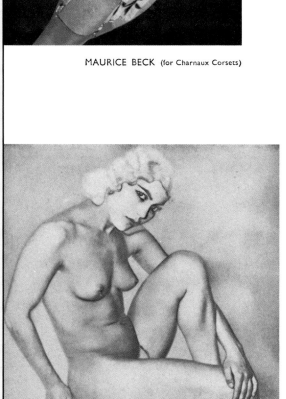

MAN RAY (*Paris*). By Courtesy J. T. Soby.

ERIKA HUBER (*Munich*)

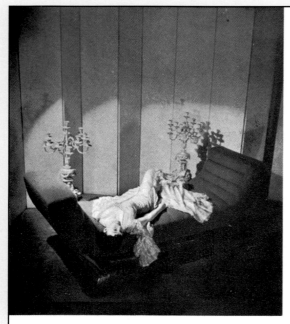

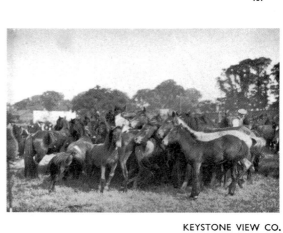

KEYSTONE VIEW CO.

PETER ROSE-PULHAM. By Courtesy " Harper's Magazine "

PHOTOGRAPHIC ADVERTISING LTD.

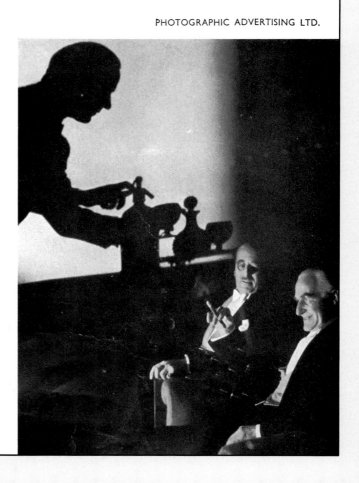

VIOLET BANKS

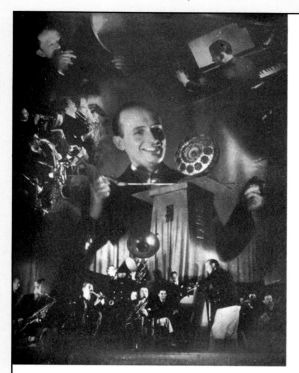

EUGENE FRIDUSS (*U.S.A.*) (for S. C. Johnson & Son)

TRICK PHOTOGRAPHY

PHOTOMONTAGE

PHOTOGRAMMES

COMPOSITE

ONE-PLANE

DISTORTOGRAMS, Etc.

ROSS. By Courtesy *News Chronicle*

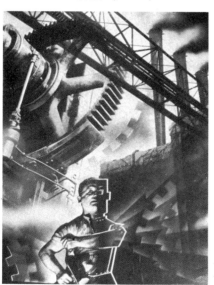

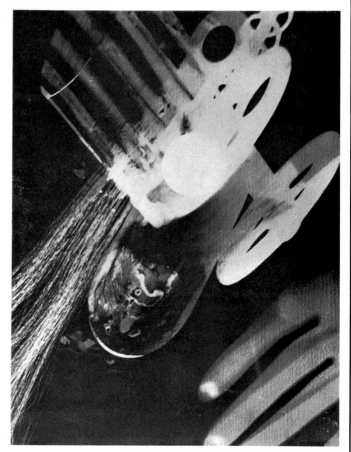

MAN RAY (*Paris*). By Courtesy J. T. Soby

HERBERT G. PONTING

HERBERT G. PONTING

 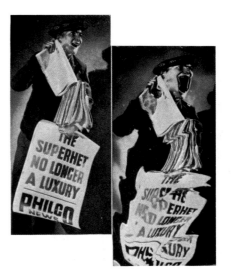

AEROFILMS LTD.

W. S. CRAWFORD LTD. (for Philco)

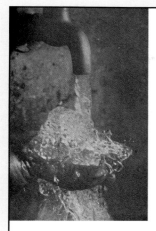
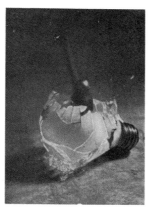

H. E. EDGERTON
A speed of 1/75,000th second was used for these action pictures.

F. C. BAWDEN (*Cambridge*)
Used to disclose Potato Leaf Disease. Infra-red picture on the right.

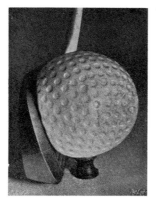

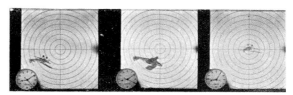

Photos taken with the Williamson Camera-Gun, in the first picture showing the exact degree of inaccuracy in shooting, and in the last that the marksman has hit the " enemy."

H.M. Stationery Office
A million-volt spark photographed at the National Physical Laboratory

Impact of golf club and ball.

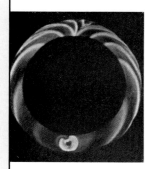

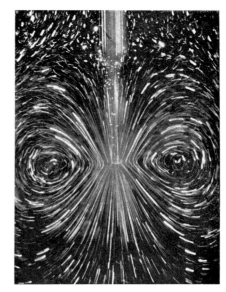

National Physical Laboratory
An explosion inside a cylinder. The dark portion in the centre is the piston. At the foot is the sparking plug.

Carbon monoxide explosion travelling at a mile a second, photographed at the National Physical Laboratory.

DR. MANFRED KOHN

PHOTO-POSTERS

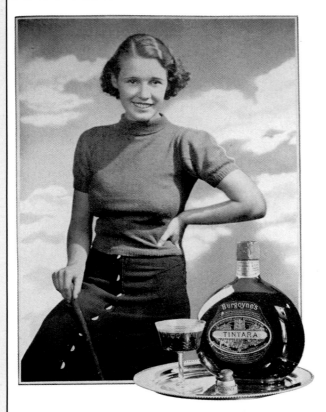

NOEL GRIGGS (for Burgoyne)

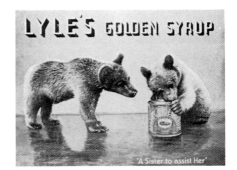

FOX PHOTOS LTD. (for Walter Judd Ltd.)

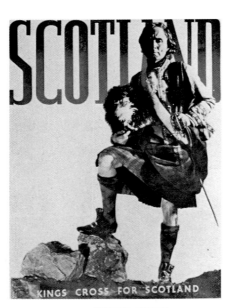

STUDIO BRIGGS (for L.N.E.R.)

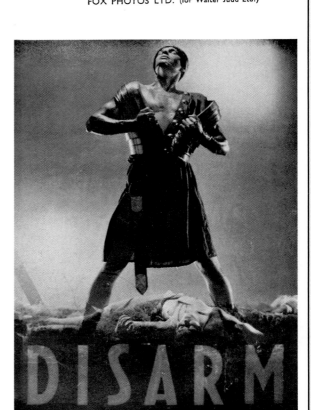

STUDIO SUN

280

MAGAZINE
AND NEWSPAPER
COVERS

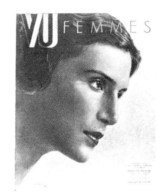
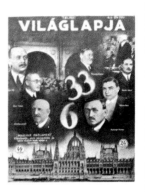

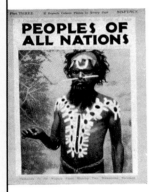
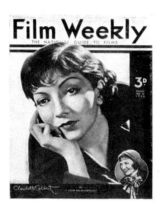
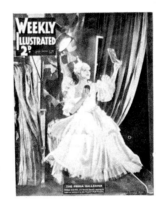
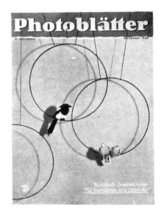

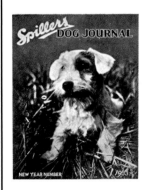
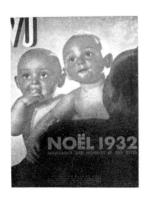
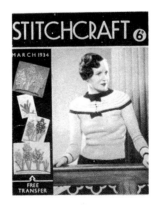

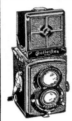

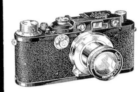

464

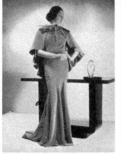
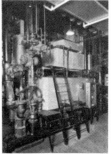

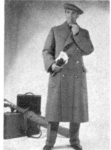

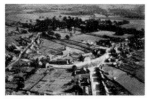
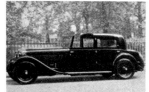

ANYTHING PHOTOGRAPHED

IN OUR STUDIOS (STILL LIFE)

for 5/6

"Fashion" Photographs 15/6

QUANTITY PHOTOGRAPHS
SHOWCARDS · POSTCARDS
ETC.
AERO PHOTOGRAPHS

Expert photographers sent anywhere at a moment's notice

PRICE LIST AND QUOTATIONS FREE

WALLACE HEATON LTD.

Commercial photographers to the leading Palace Galleries, Societies, Fashion and Business Houses

119, NEW BOND STREET, LONDON, W.1

Contracts to H.M. Government

Phone: Mayfair 0910-0917

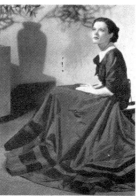

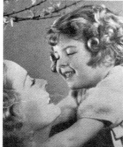

We are indebted to "The Drapers Record" for permission to reproduce the two fashion photographs of Gowns, and to Messrs. Morrell Ltd., Builders, for the photograph of Mother and Child.

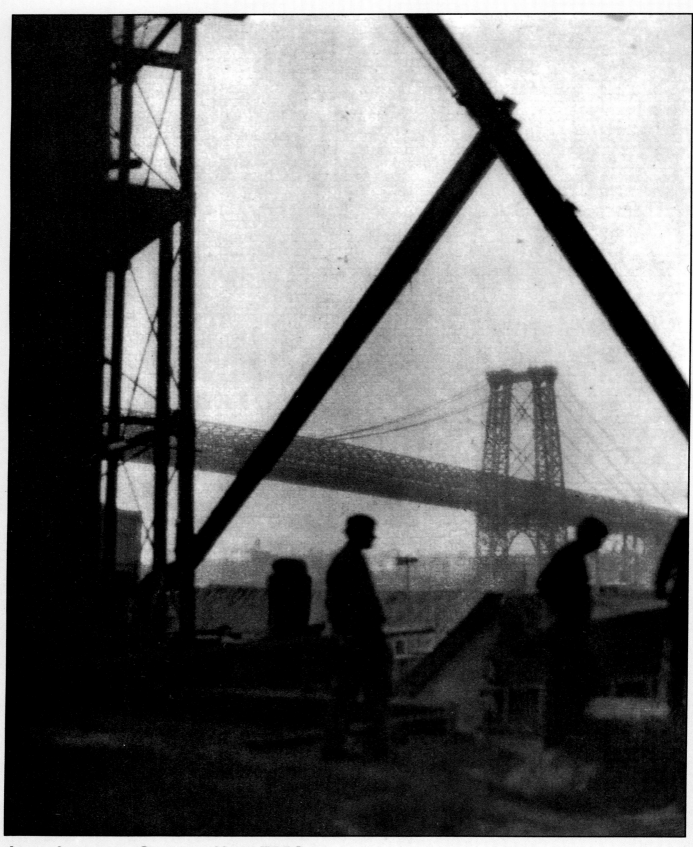

ALVIN LANGDON COBURN, HON. FRPS

THE ROYAL
PHOTOGRAPHIC
SOCIETY

JOIN US ON THE ROAD TO SUCCESS

For 142 years THE ROYAL PHOTOGRAPHIC SOCIETY has been helping photographers of all ages and abilities successfully to develop the potential of their photography. Whether you are a total beginner, a dedicated amateur or someone who earns a living from full-time work in the photographic world,, membership of the Society is an open road to achievement.

As a member of The Society you are entitled to submit work for the Licentiateship, Associateship and in due course, Fellowship, the three distinctions that The Society offers. All over the world people who hold distinctions of The Society are recognised as high achievers in the art or science of photography.

The Society actively encourages and supports its members as they work towards distinctions and membership provides the opportunity to become part of a wide network of fellow photographers. There are workshops, lectures, masterclasses, conferences, field trips and informal meetings; in fact there's something different happening almost every day organised by The Society. As a member you will receive the complete national Programme guide to the 600+ events that The Society organises throughout the year.

Members also receive monthly the comprehensive *Photographic Journal* – a lively and informative periodical with debates on controversial aspects of photography and reviews and views on the latest in art and technology – mailed free to their home.

There are fourteen Special Interest Groups which range from Archaeology & Heritage to Visual Journalism, and all members can join these. The Pictorial Group, established in 1921, in particular

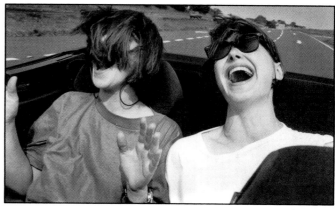

ERIC HOWARD

encourages members to develop their own styles. The Group's principle aim is total quality – creative, imaginative and technical – and seeks to instill confidence built on skill and a knowledge of photography past and present. Descriptions of other Groups are to be found in the New Members' Pack which you will receive as soon as you apply for membership. This also contains information about The Society's permanent Collection, the exhibitions, discounts negotiated for members and full details of membership.

A special offer to readers of PHOTOGRAPHY YEARBOOK! The opportunity to enjoy three months' free membership – join now and enjoy fifteen months for the price of twelve. Write now to The Membership Officer, THE ROYAL PHOTOGRAPHIC SOCIETY, Milsom Street, Bath, BA1 1DN. Telephone 0225 462841, or Fax 0225 448688. Be sure to mark your request PYB '95.

THE PHOTOGRAPHERS

THE PHOTOGRAPHERS

THE PHOTOGRAPHS

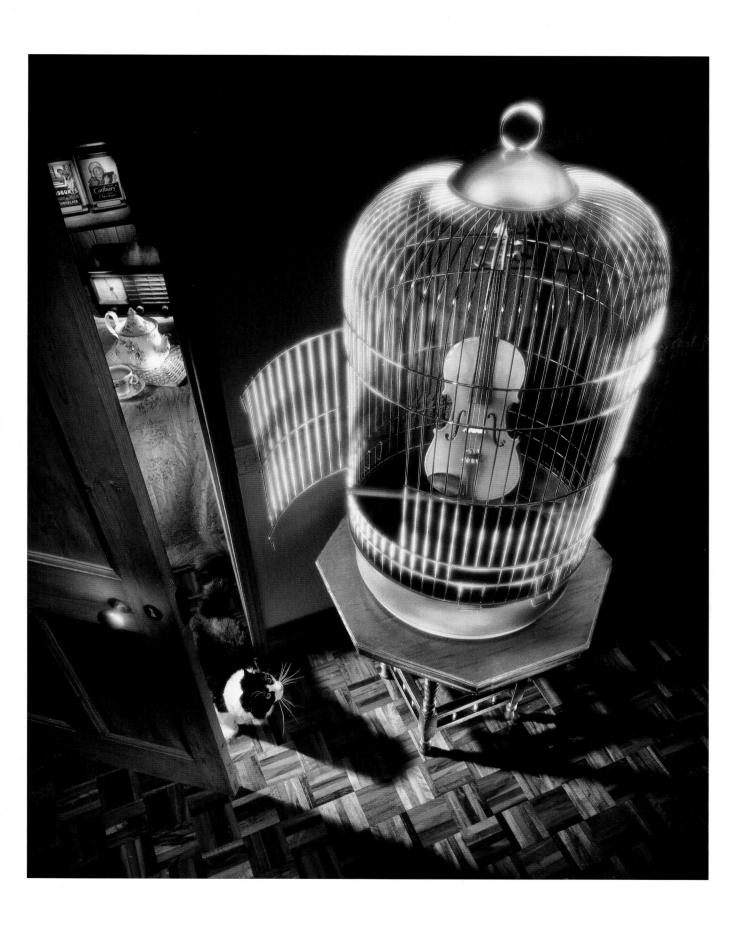

PAUL WENHAM-CLARKE - UK

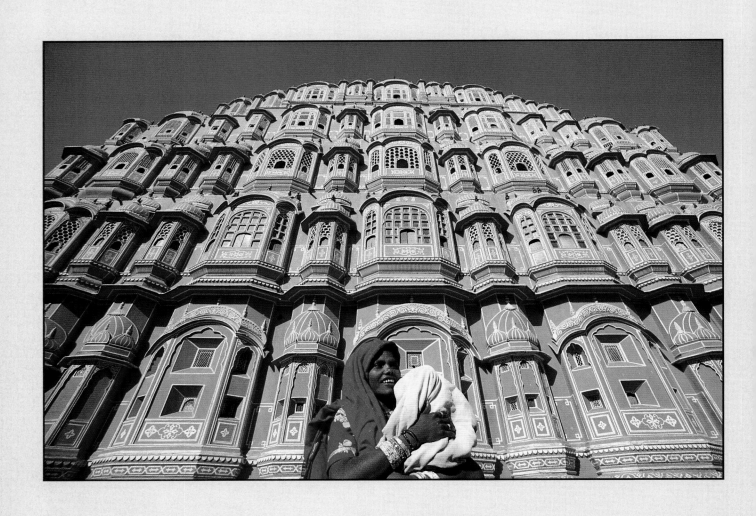

ROGER REYNOLDS - UK

18

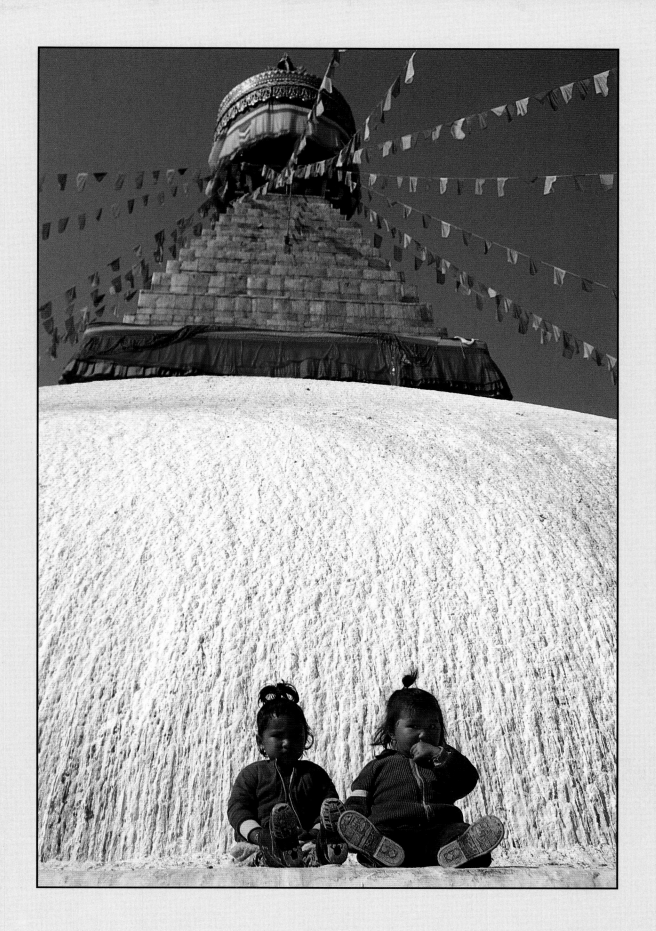

BOB MOORE - UK

19

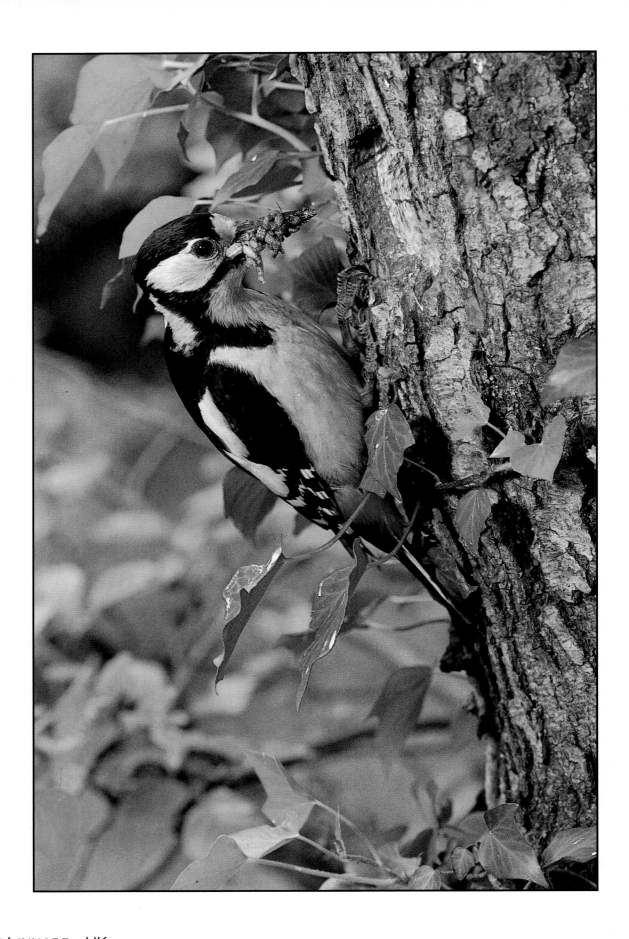

KEN LINNARD - UK

20

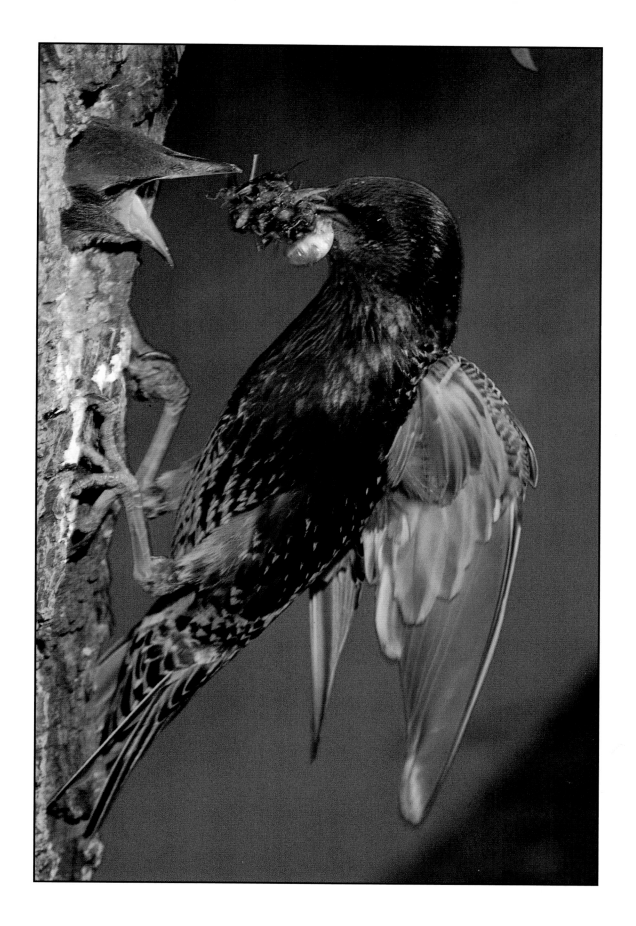

21

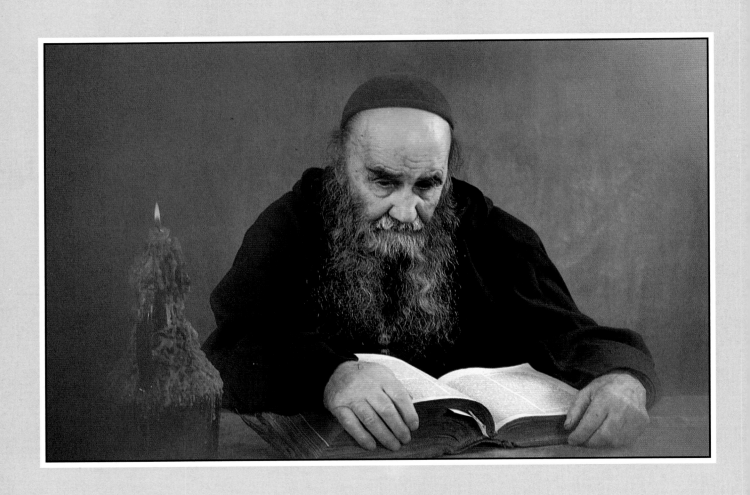

ERWIN TRAUNMÜLLER · AUSTRIA

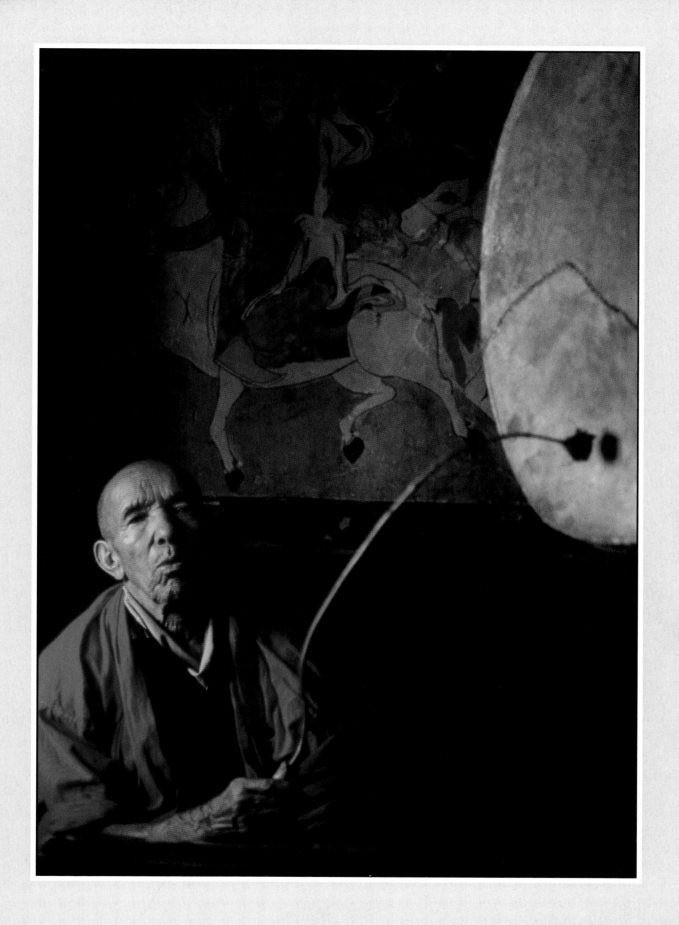

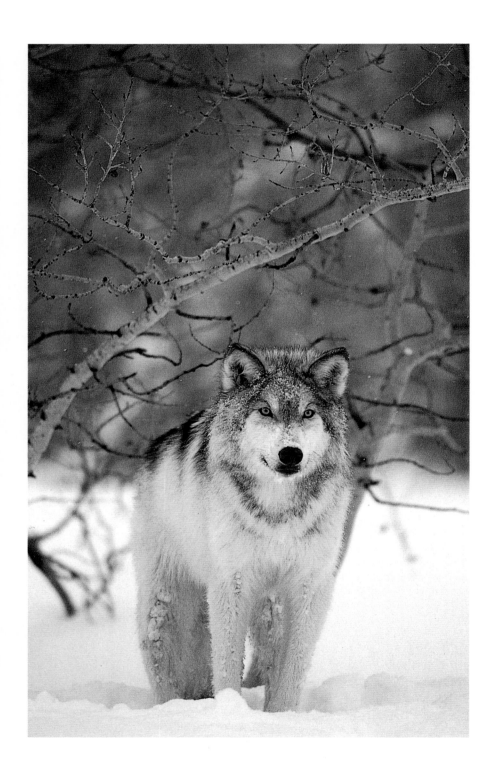

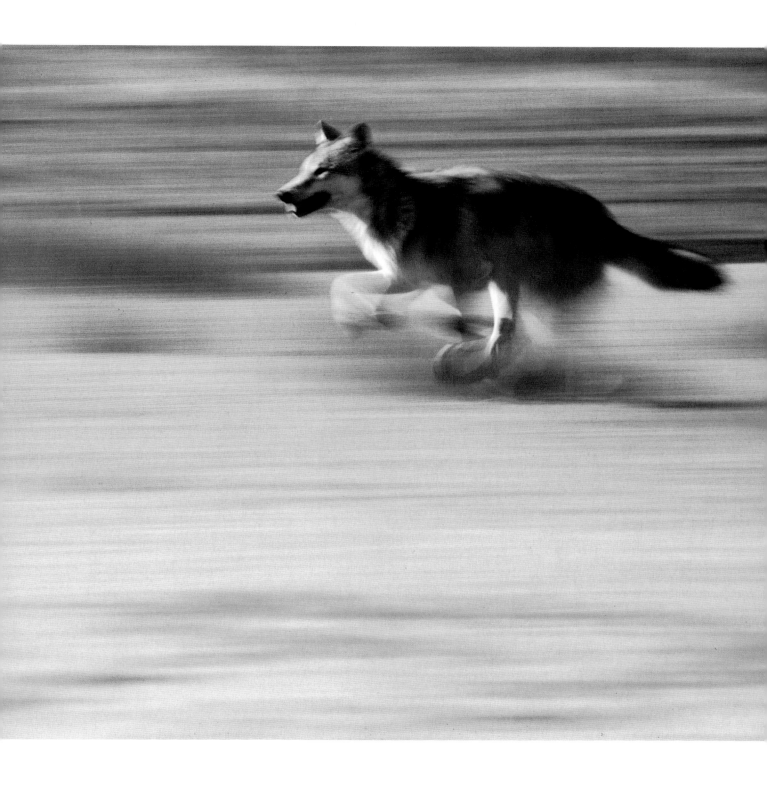

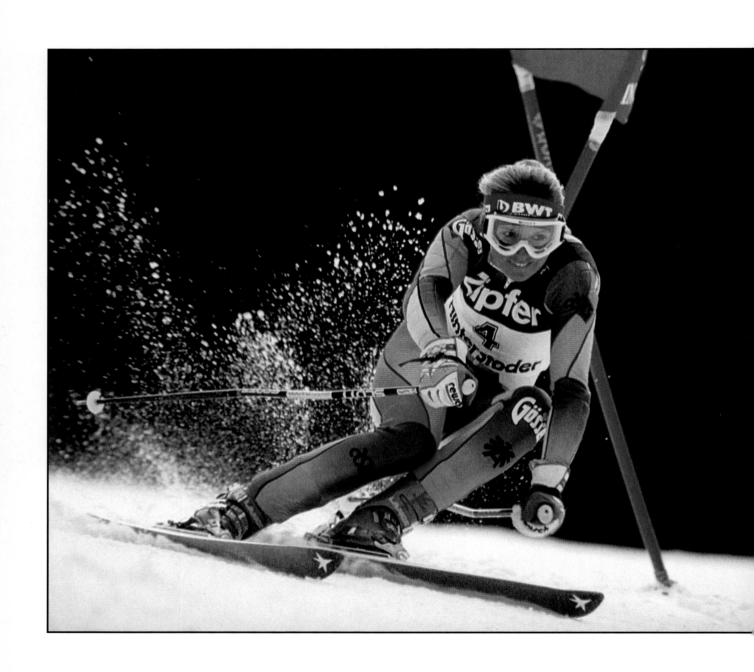

JOSEF HINTERLEITNER · AUSTRIA

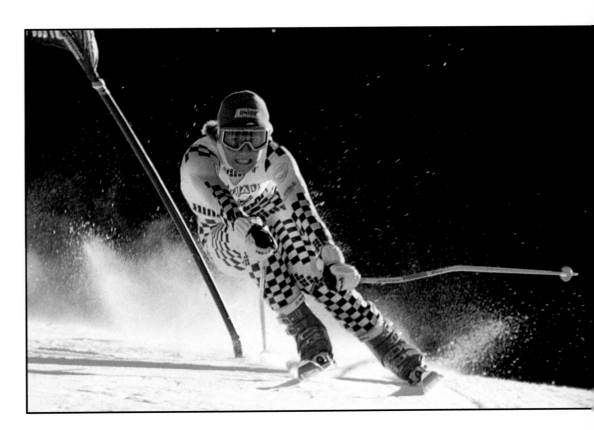

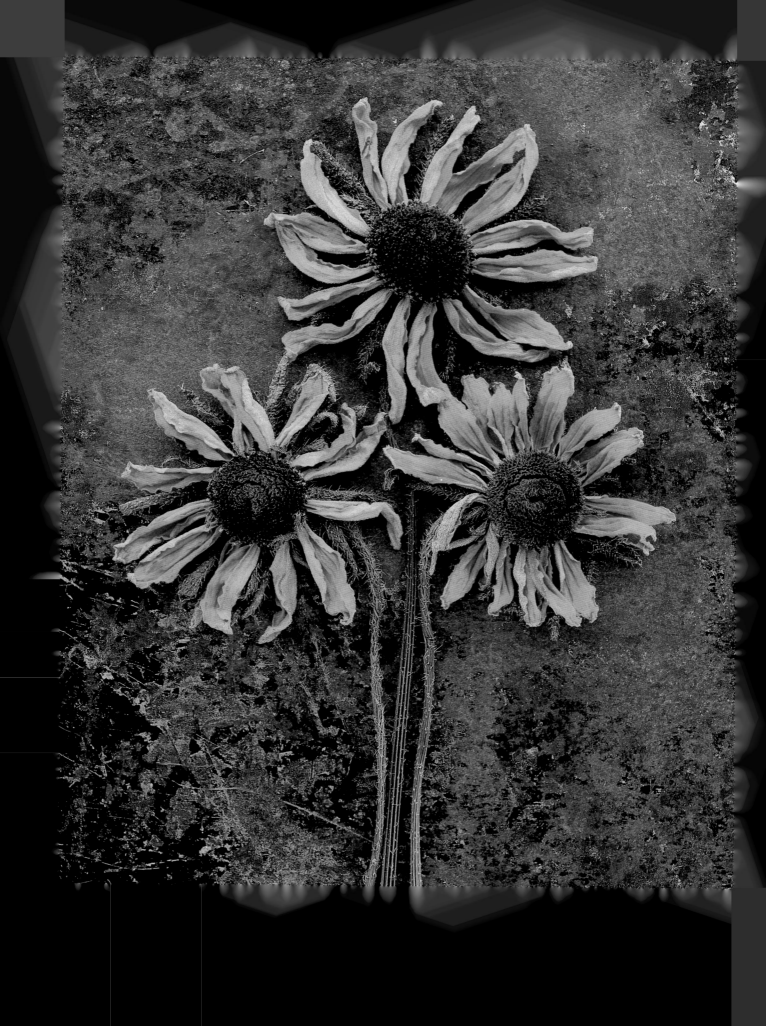

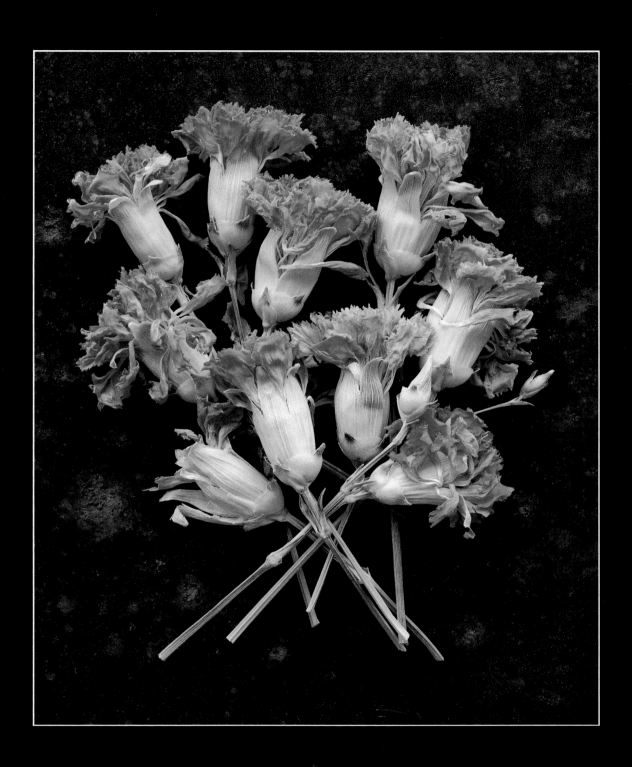

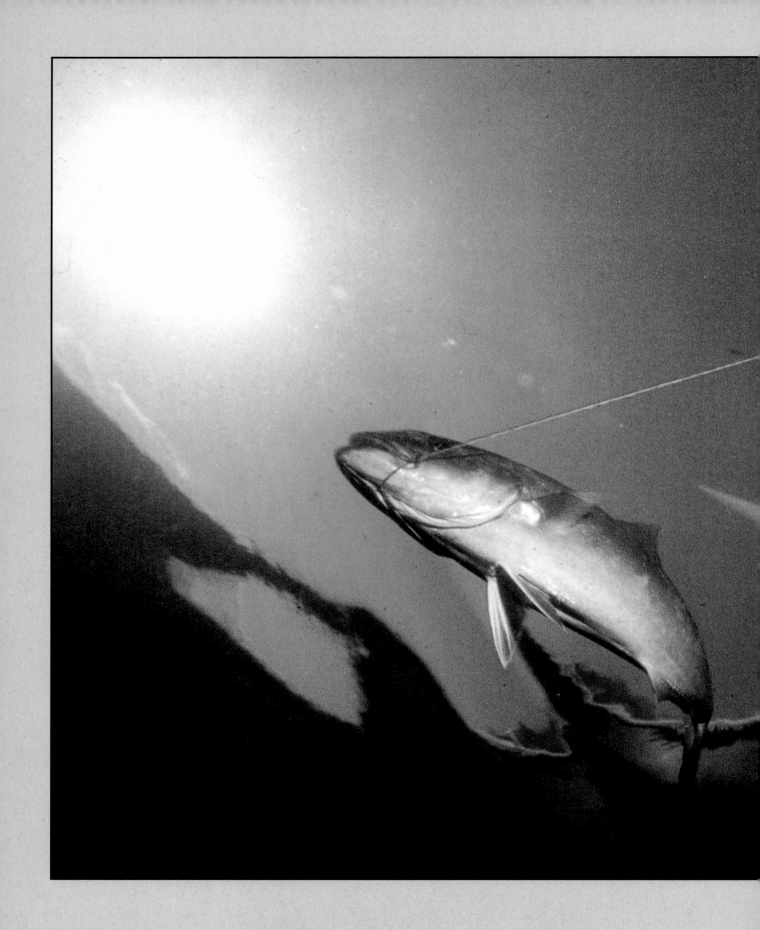

CIRIL MLINAR – SLOVENIA

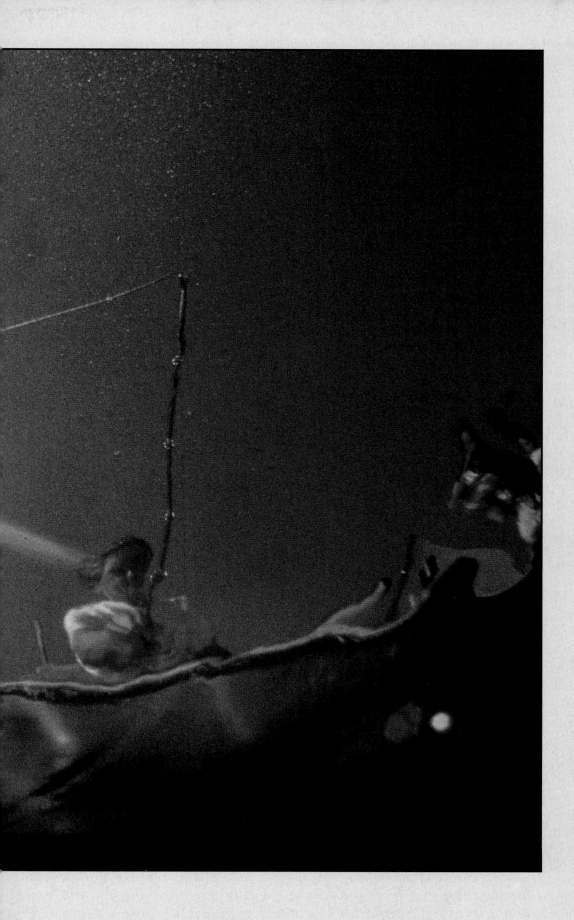

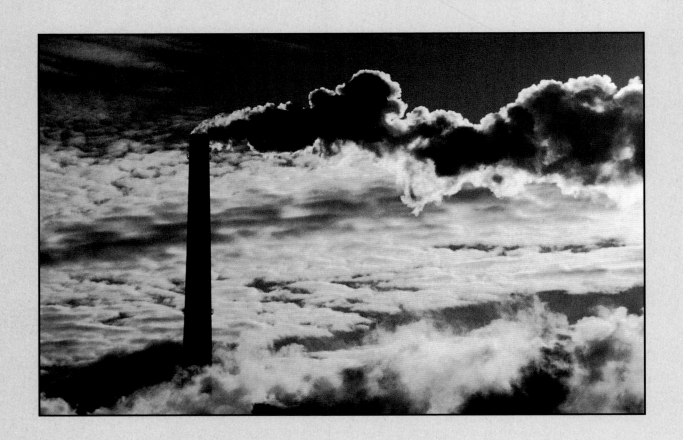

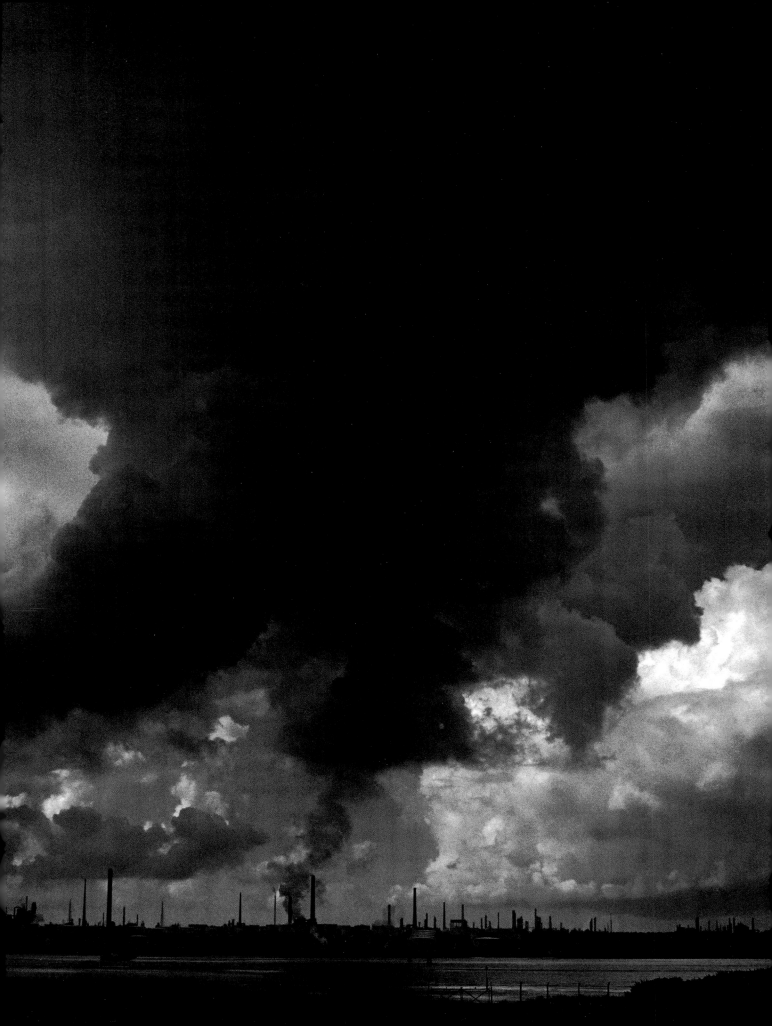

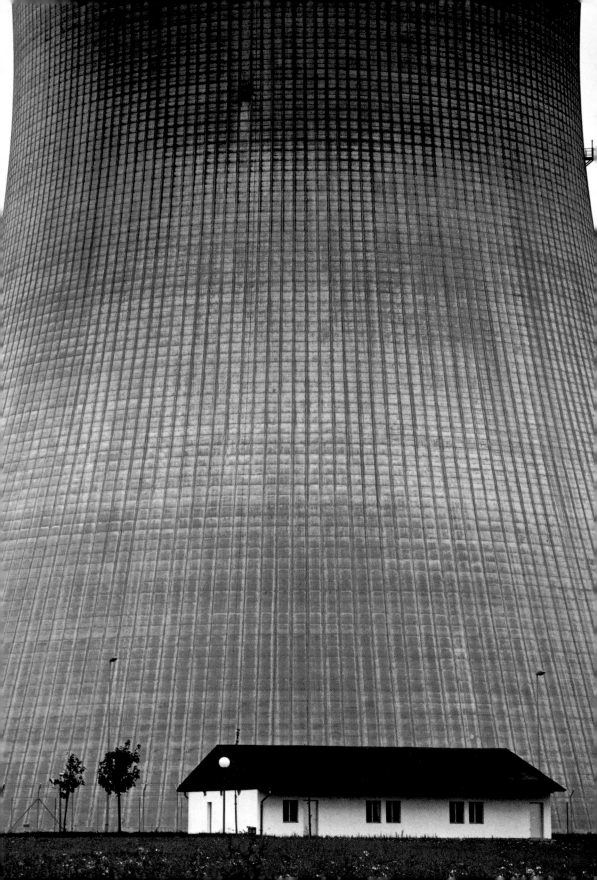

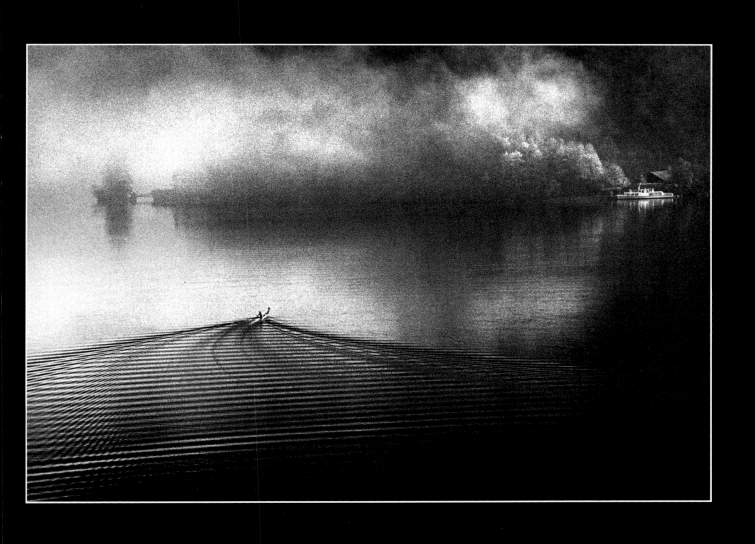

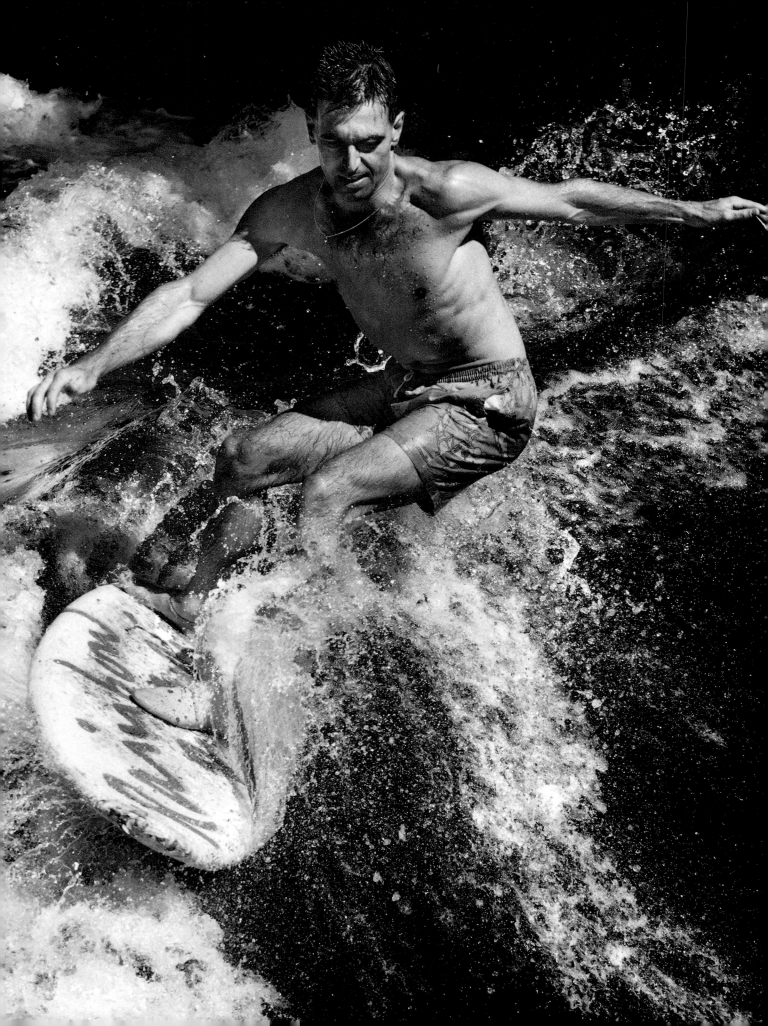

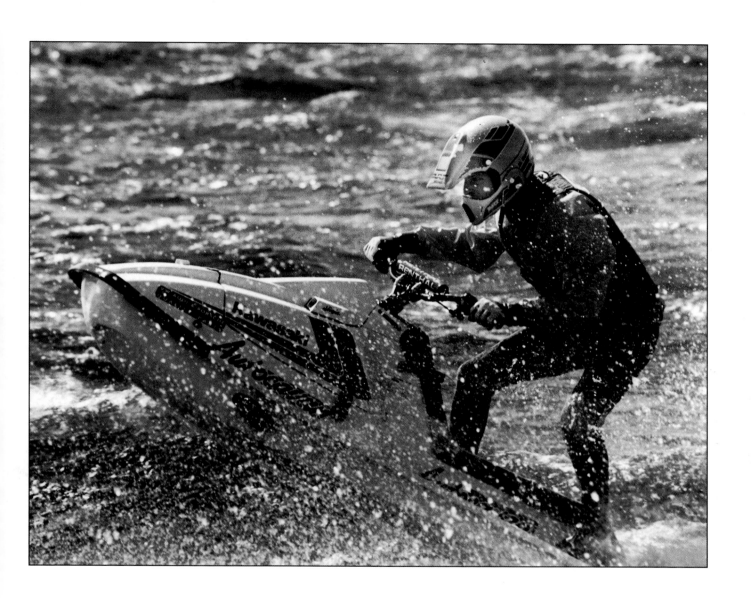

ERICH EFFENBERGER · GERMANY

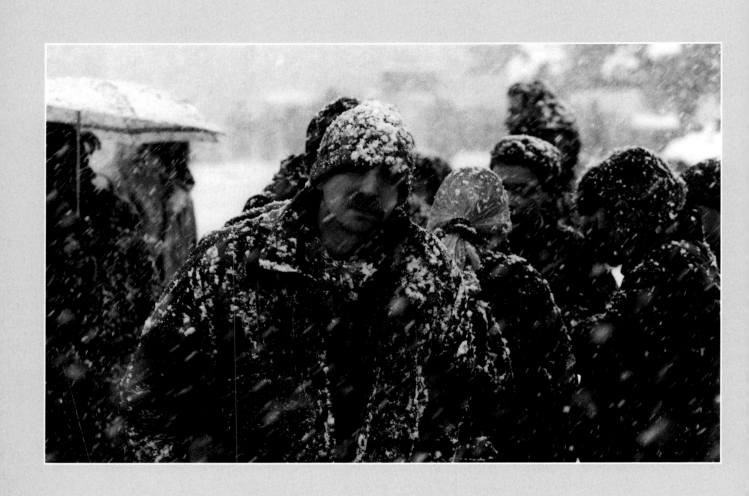

CHRIS WAINWRIGHT - UK

38

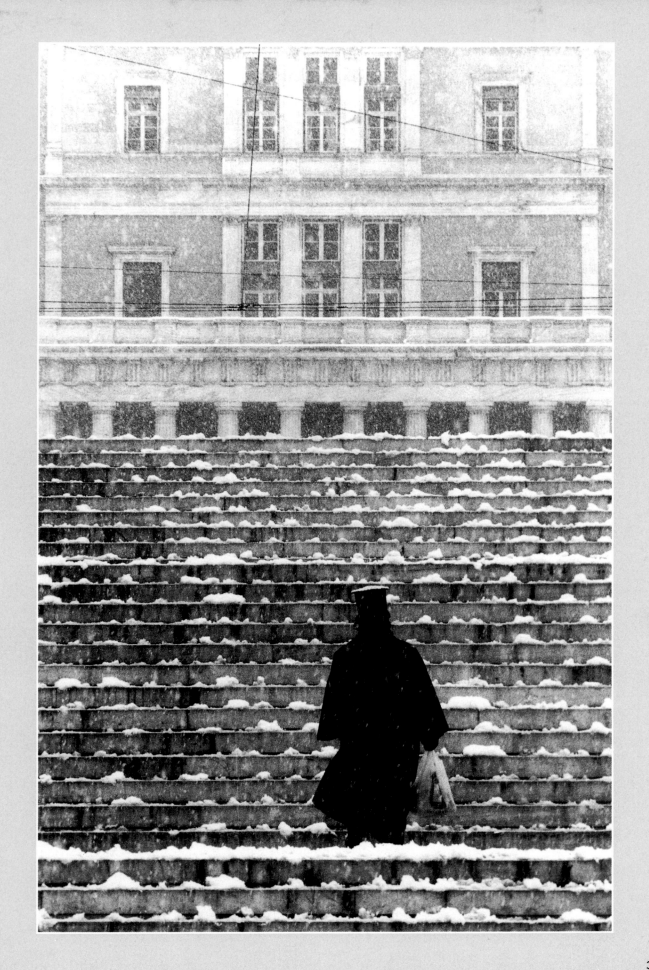

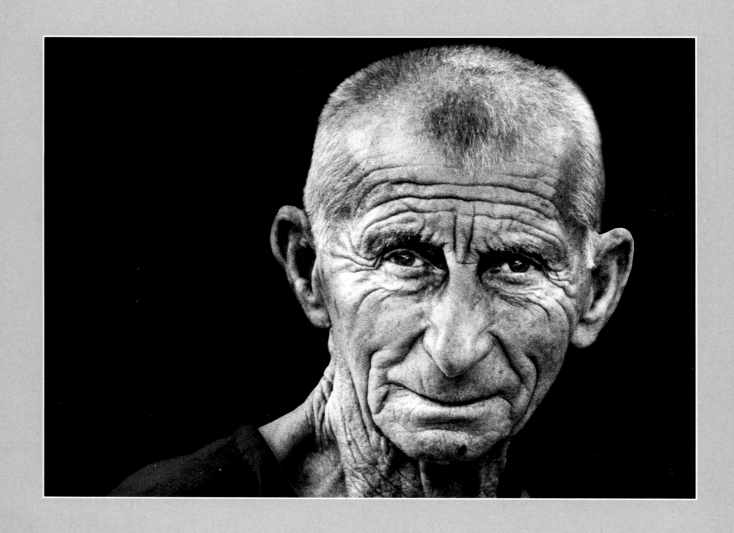

JOSEF GUSENBAUER · AUSTRIA

40

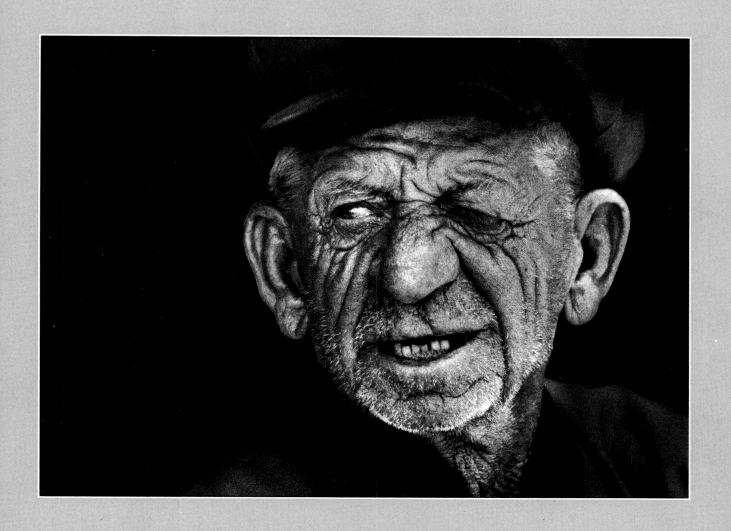

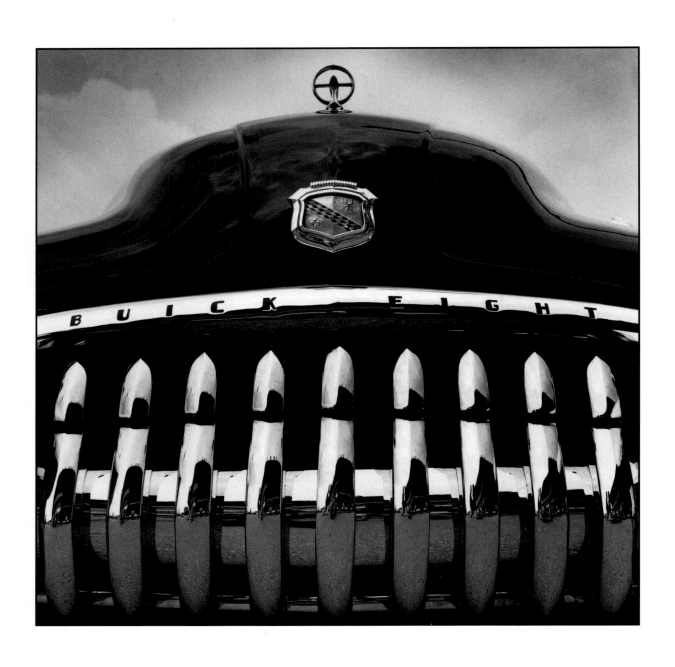

ERICH EFFENBERGER · GERMANY

42

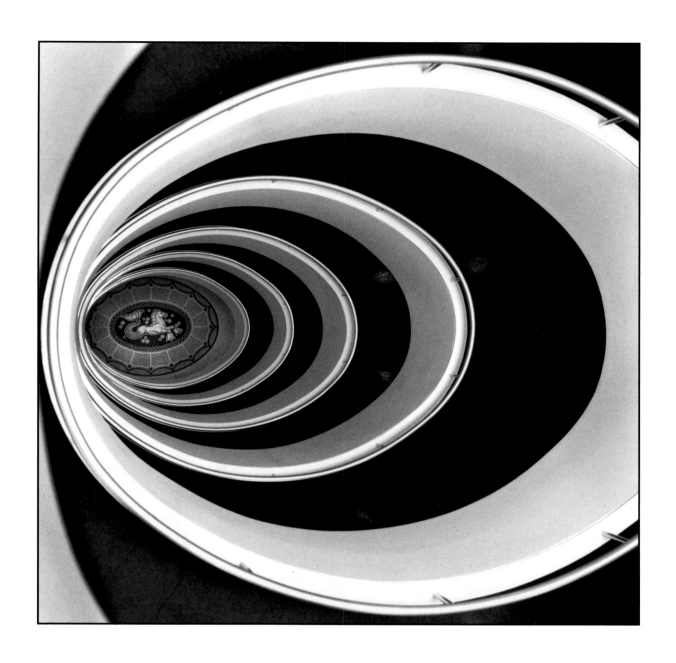

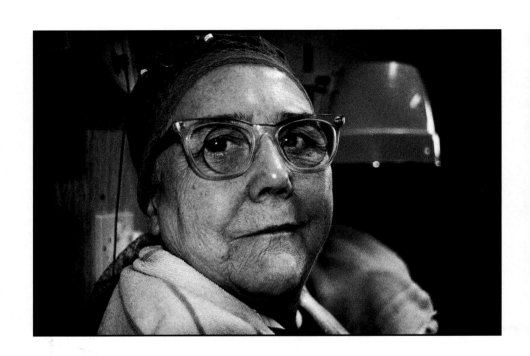

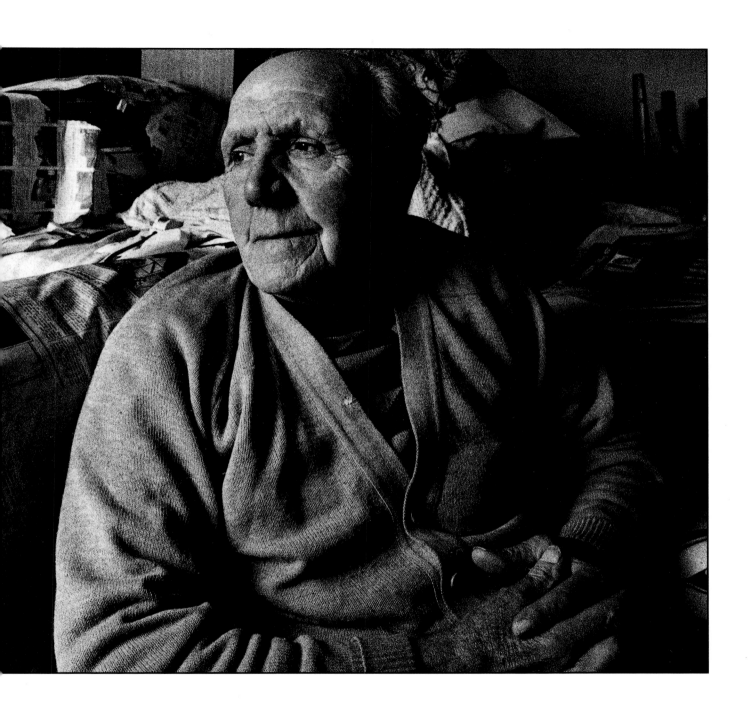

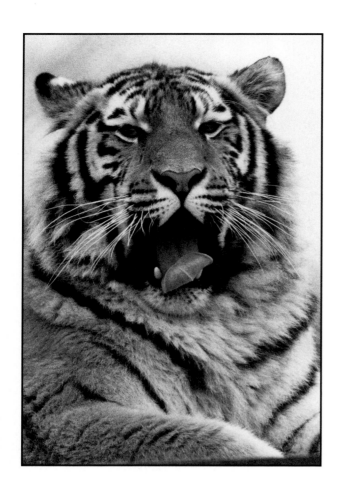

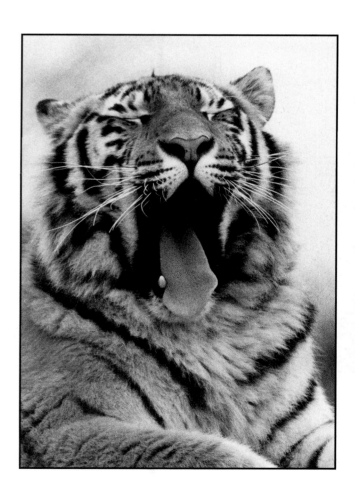

BRIAN TAYLOR - UK

46

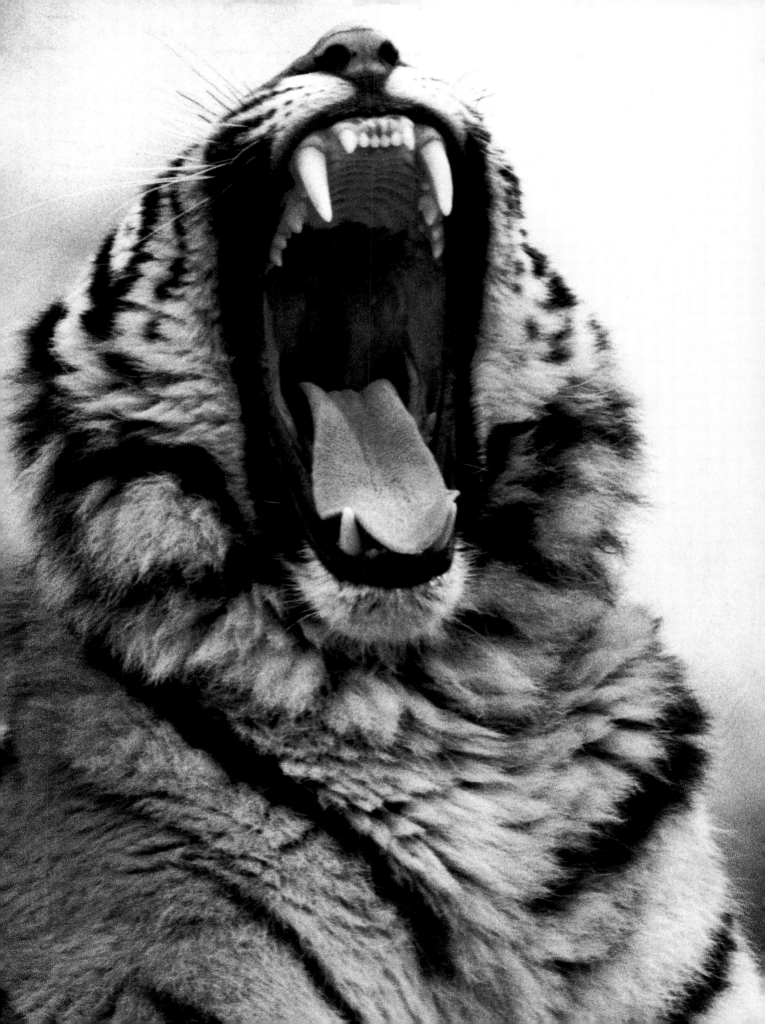

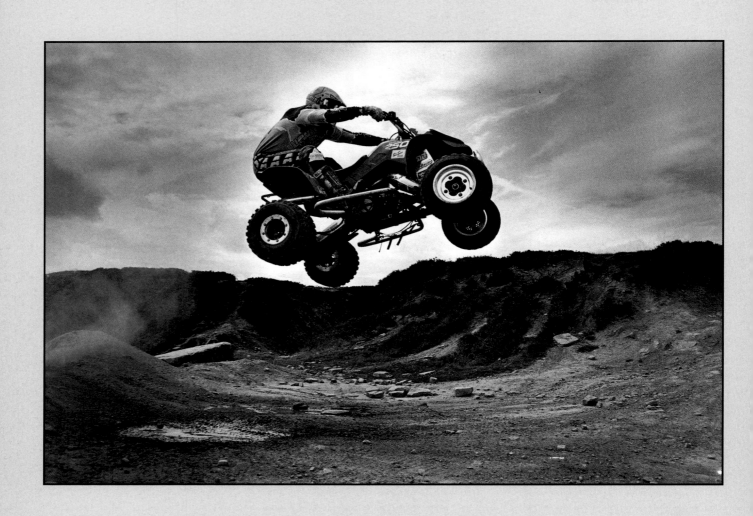

ALAN BARTON - UK

48

JOSEF HINTERLEITNER - AUSTRIA

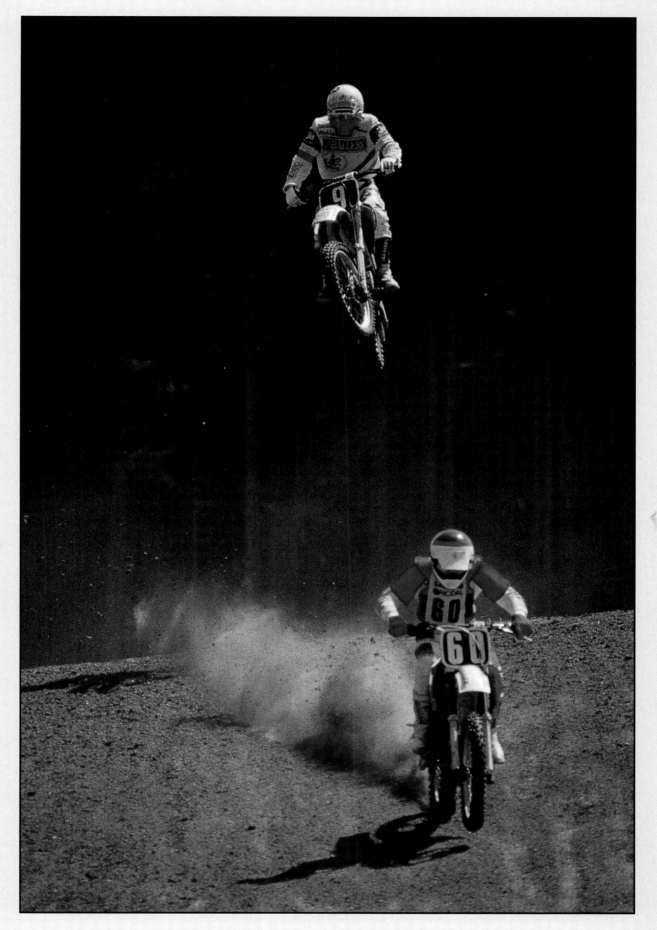

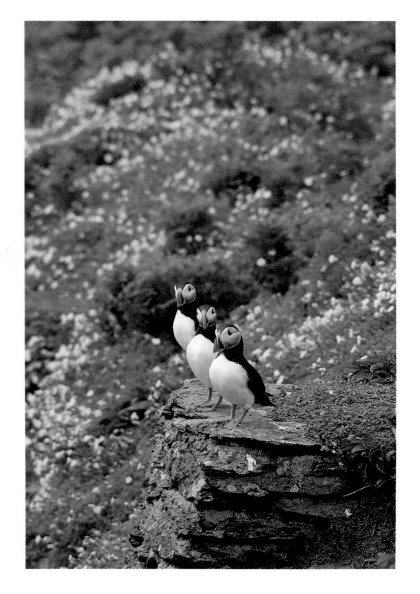

HUW EDWARDS - UK

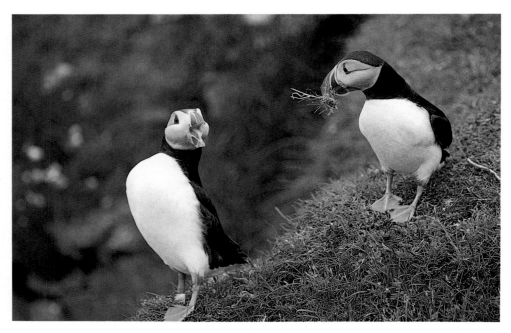

DAVID OWEN - UK

50

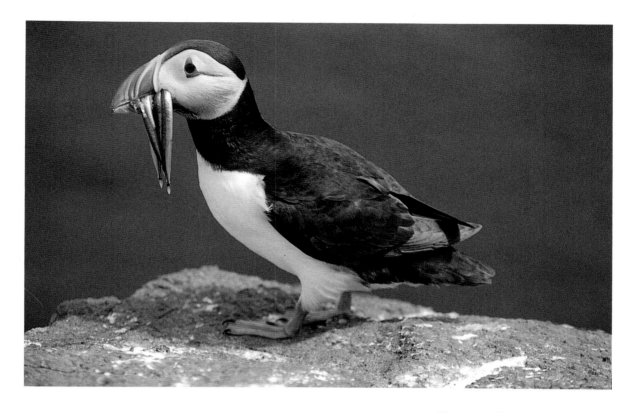

ROGER REYNOLDS - UK

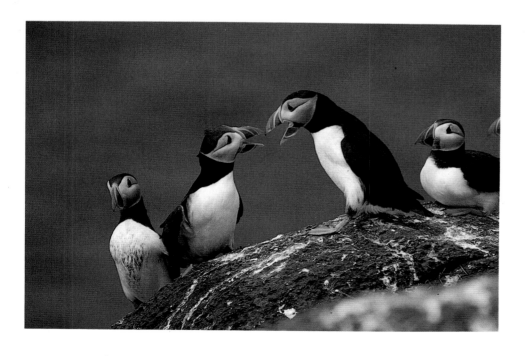

ANDREW TURNER - UK

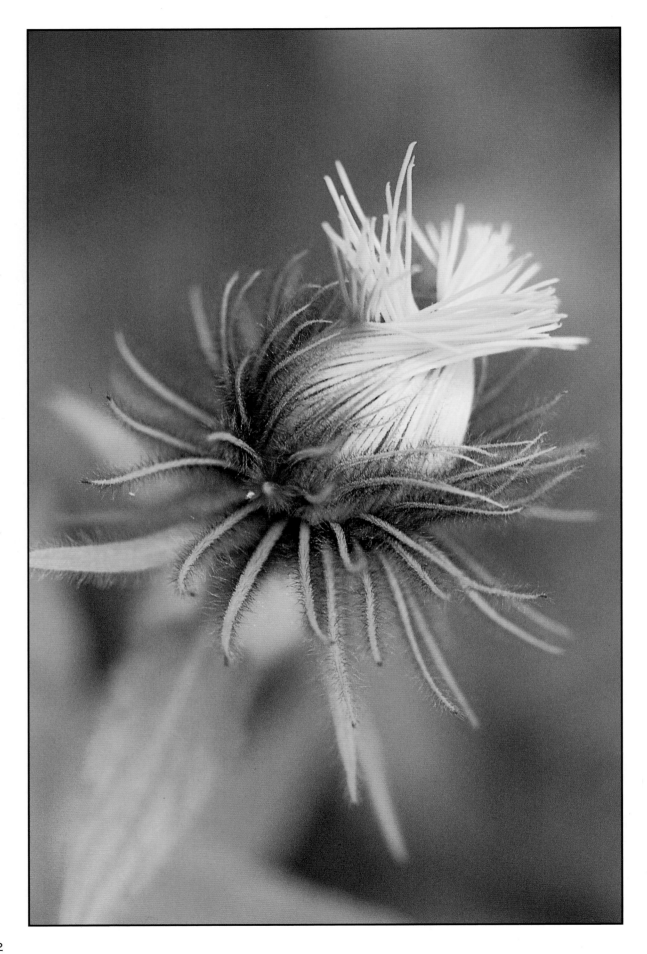

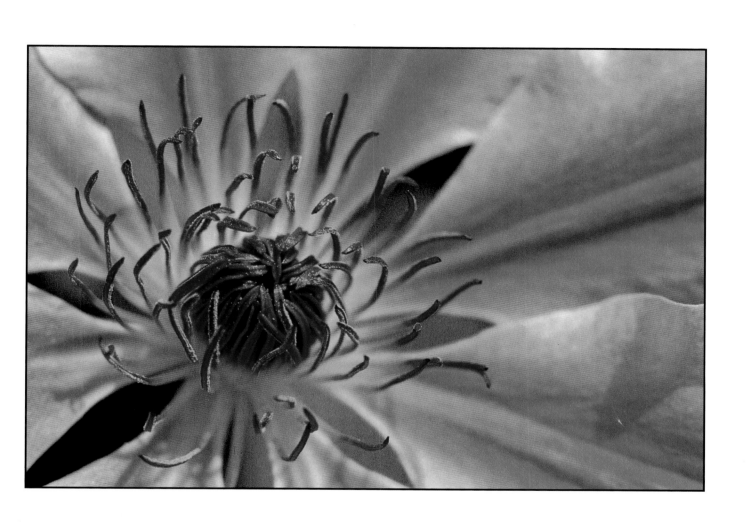

53

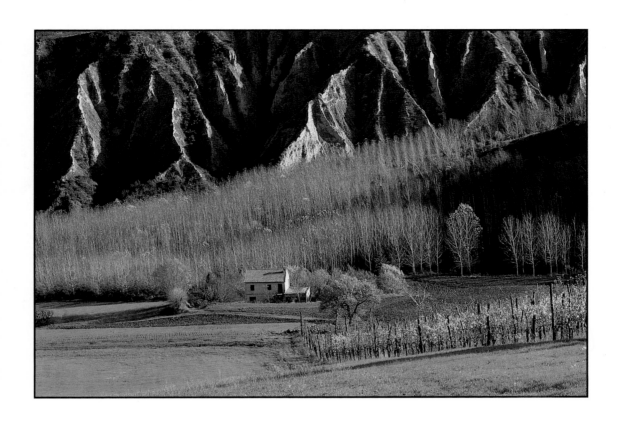

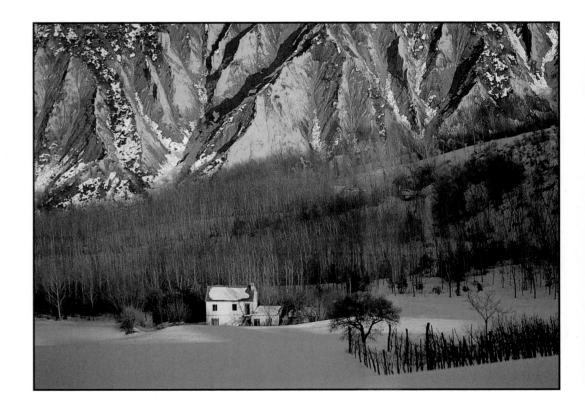

CLAUDIO MARCOZZI - ITALY

54

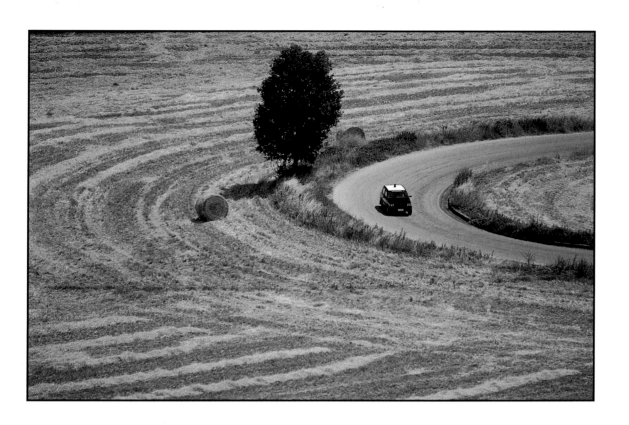

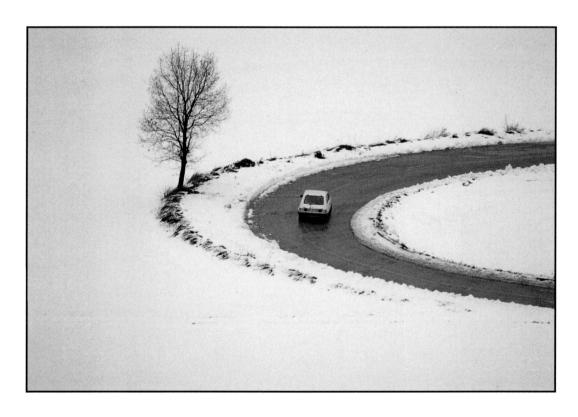

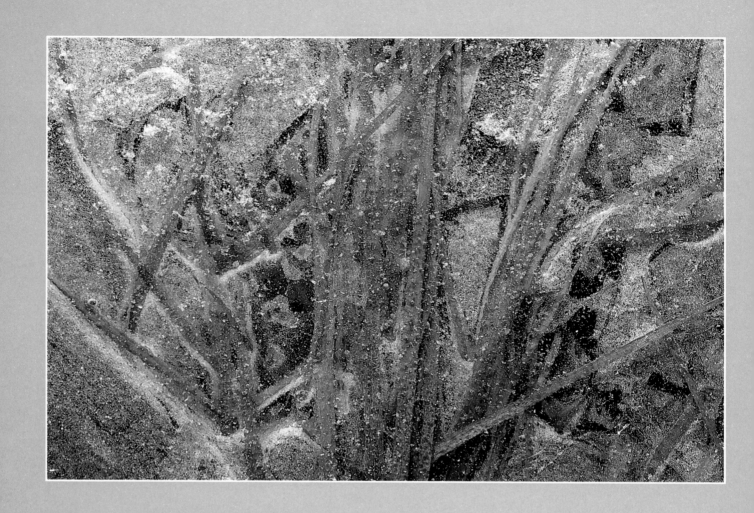

Jari Hakala · Finland

56

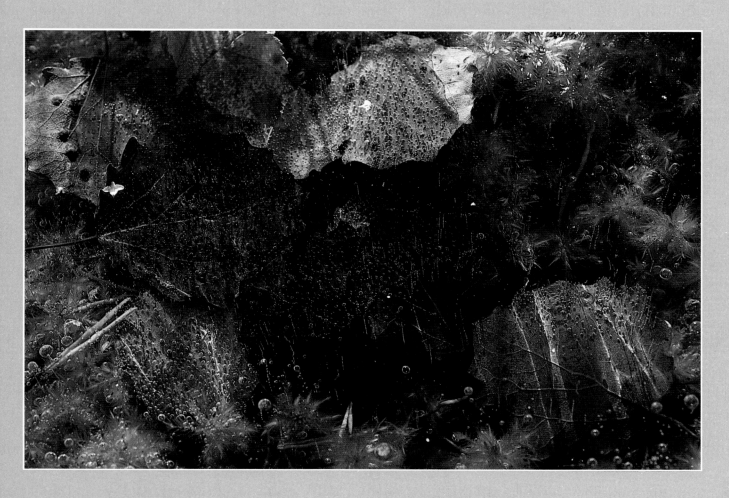

57

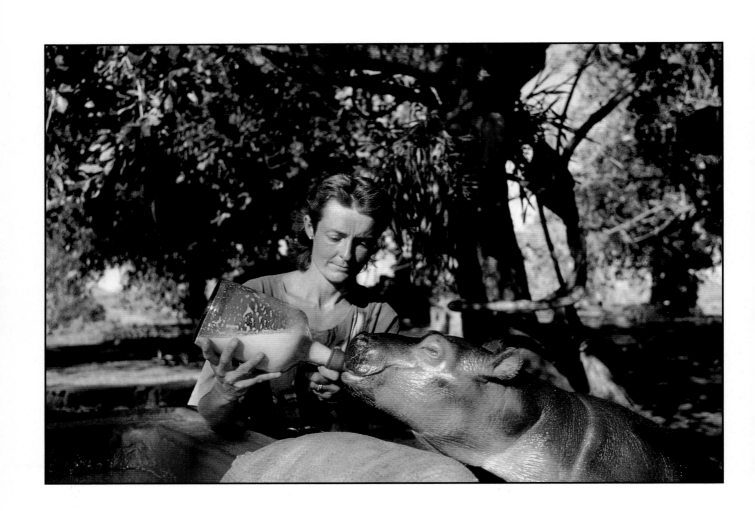

JOHN EVANS - UK

58

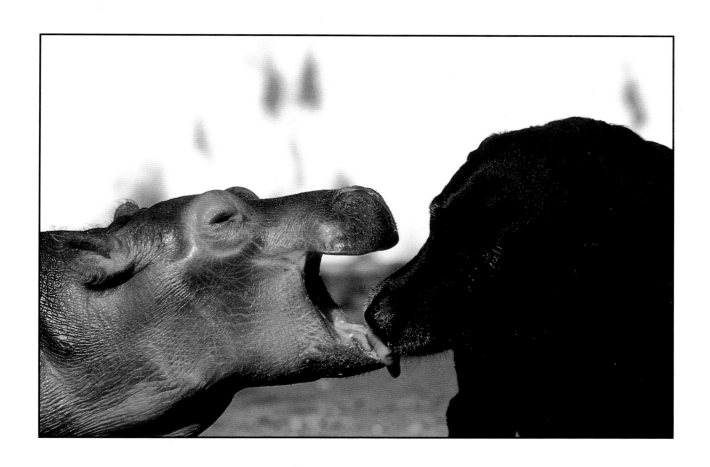

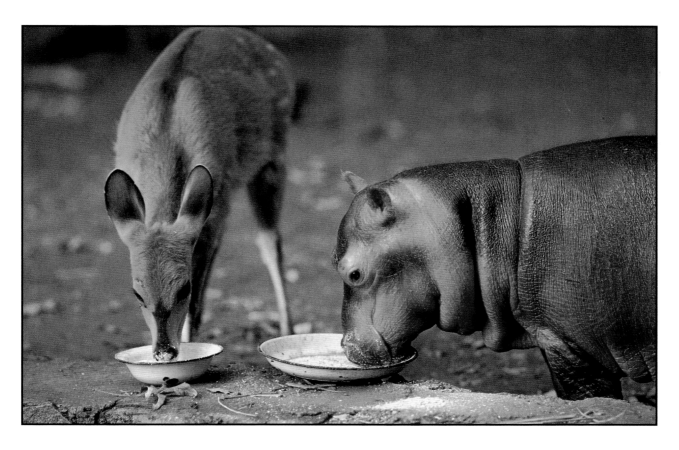

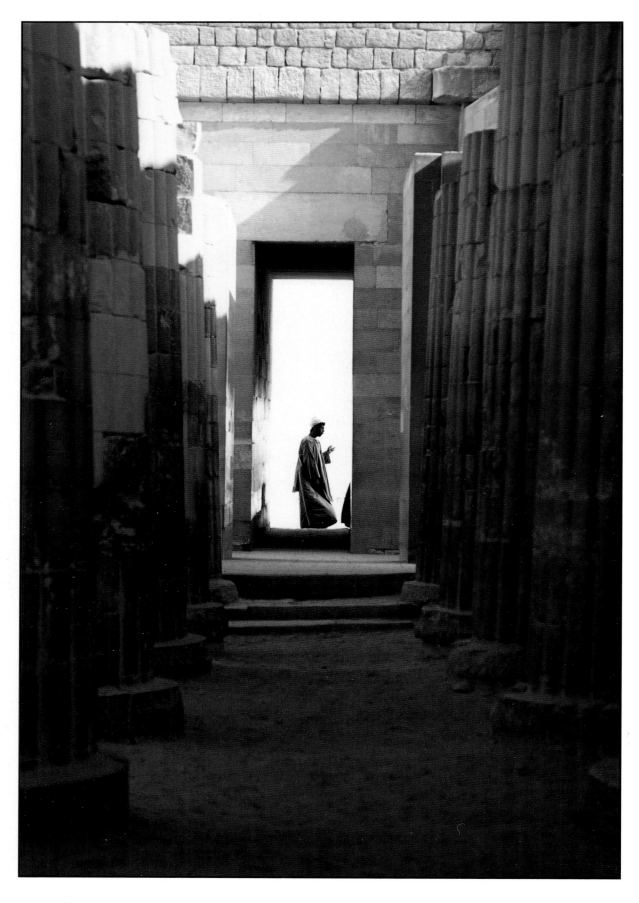

CHRISTIAN NAGL - AUSTRIA

PRASERT PATTANASITUBOL - THAILAND

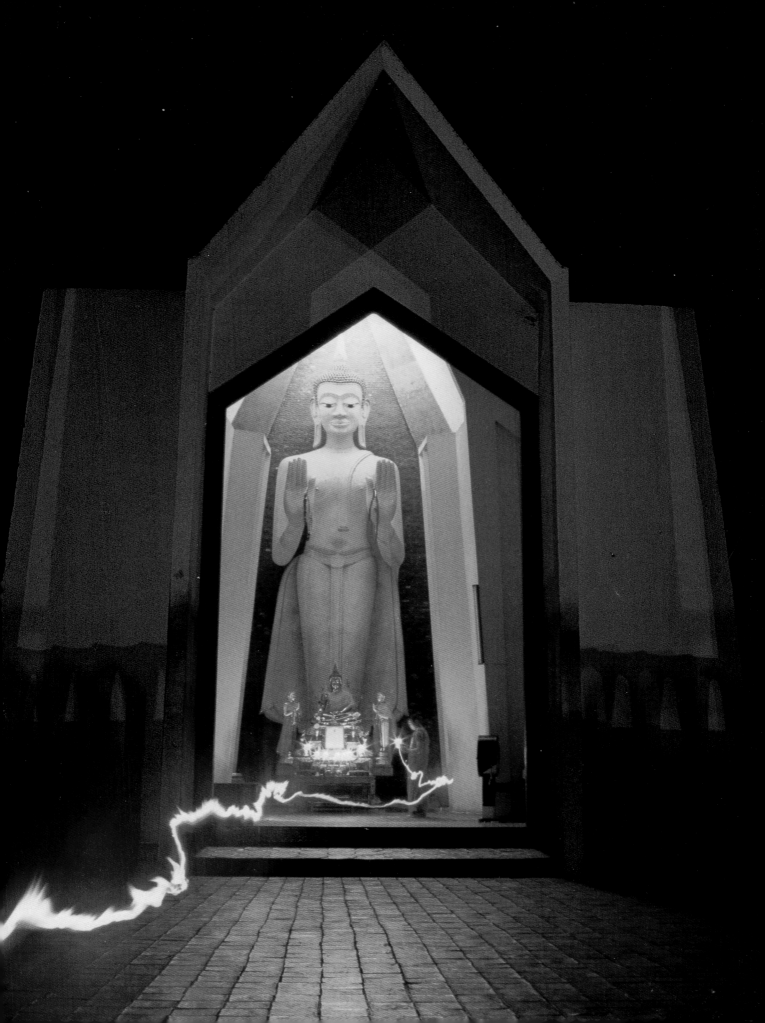

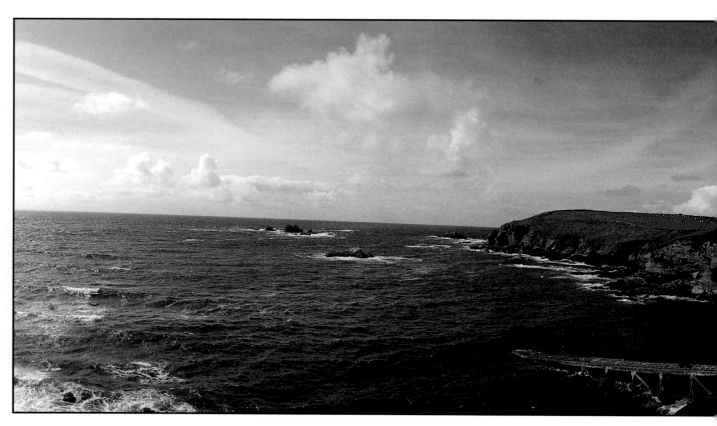

HELENE ROGERS - UK

62

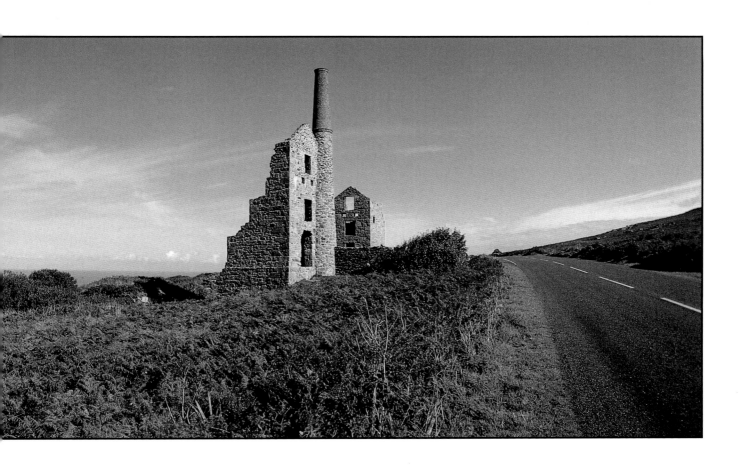

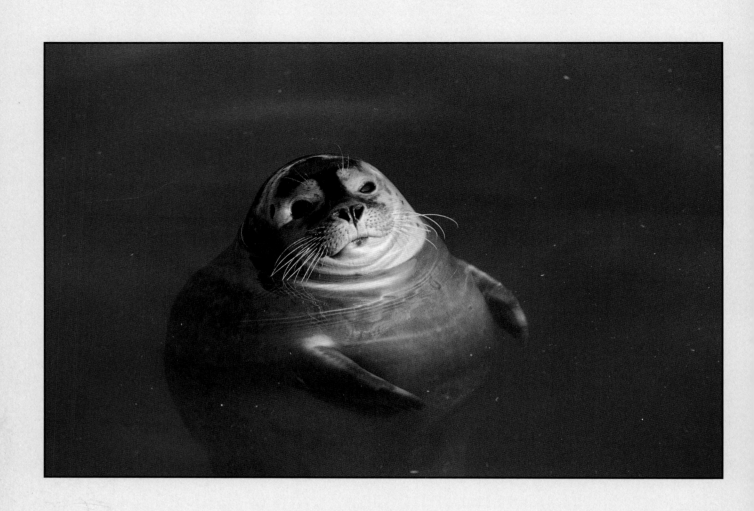

JEAN FEHLMAN - SWITZERLAND

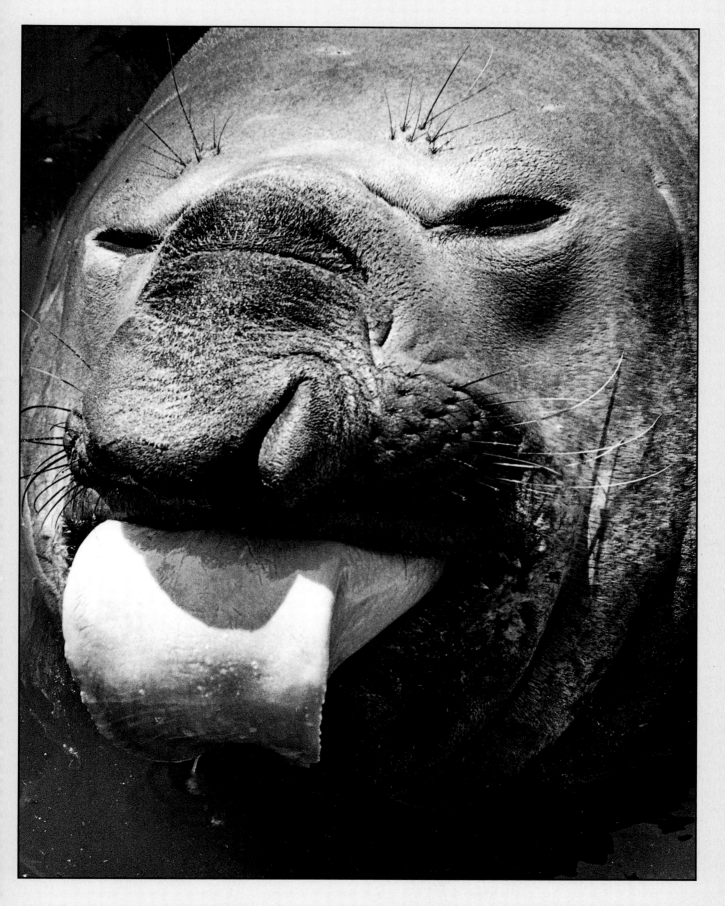

65

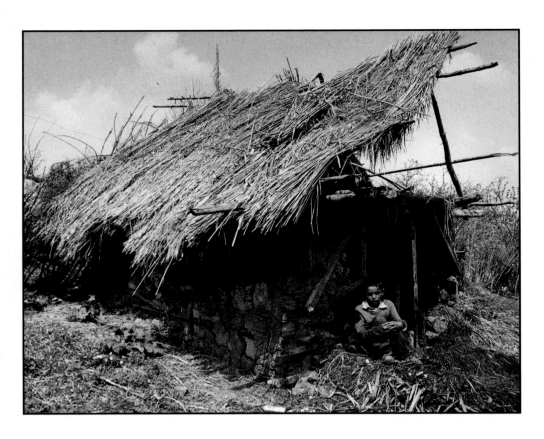

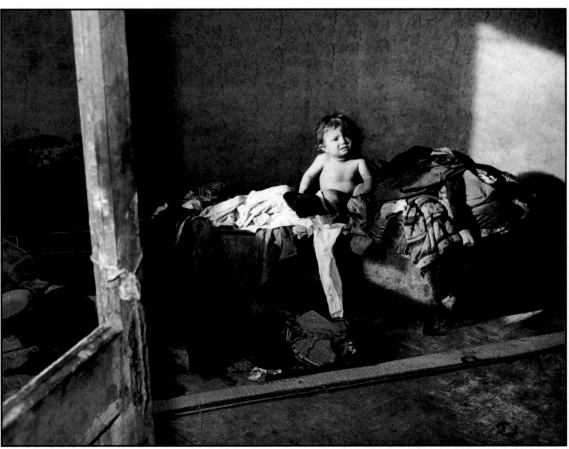

TIBOR JAKAB - ROMANIA

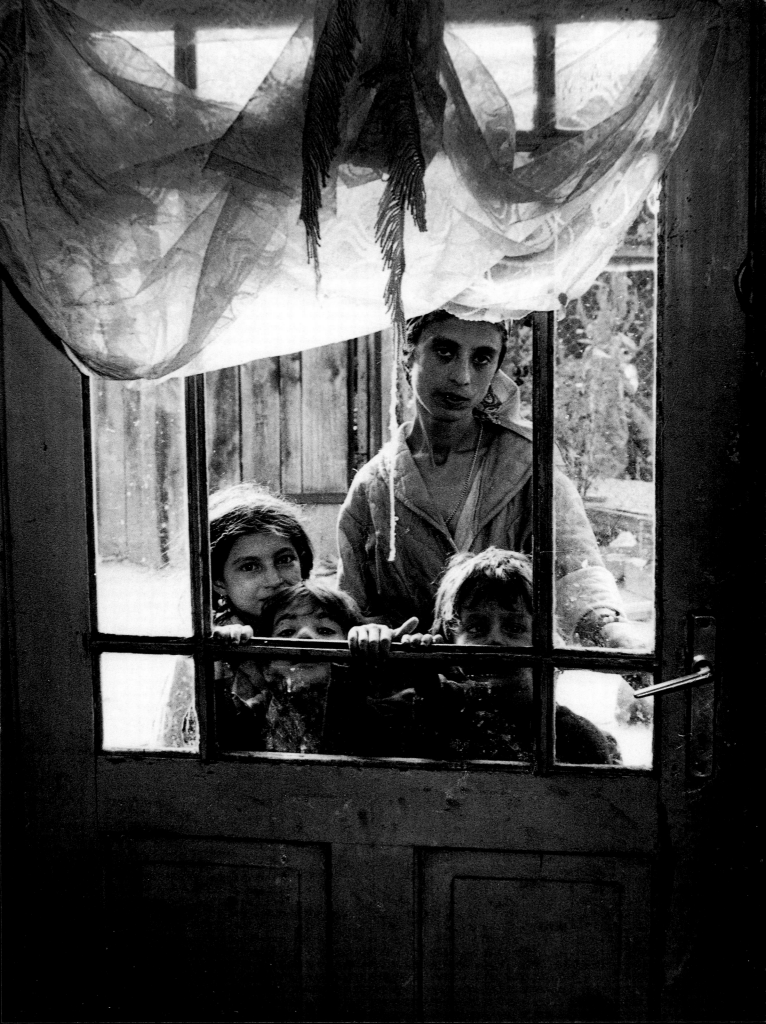

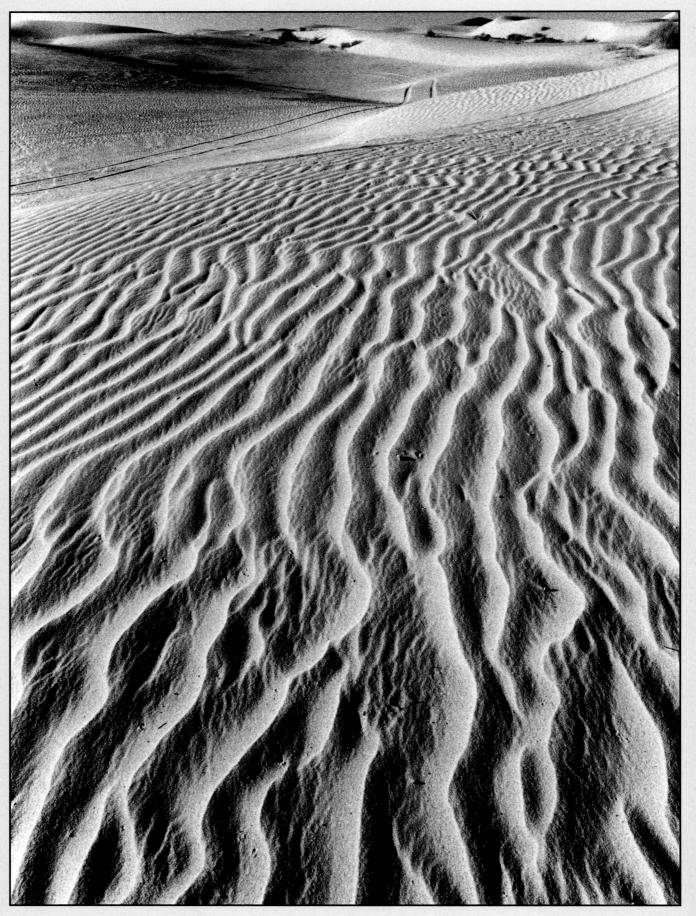

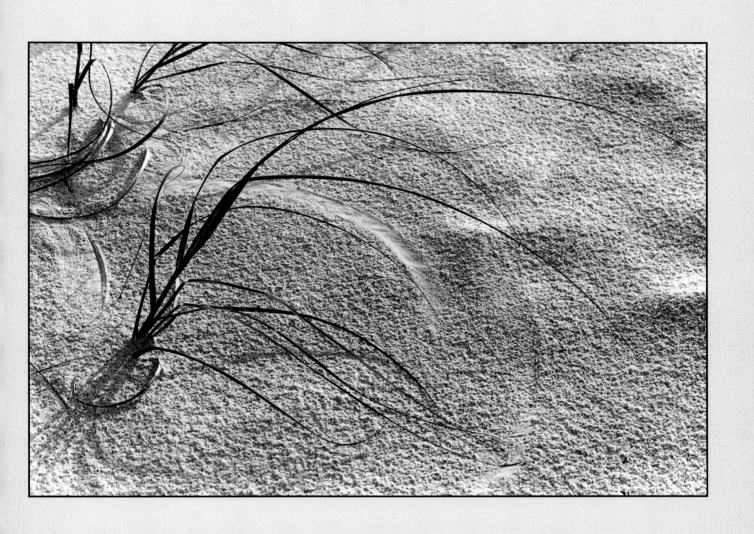

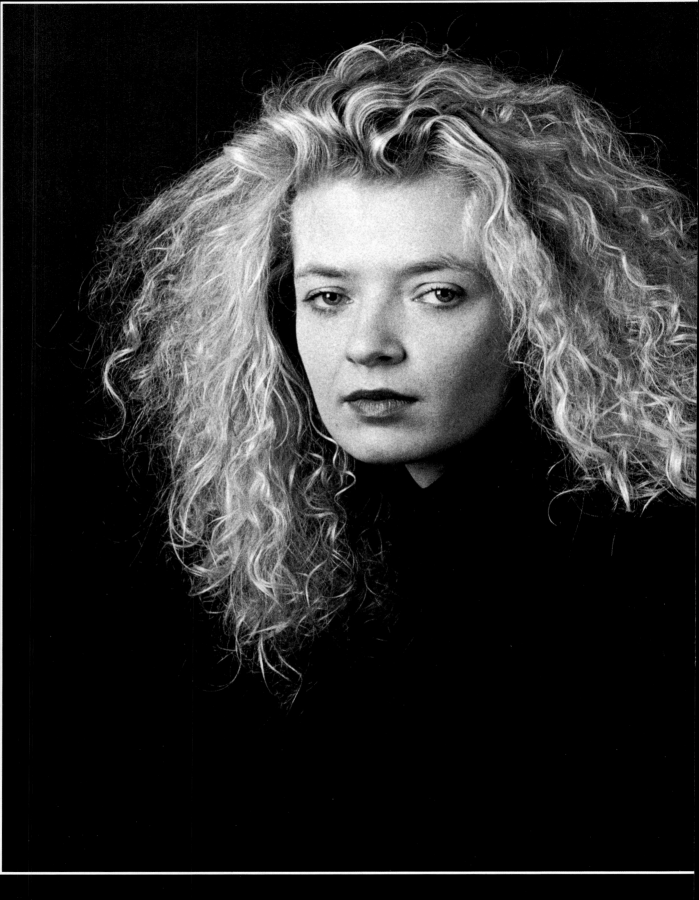

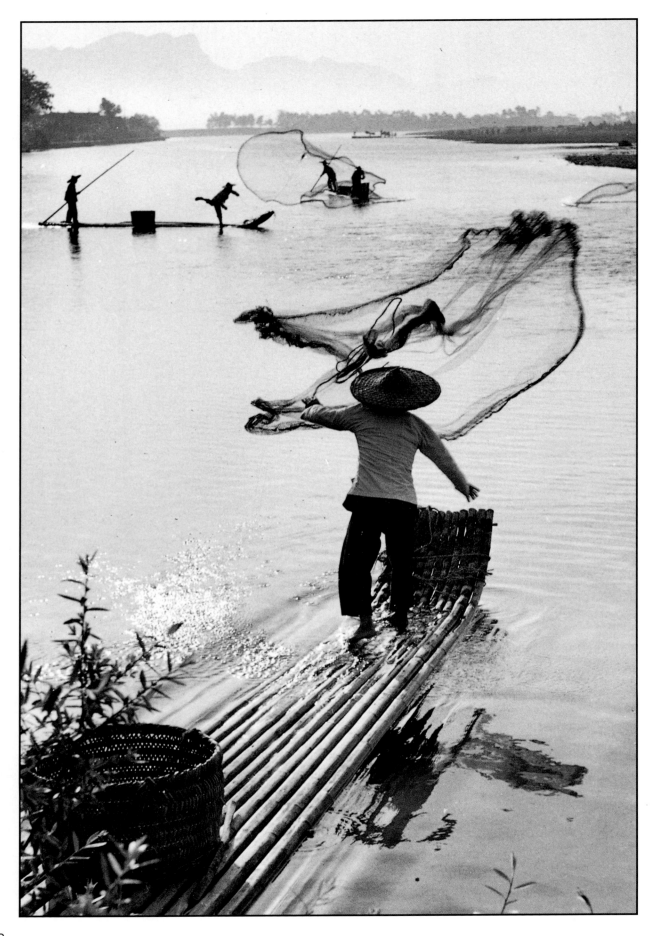

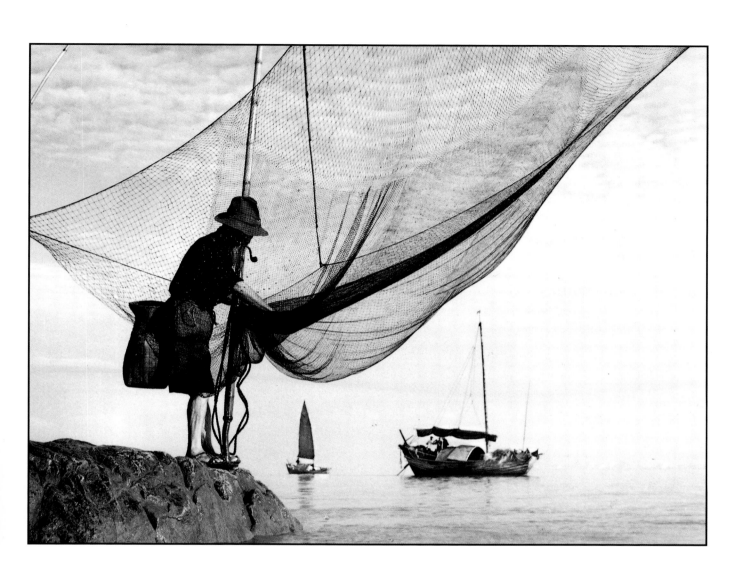

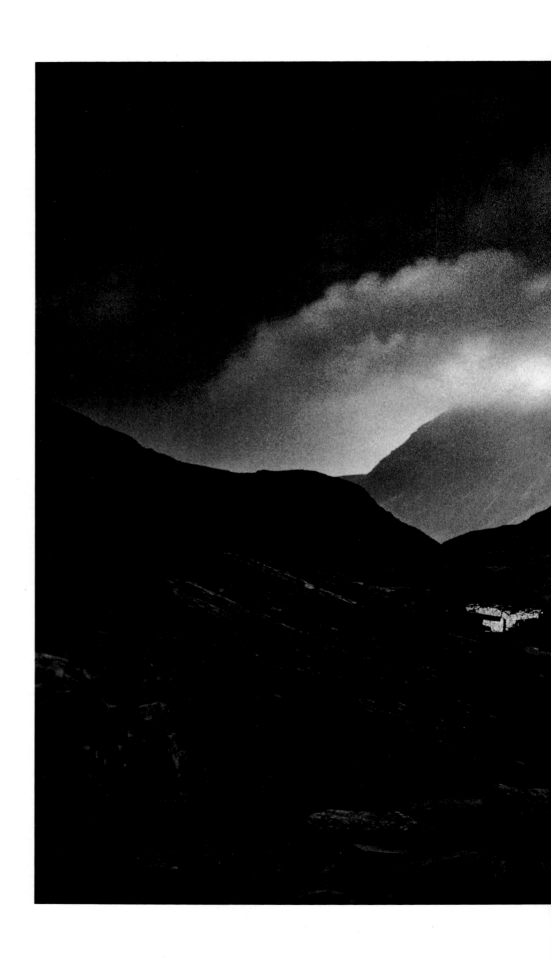

TIM RUDMAN - UK

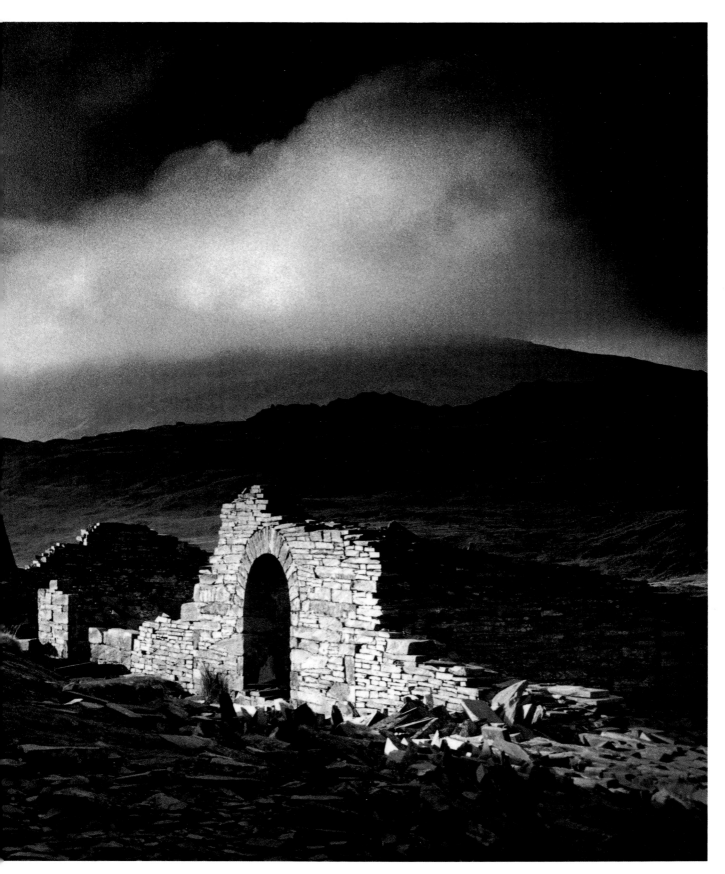

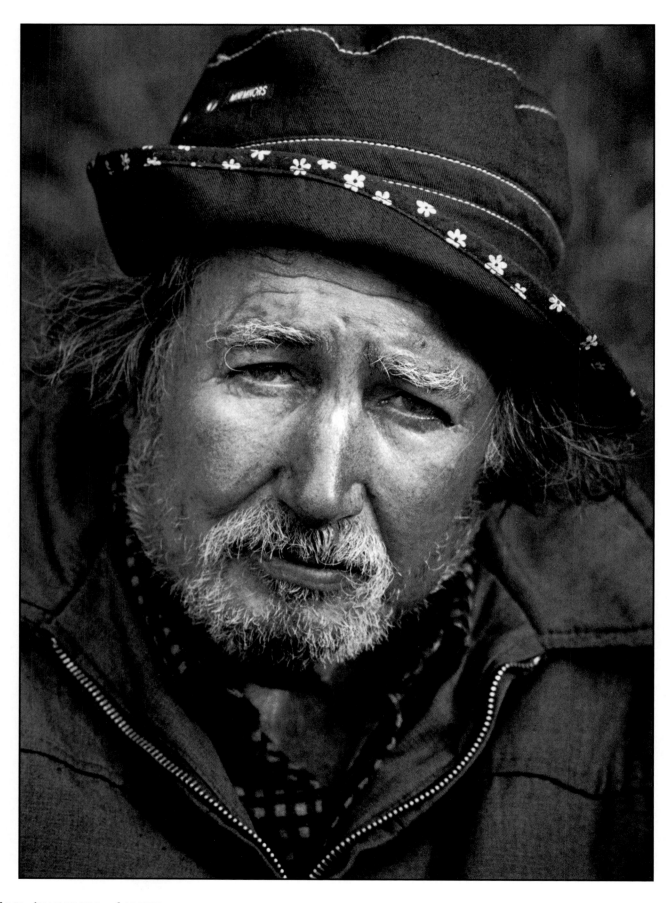

MAX JOHNSON - AUSTRALIA

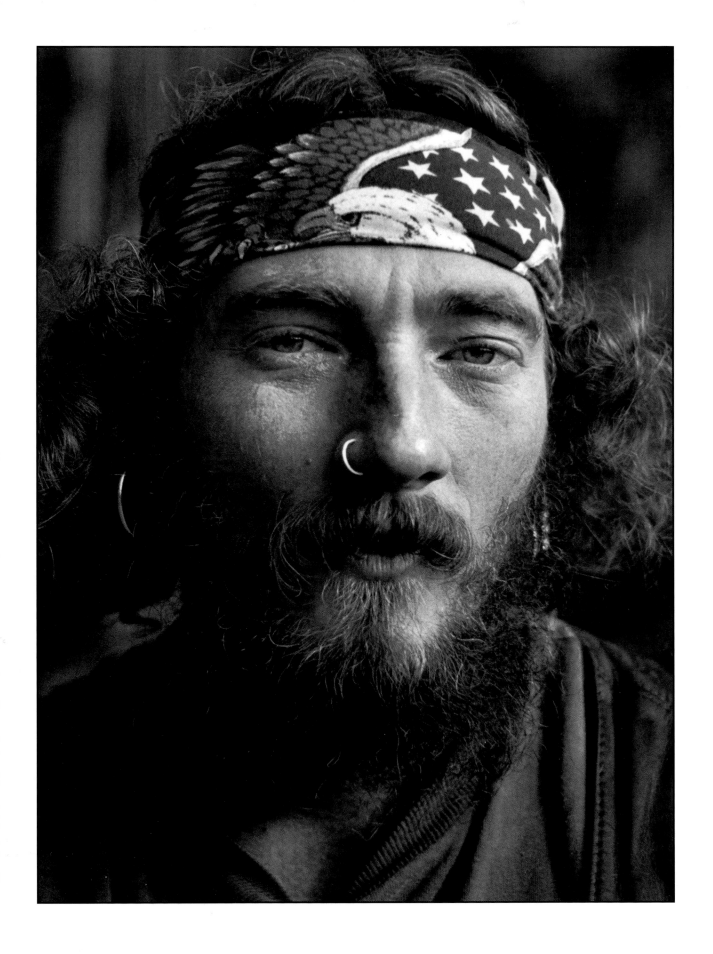

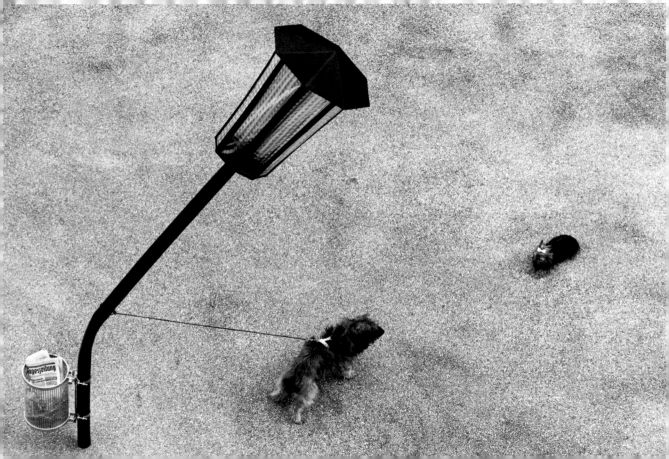

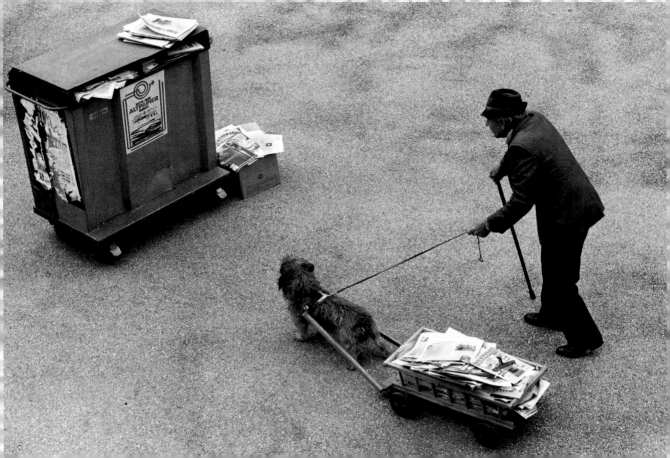

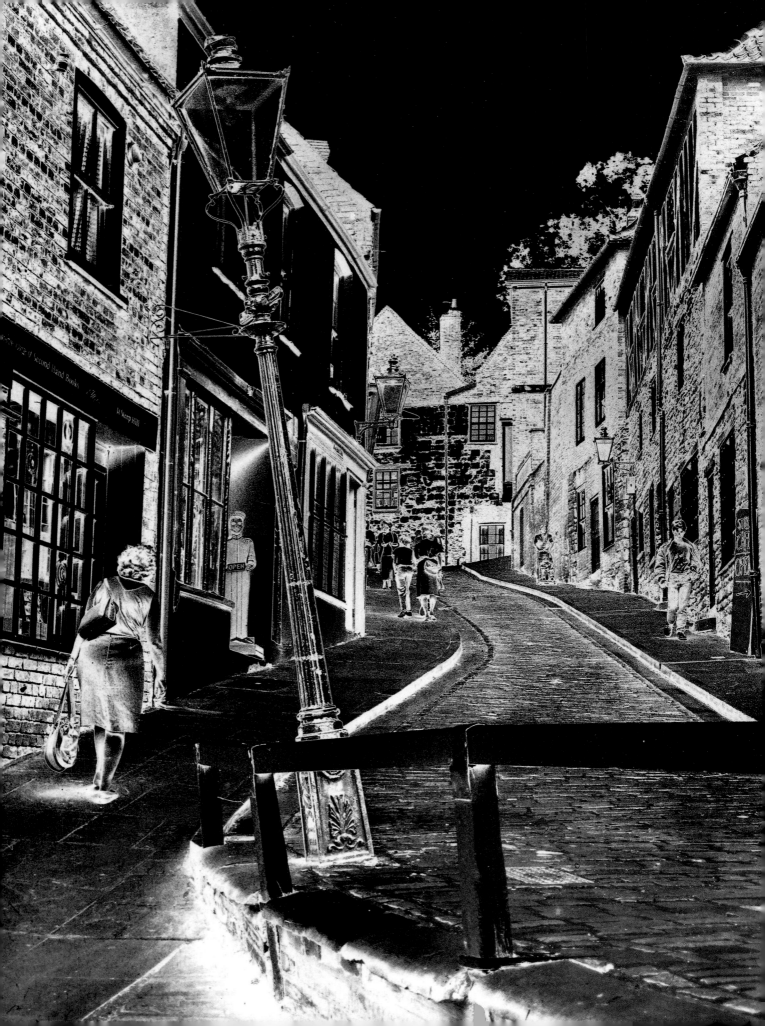

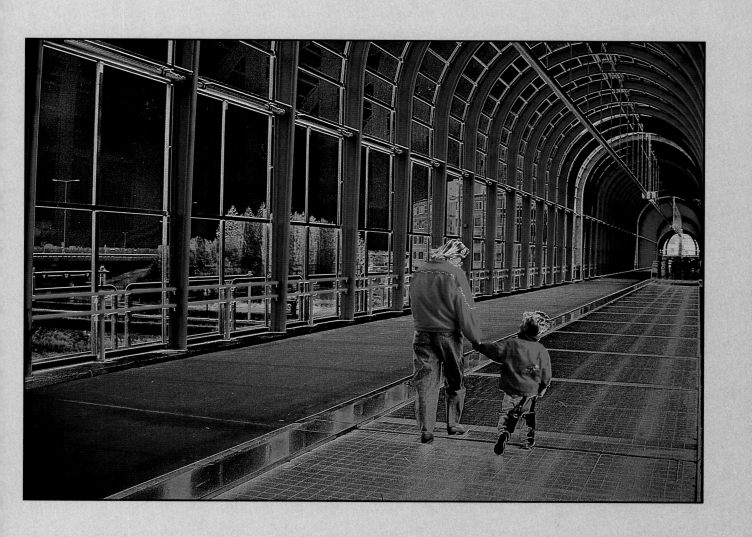

WILLIAM ATTENBOROUGH - UK

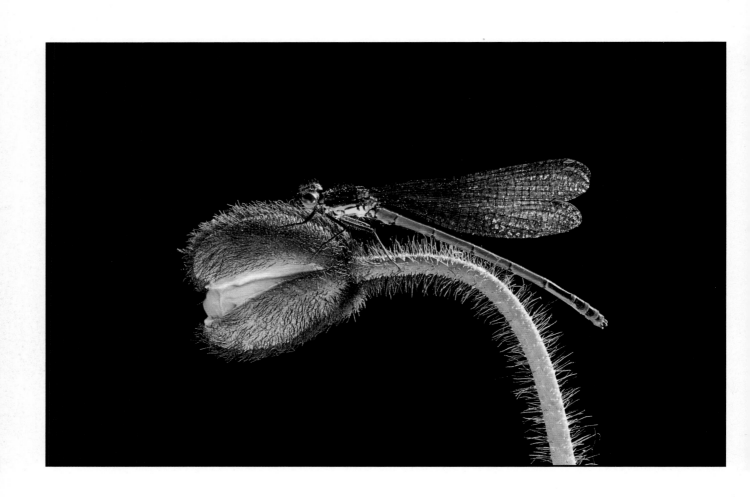

KARL REITNER - AUSTRIA

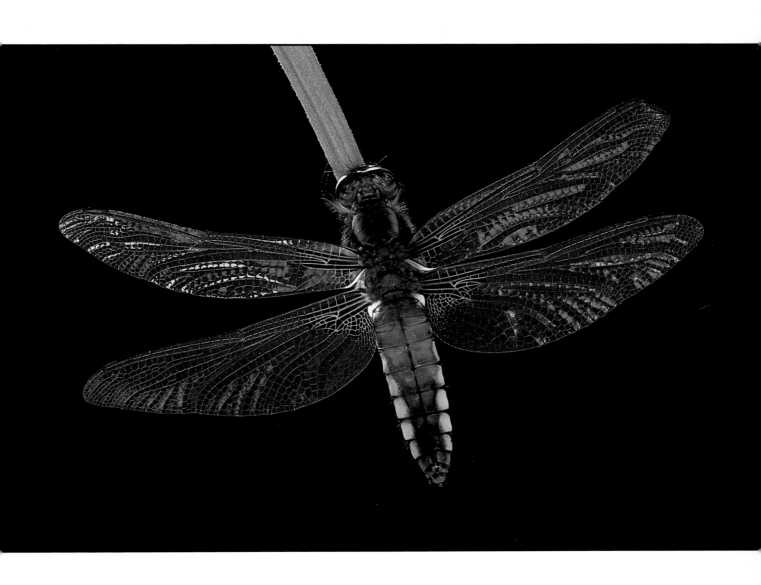

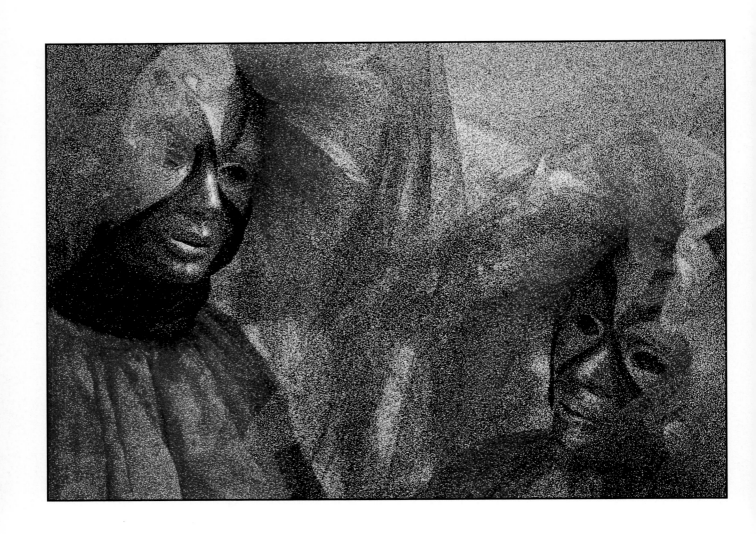

BOB MOORE - UK

84

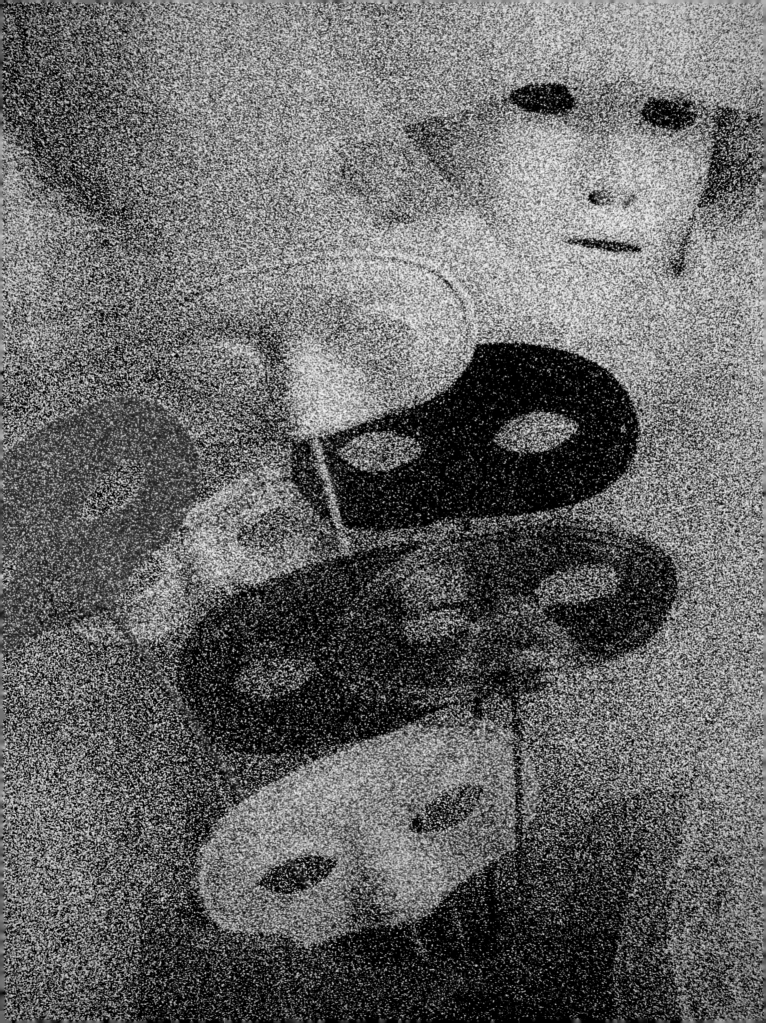

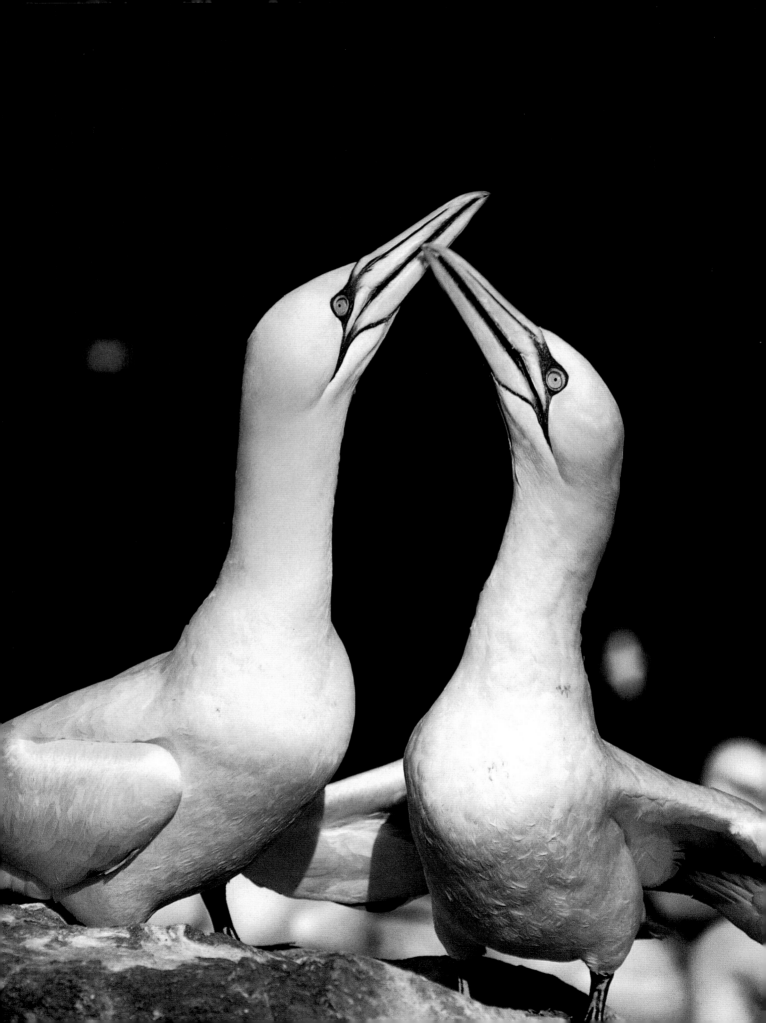

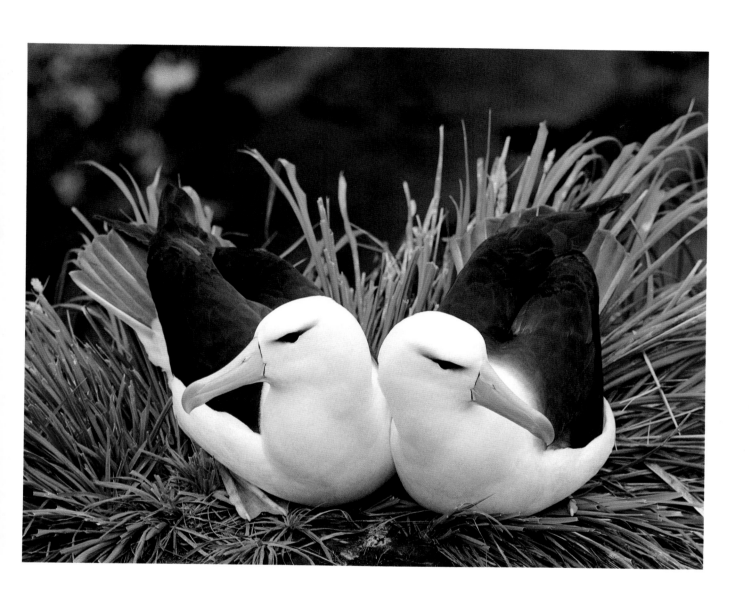

ANDREW TURNER - UK

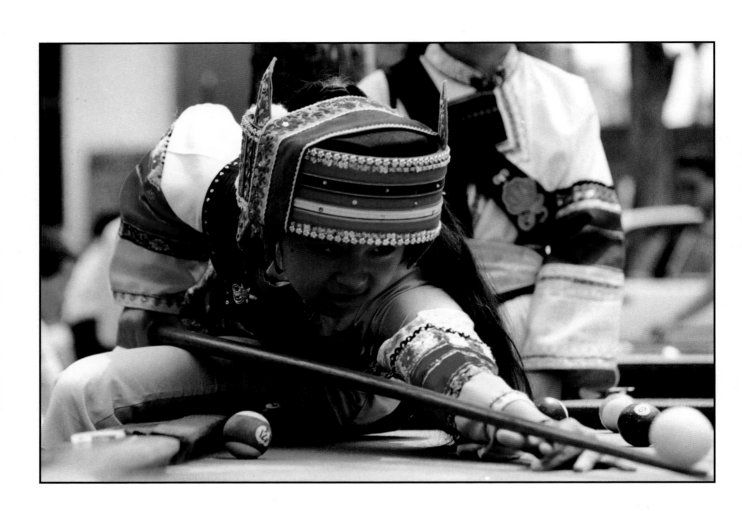

MOK THAIM FOOK - MALAYSIA

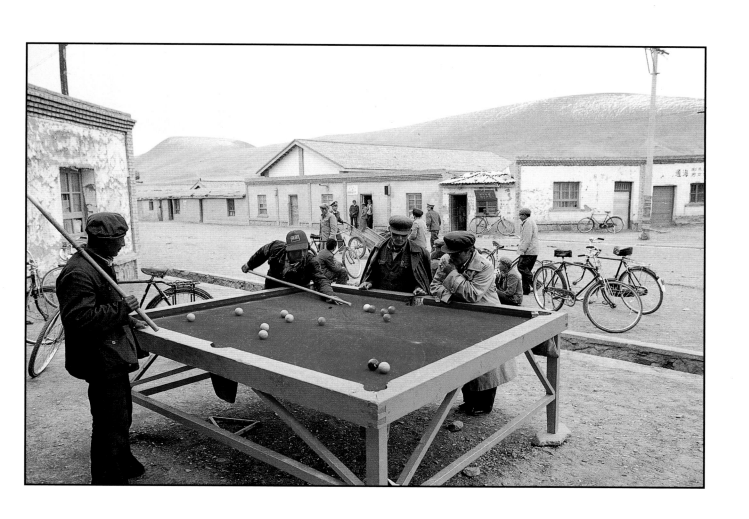

JEREMY BROWN - UK

89

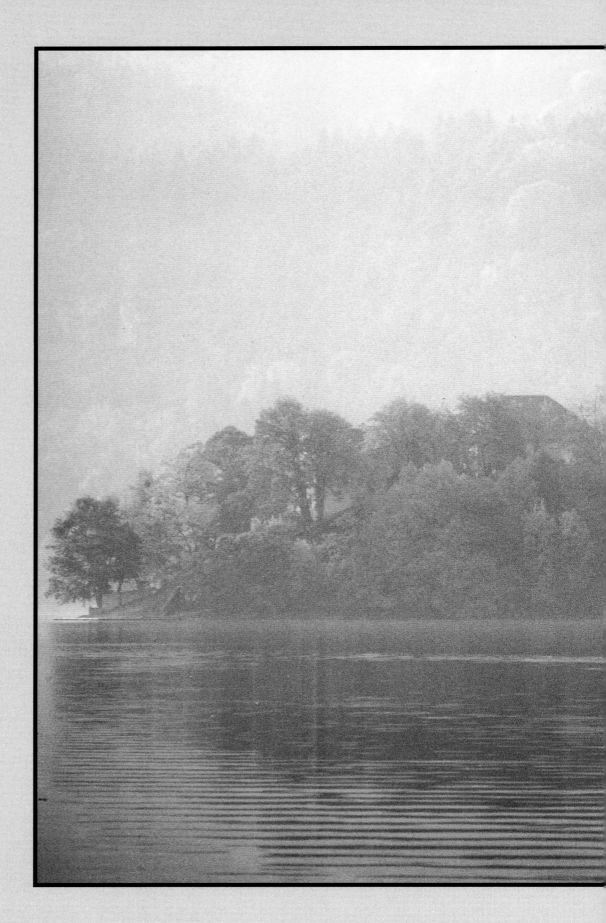

GEORGE FELTON - UK

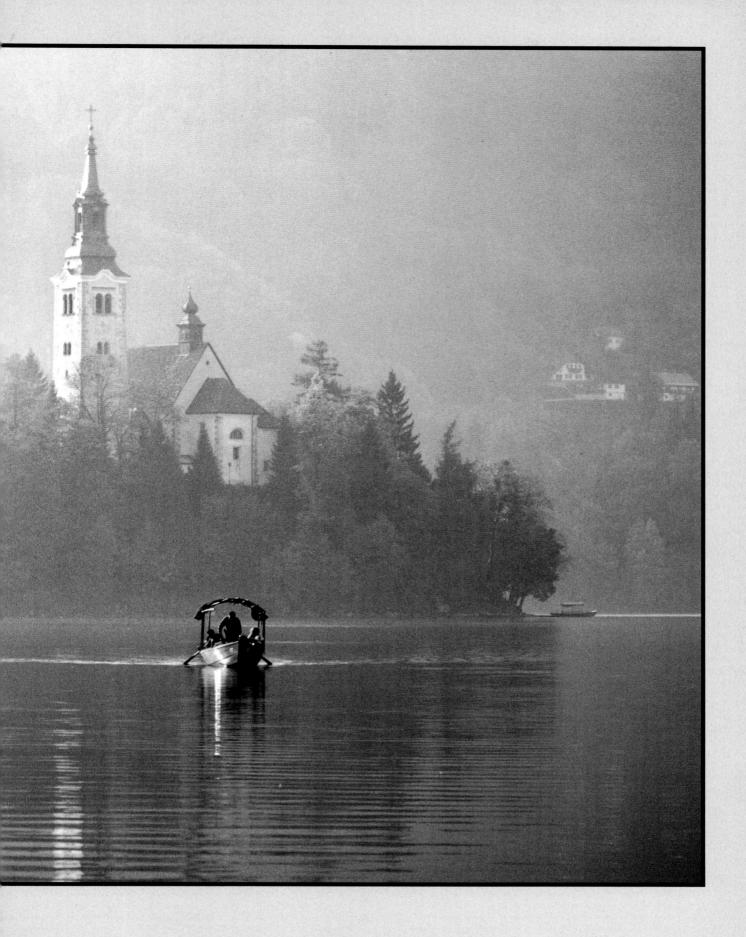

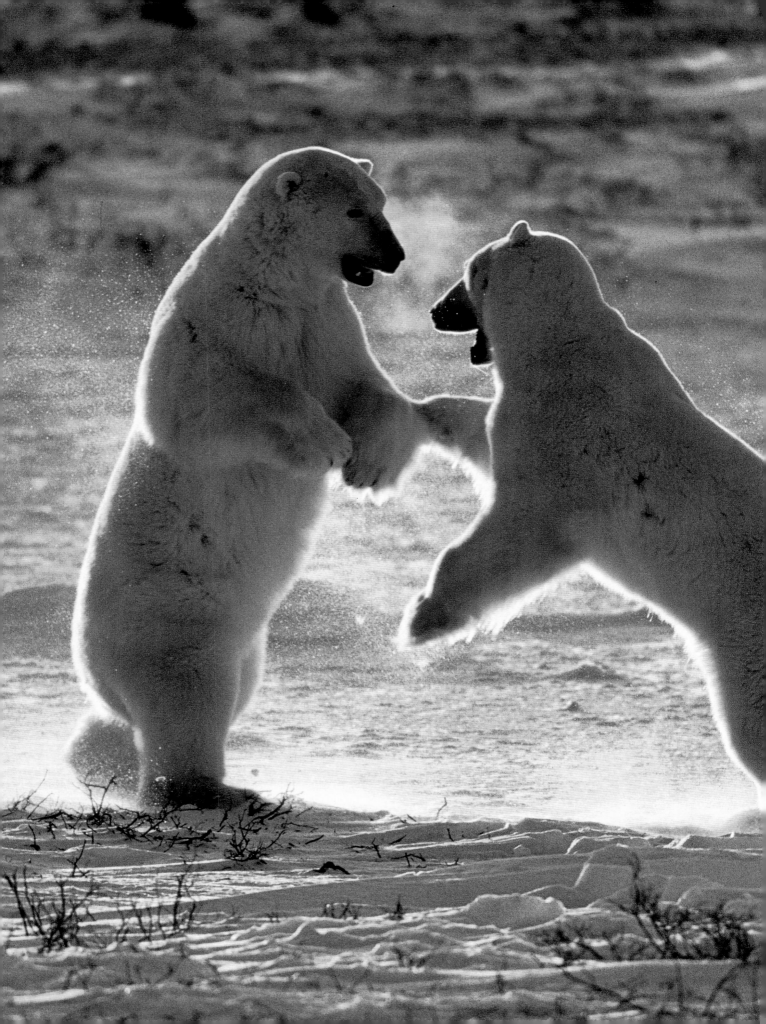

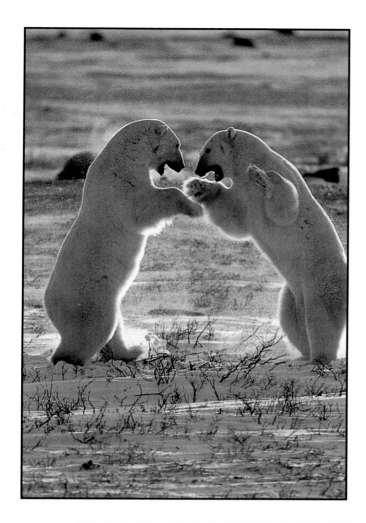
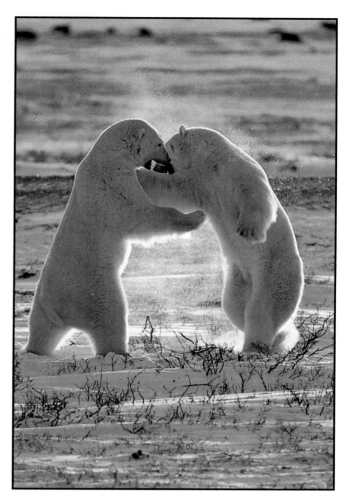
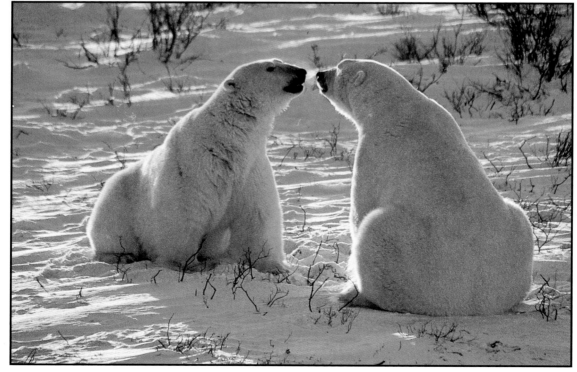

ROSEMARY CALVERT - UK

VANESSA SLAWSON - UK

94

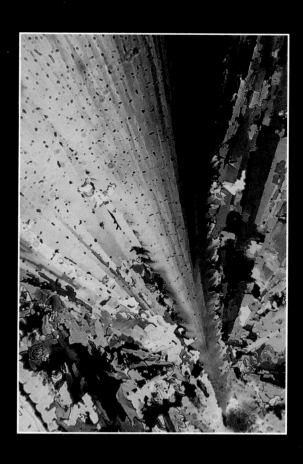

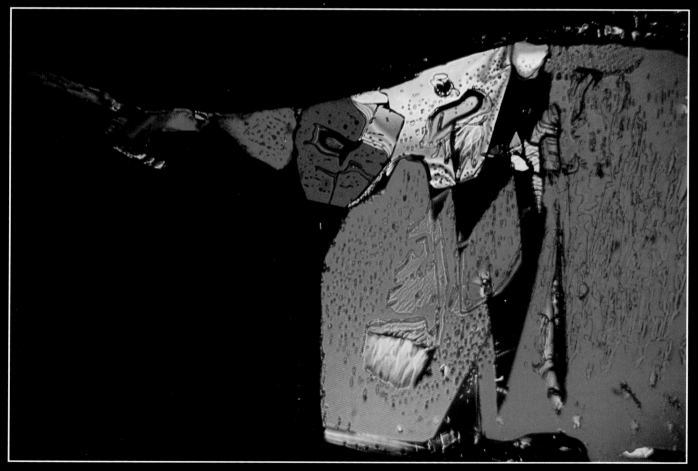

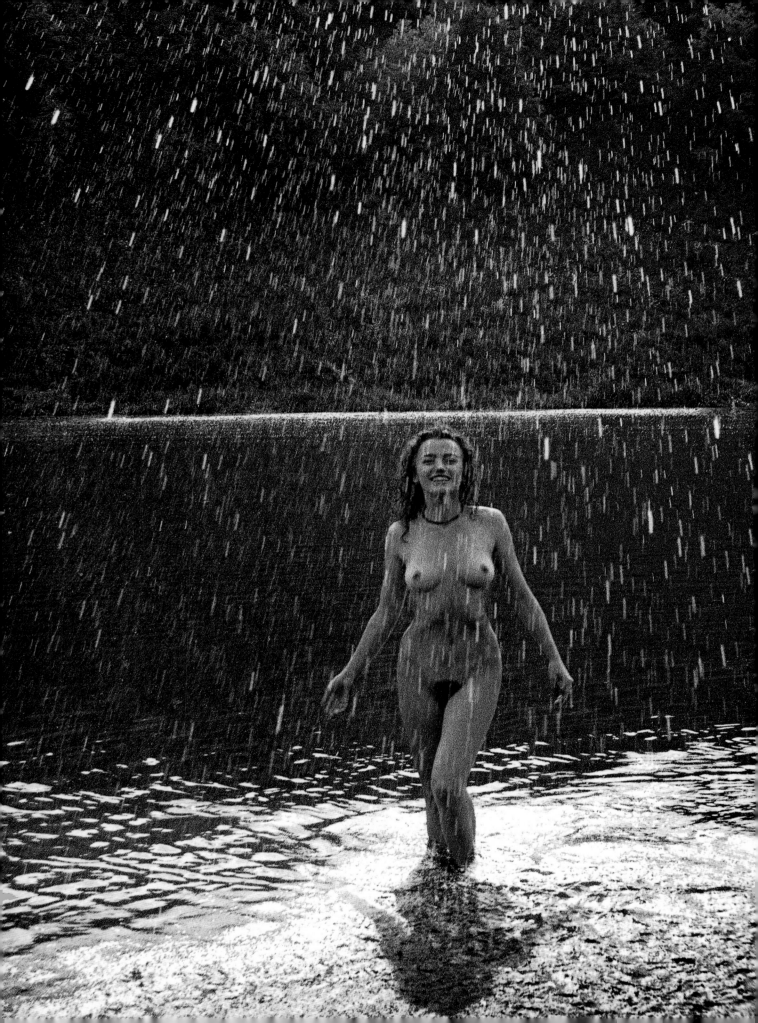

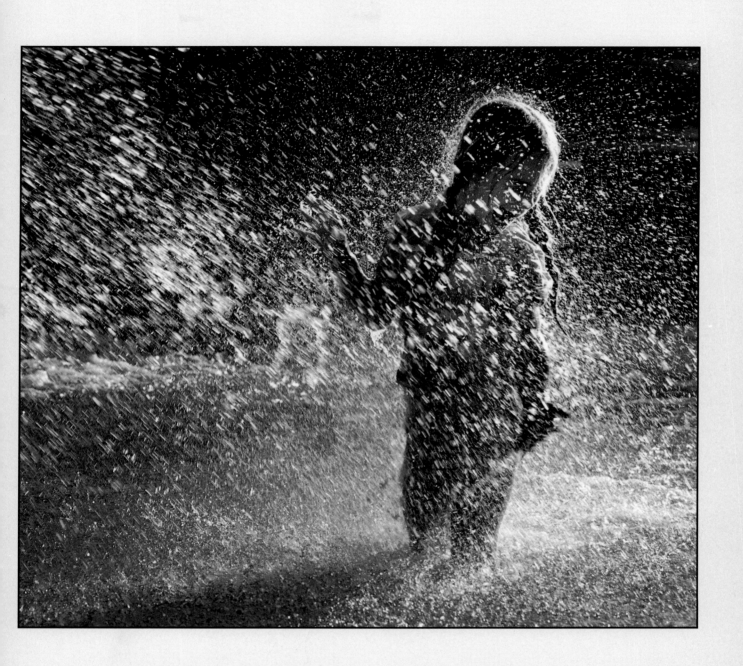

SERGEY BUSLENKO - UKRAINE

CLIVE HARRISON - UK

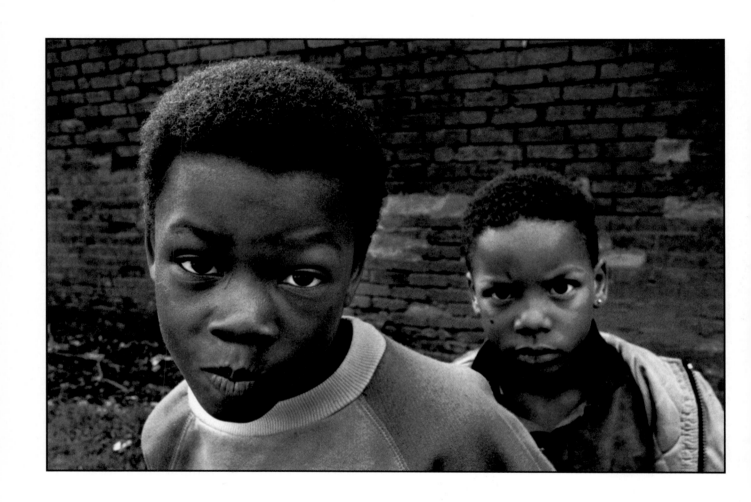

ROGER HANCE - UK

98

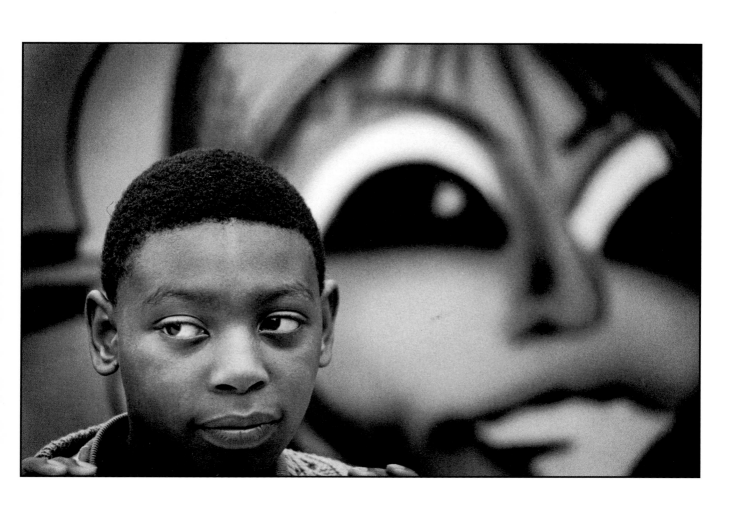

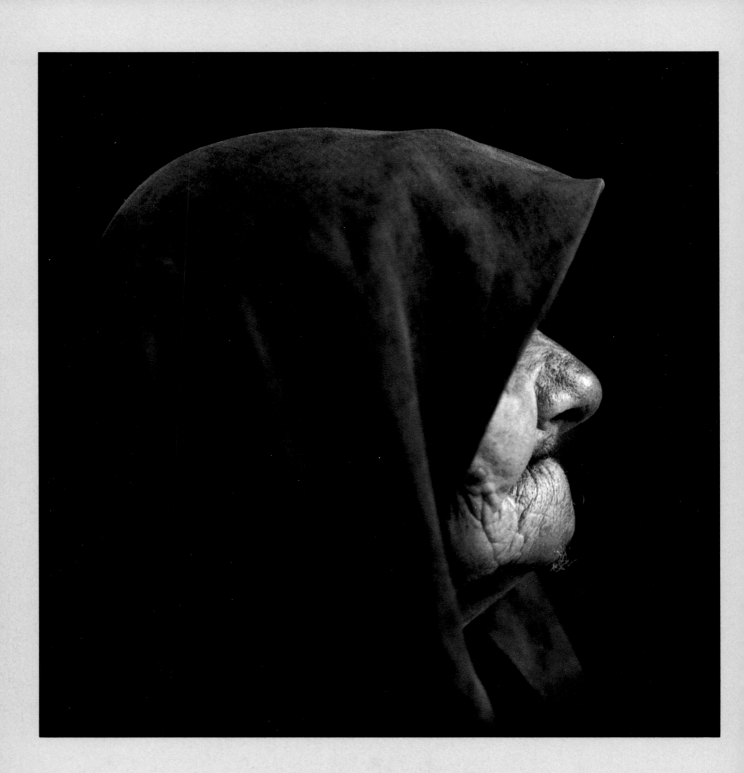

NIC GAUNT - UK

100

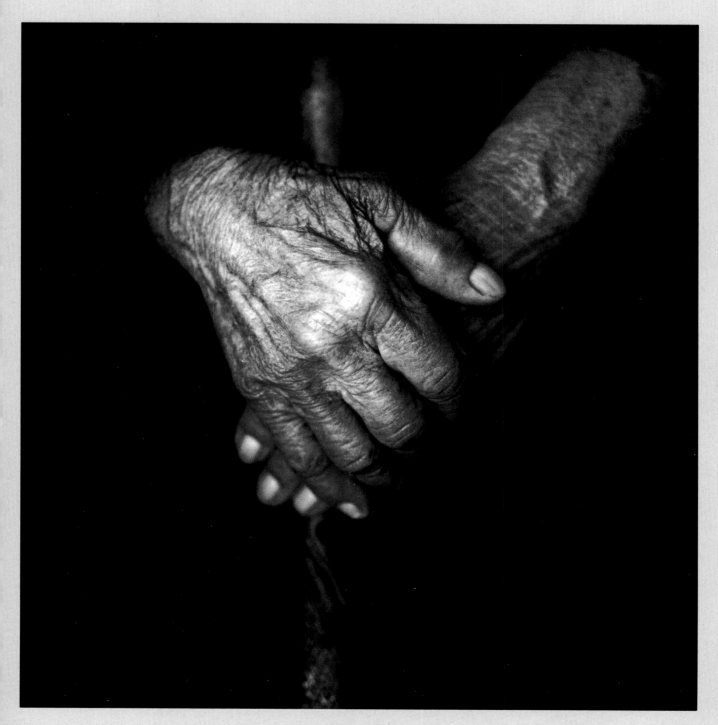

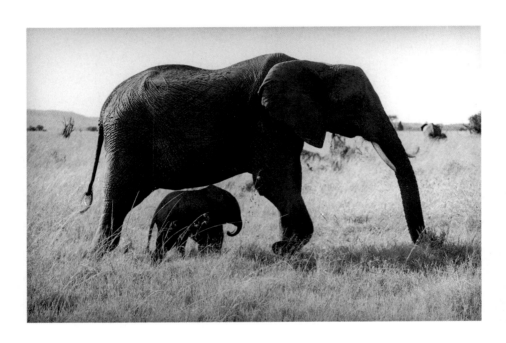

RAJAN KAPOOR - INDIA

102

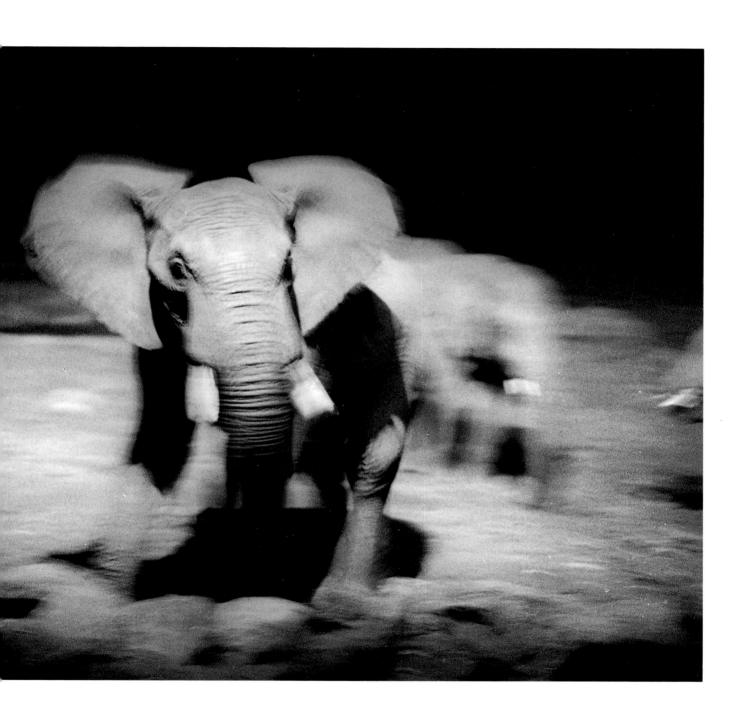

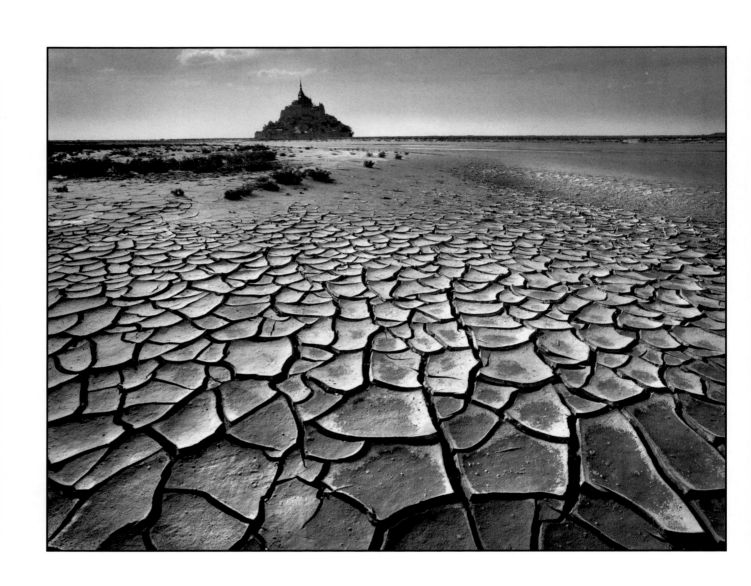

TONY WOROBIEC - UK

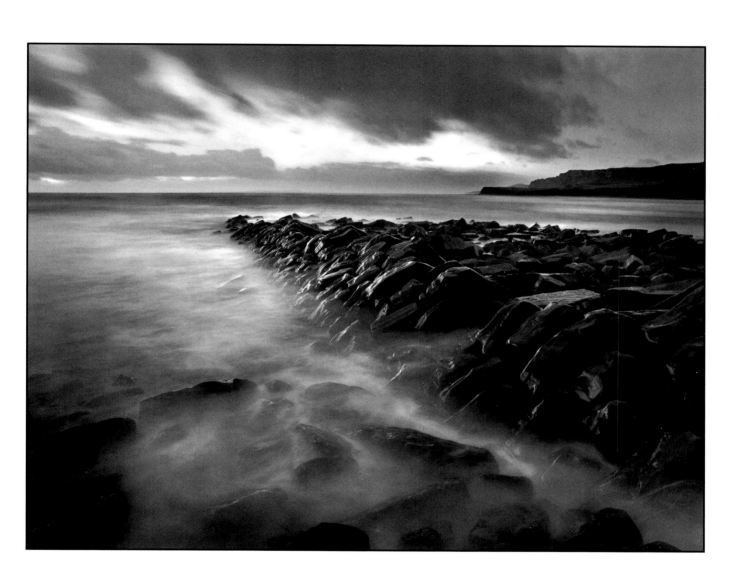

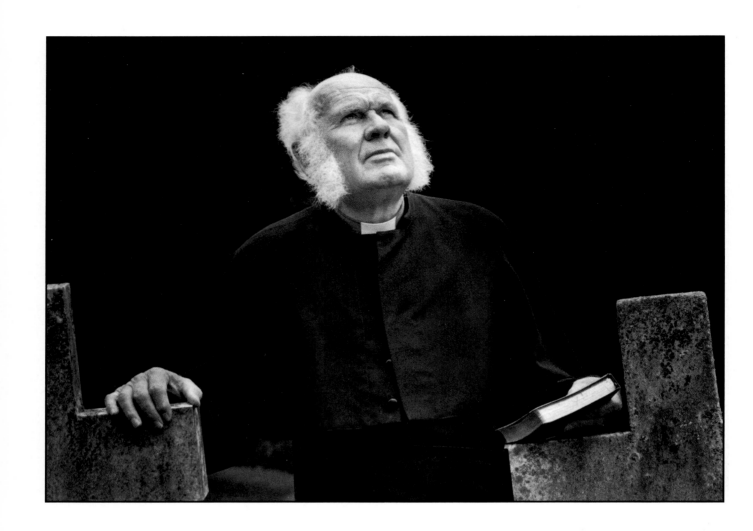

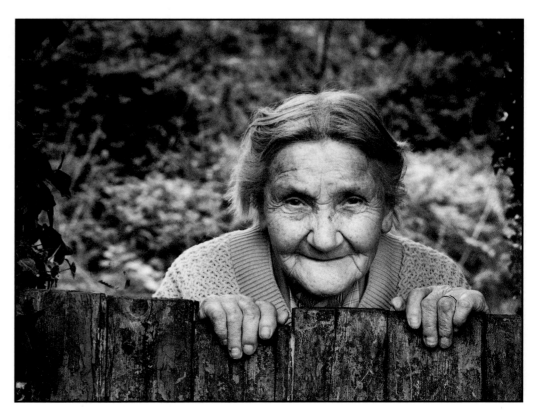

JOHN PHILPOTT - UK

106

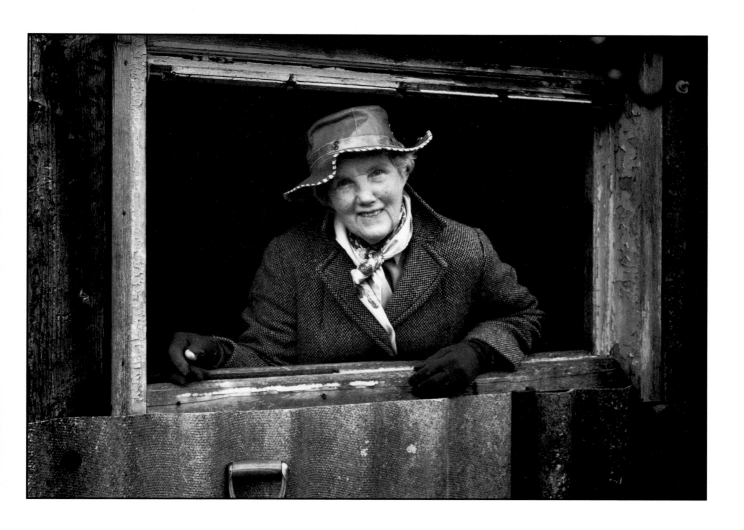

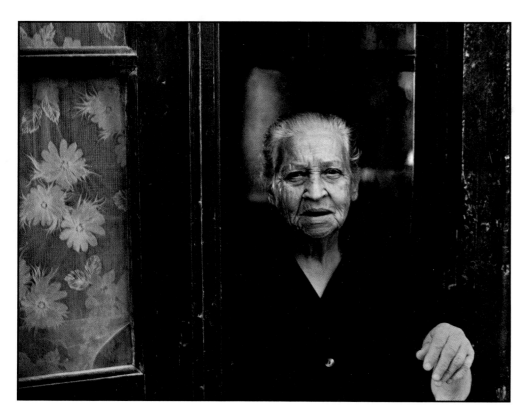

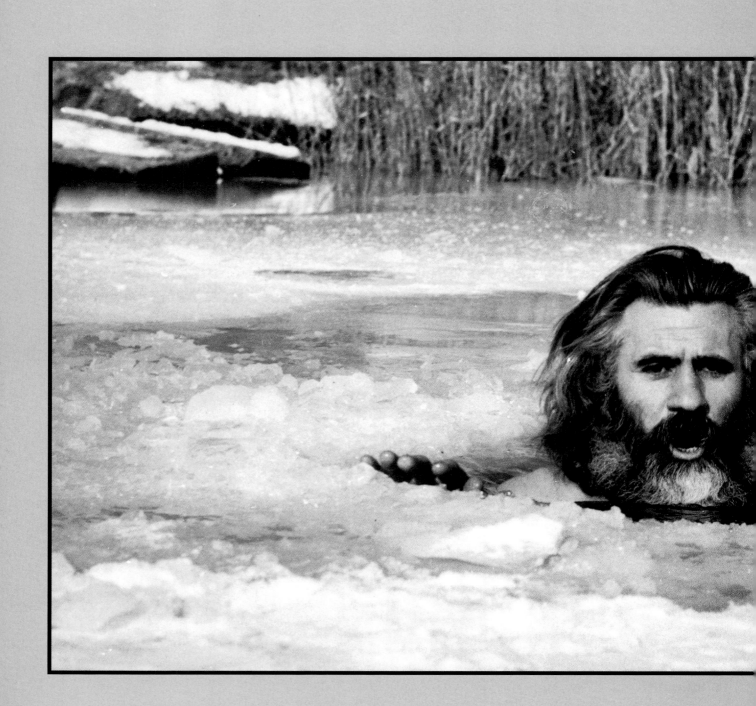

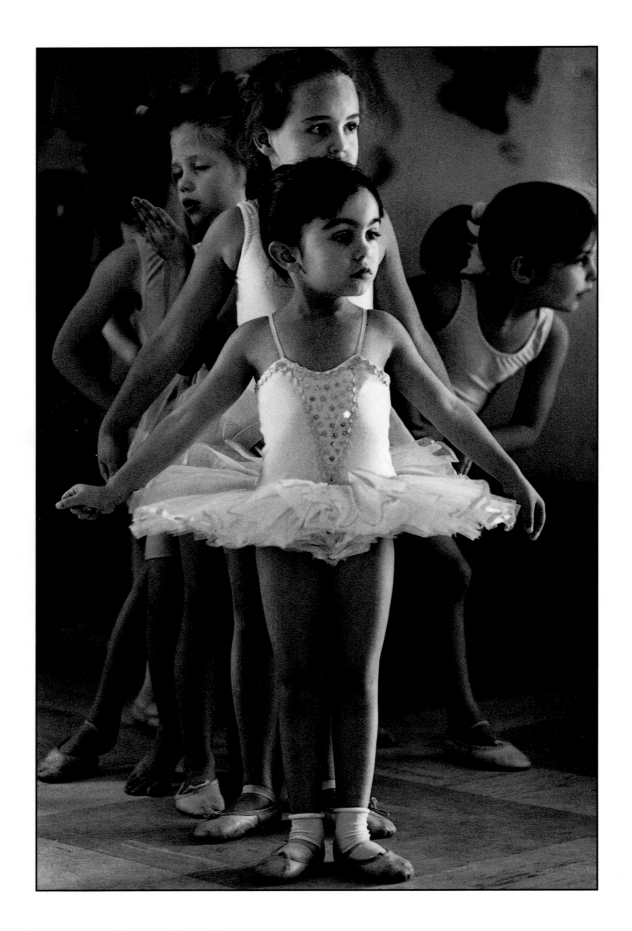

DAVID SANDISON - SOUTH AFRICA

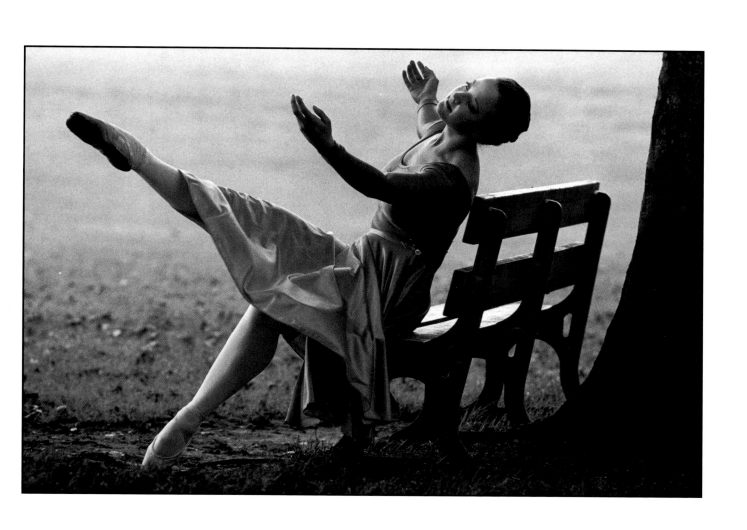

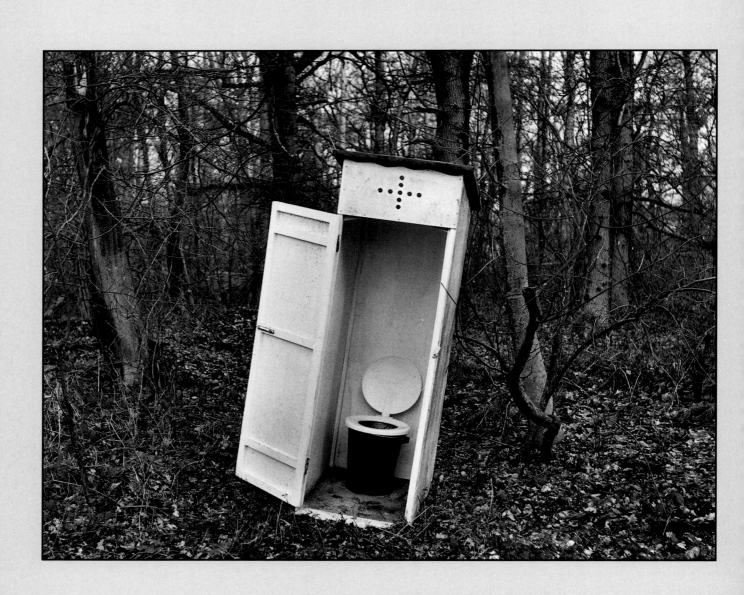

BILL CARDEN - UK

112

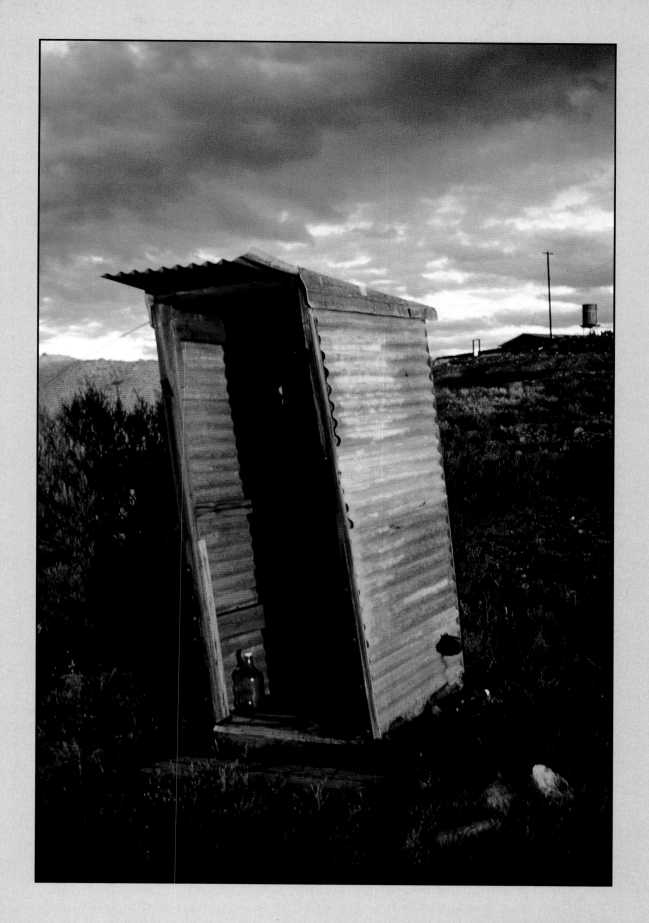

BOB MOSSEL - AUSTRALIA

113

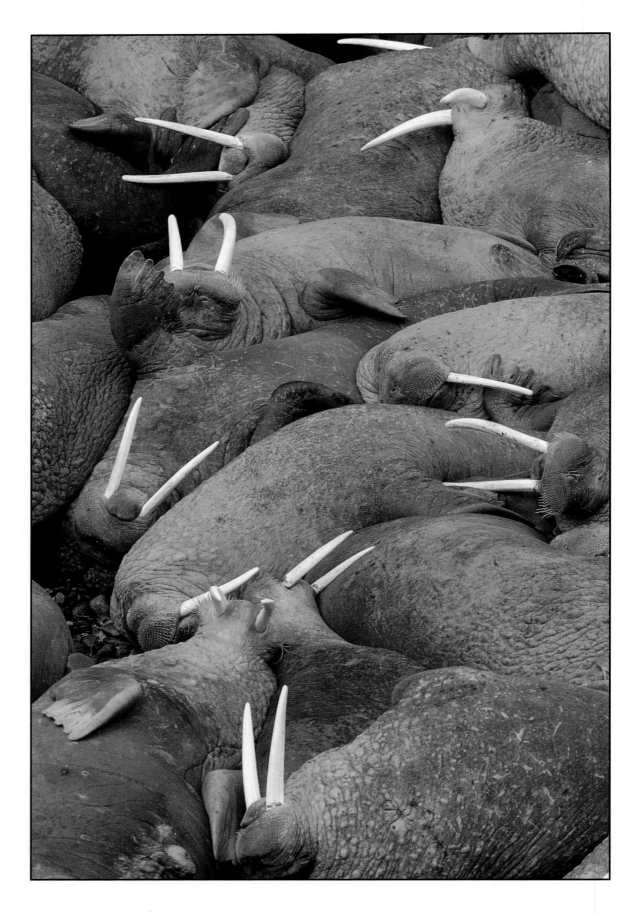

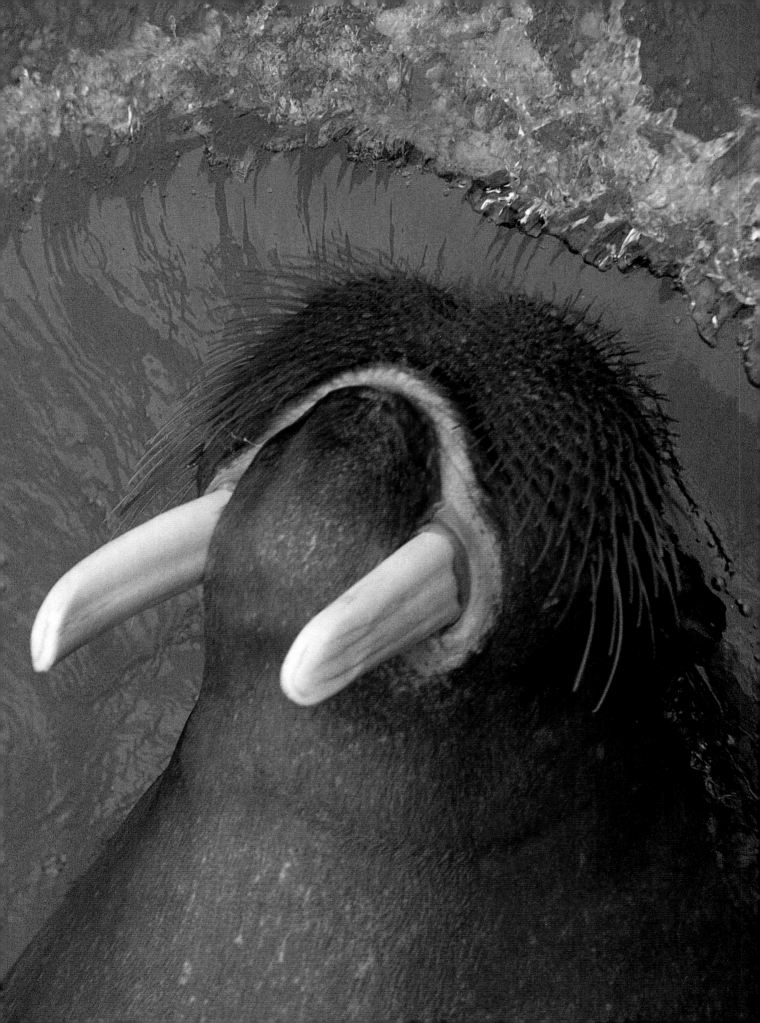

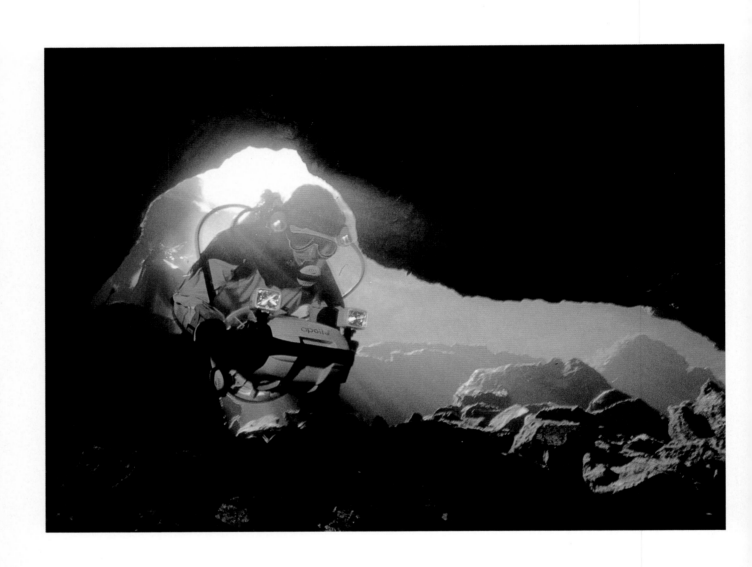

CIRIL MLINAR - SLOVENIA

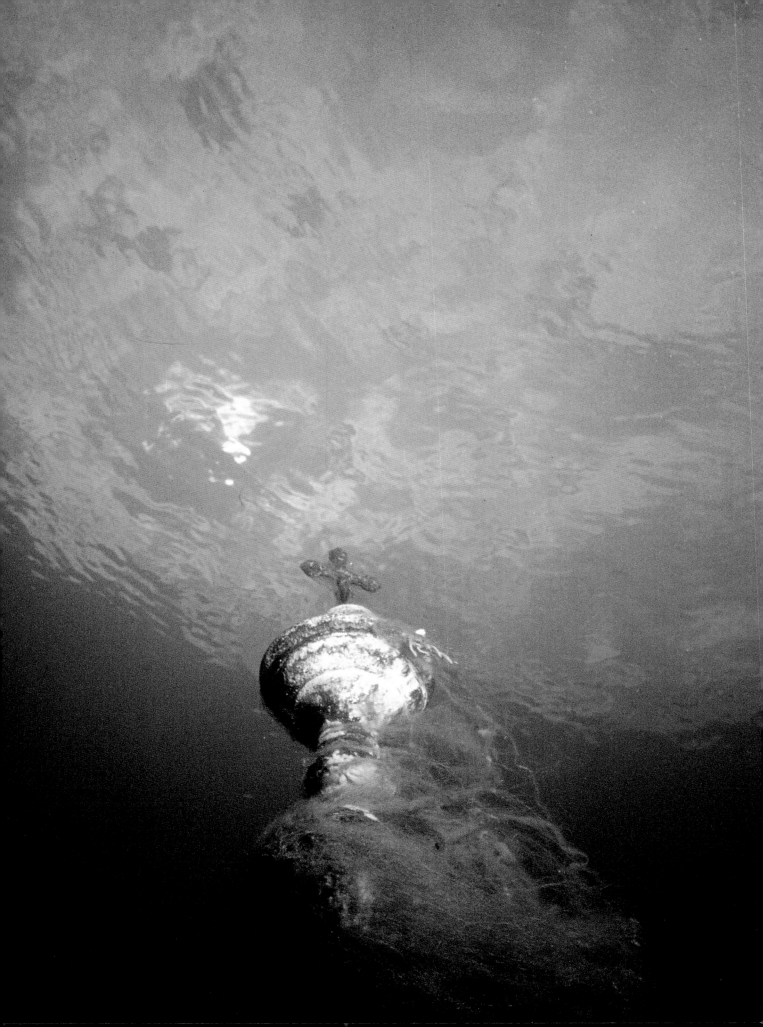

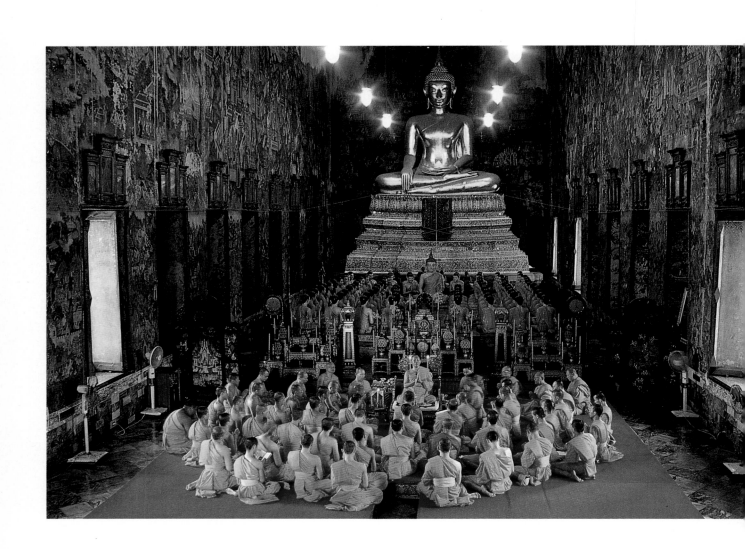

CHUTCHAWANTIPAKORN WARANUN - THAILAND

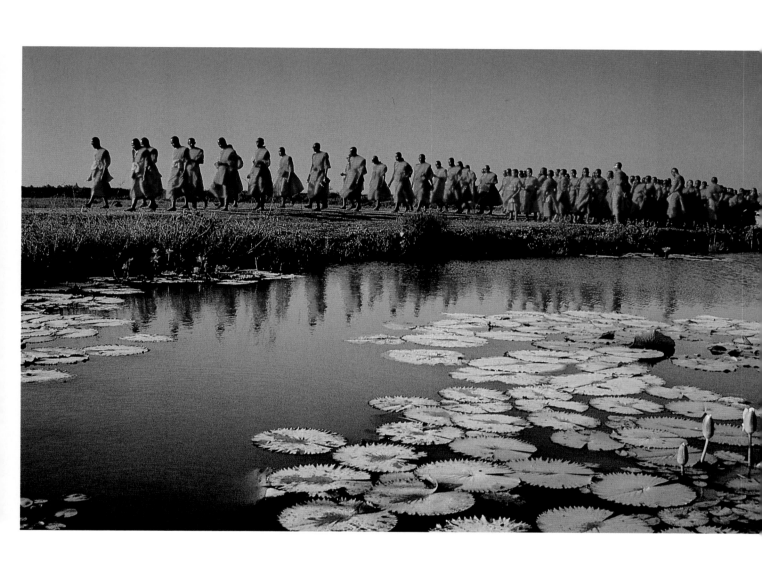

JUNTAWONSUP DAMRONG - THAILAND

119

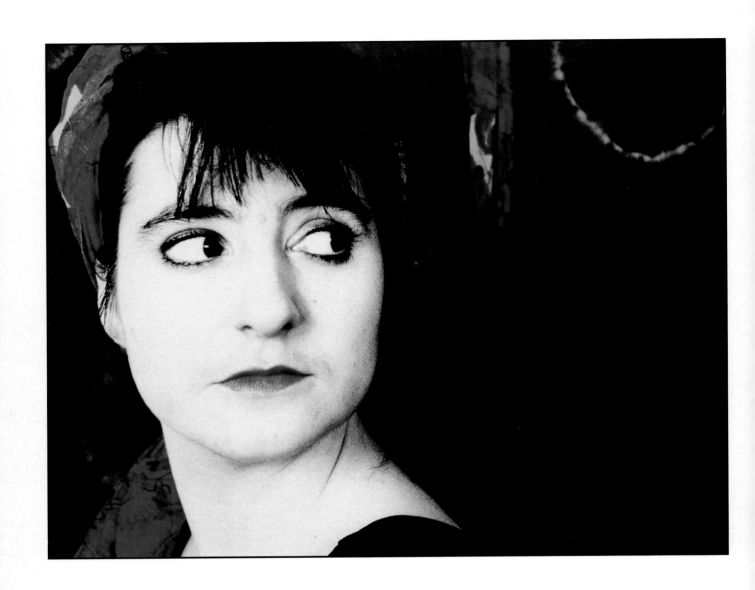

GORDON DODD - UK

KEVIN PESCHKE - UK

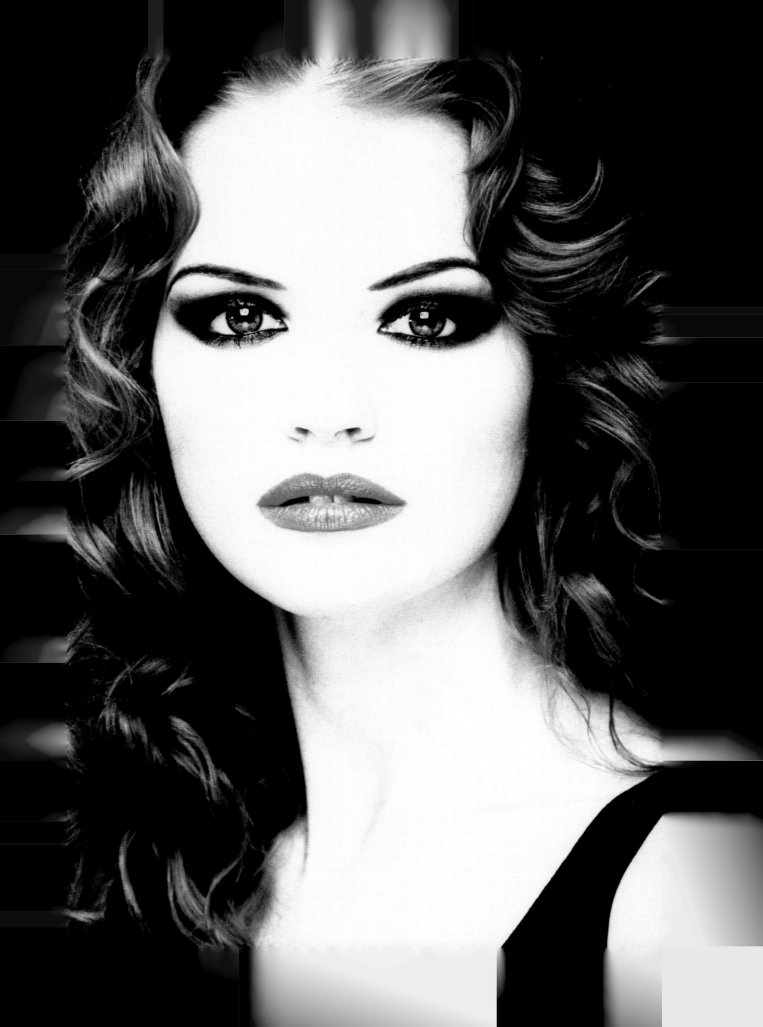

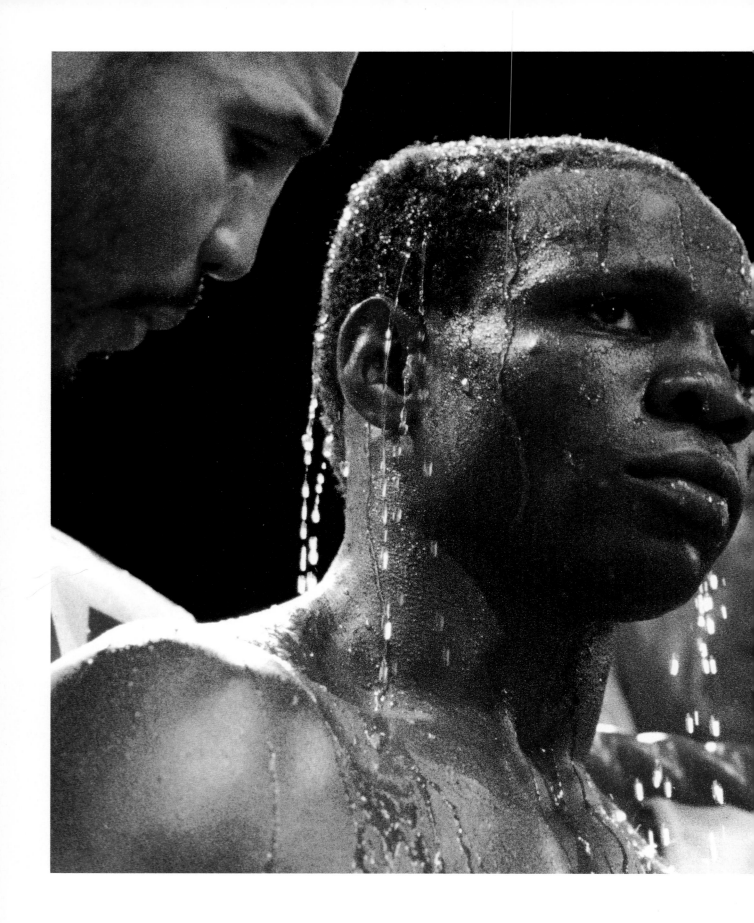

HOWARD WALKER - UK

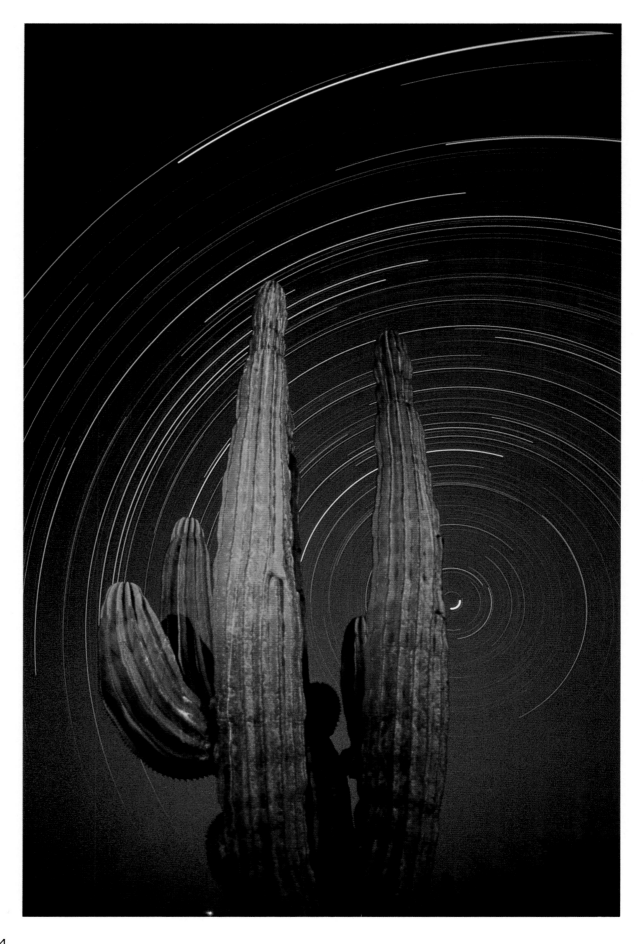

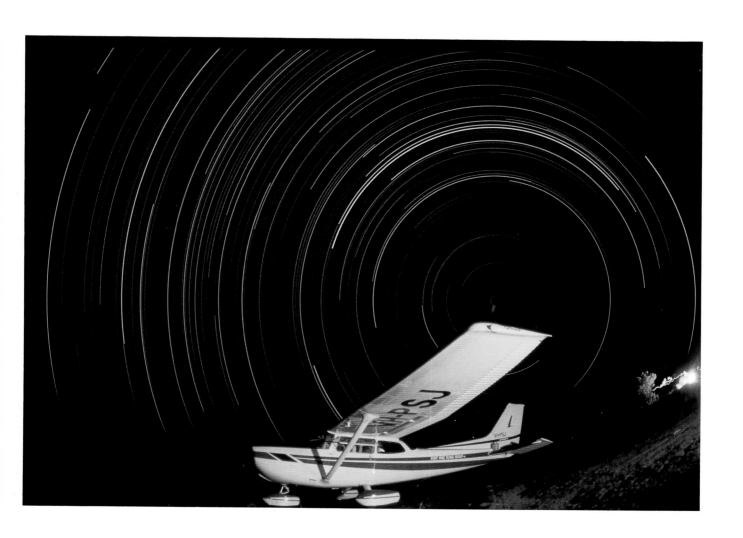

ANDREW DRAKE - USA

BOB MOSSEL - AUSTRALIA

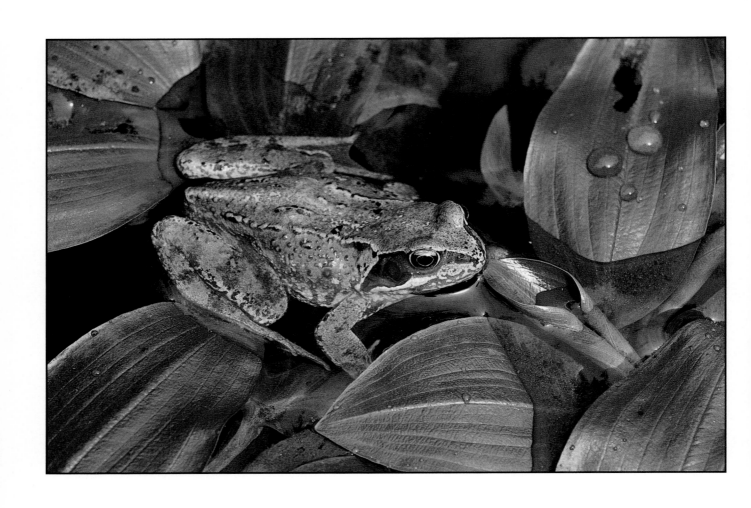

LAURIE CAMPBELL - UK

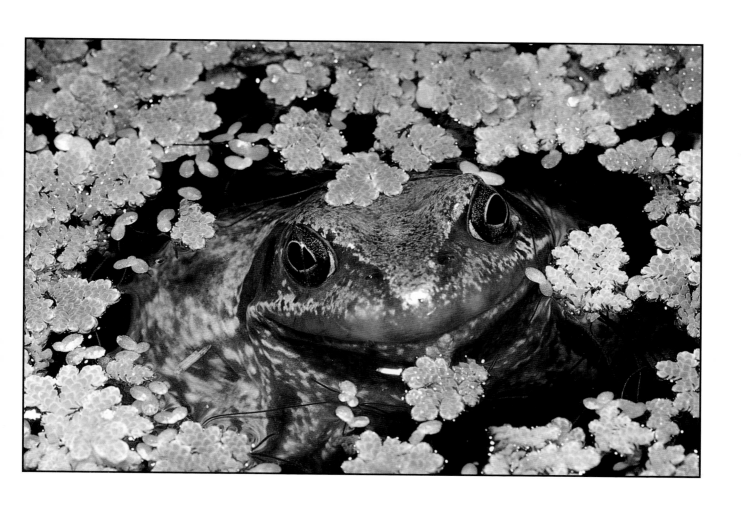

SUE BENNETT - UK

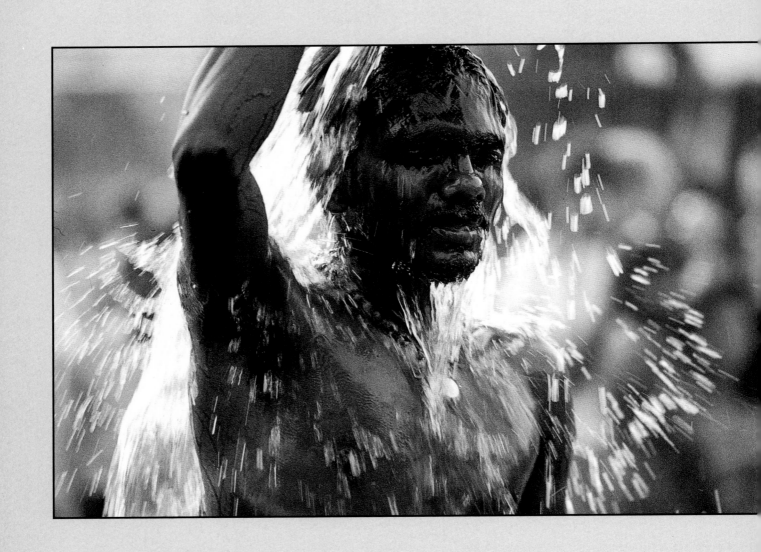

ONG JUNG KUNG - SINGAPORE

128

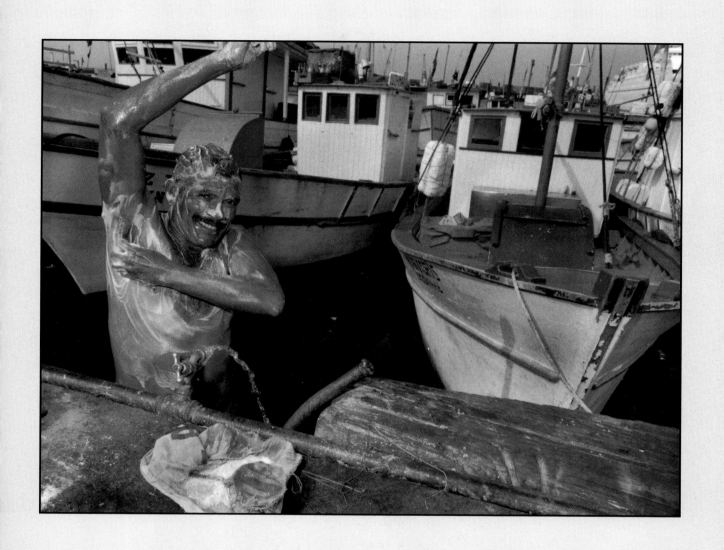

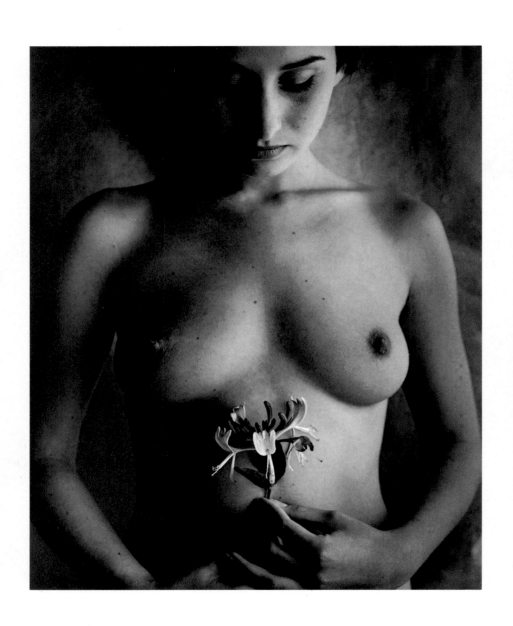

CLIVE CARTER - UK

130

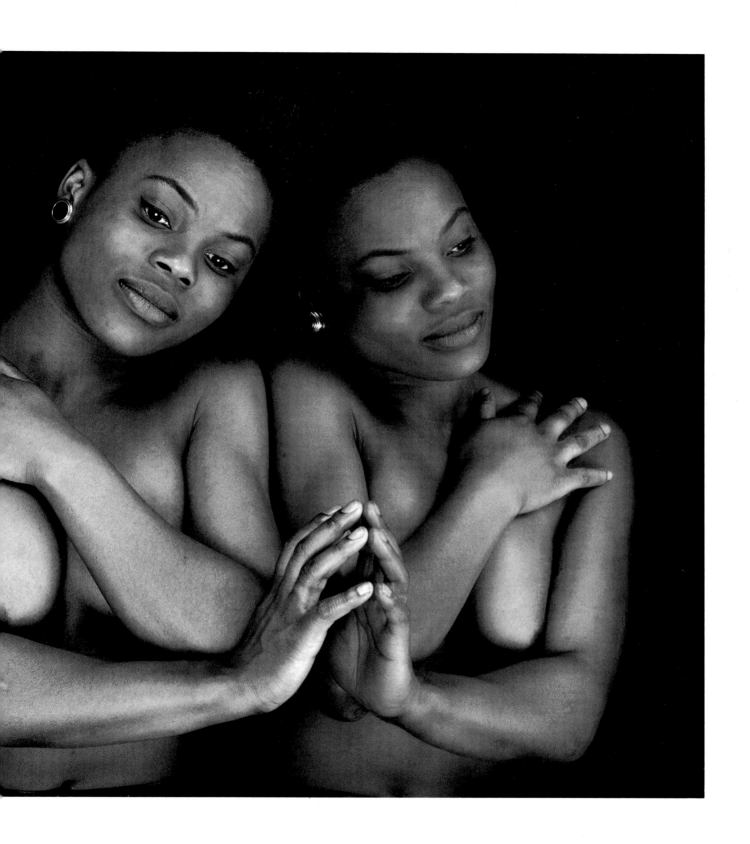

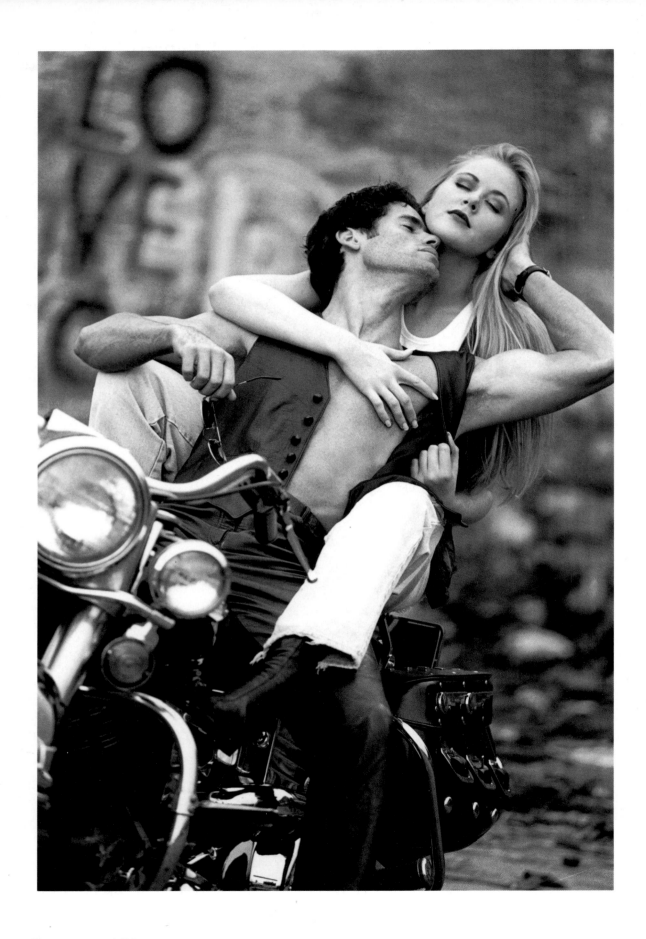

KEVIN PESCHKE - UK

132

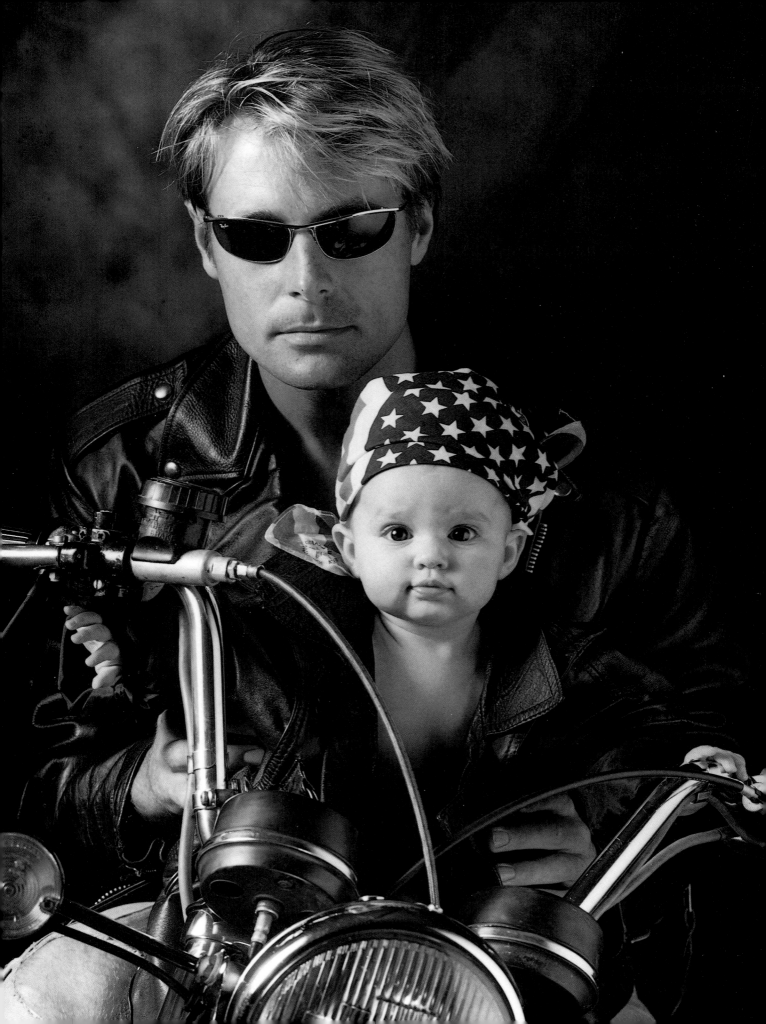

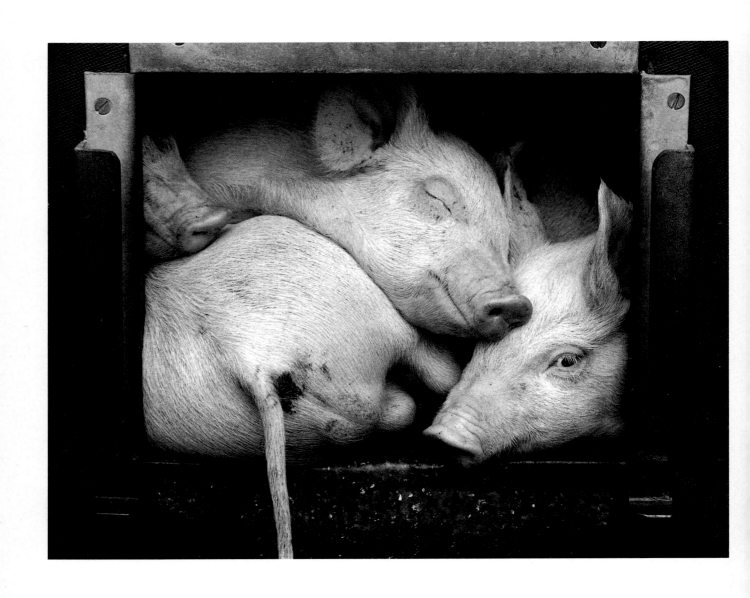

J N TYLER - UK

KEN WEBB - UK

134

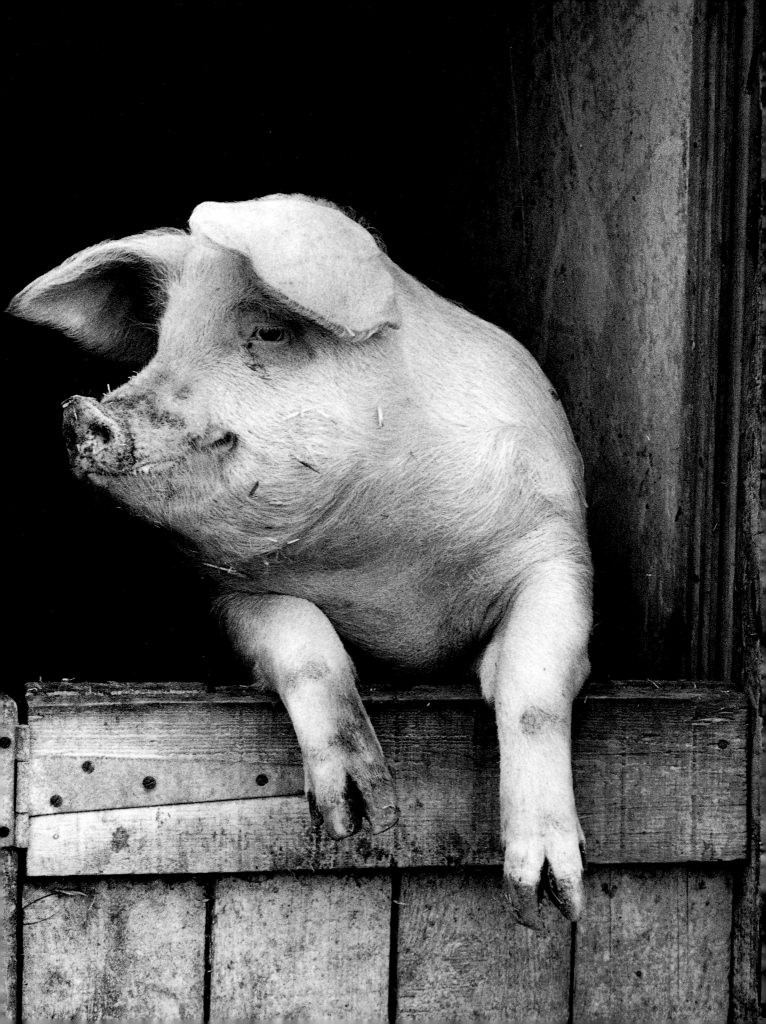

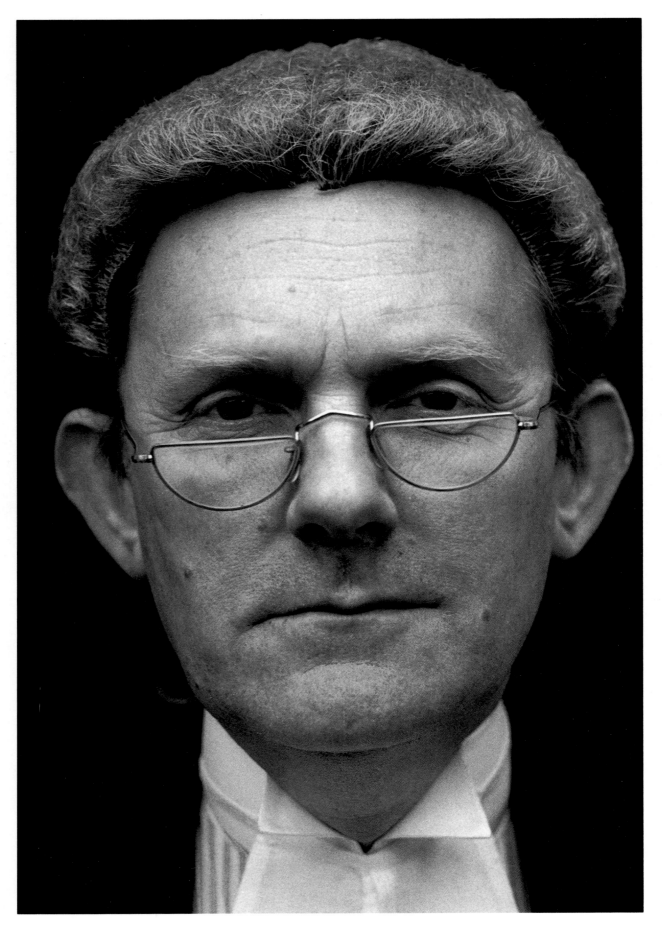

136

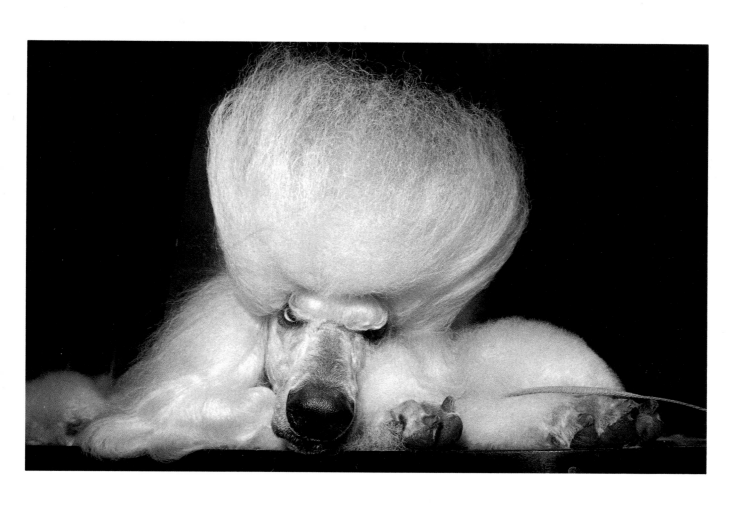

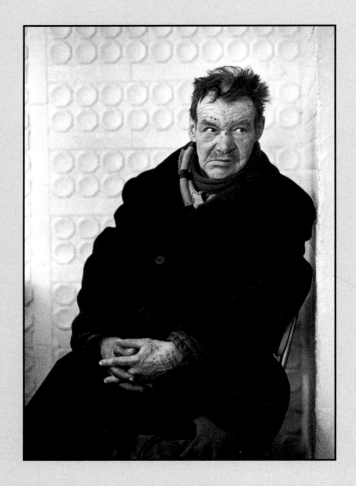

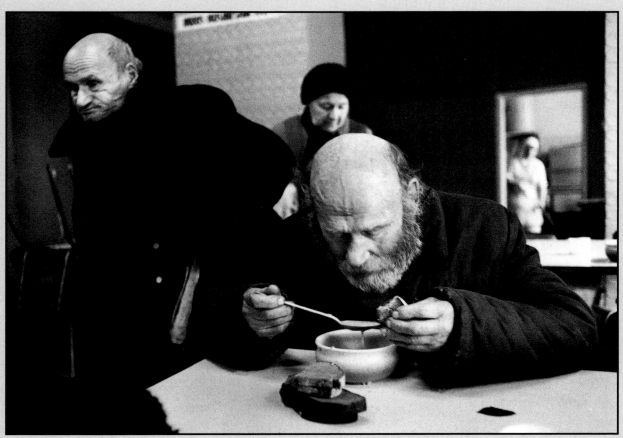

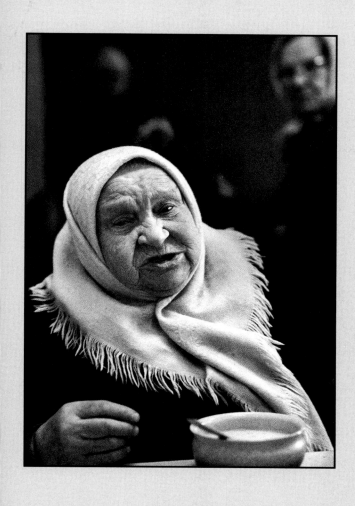

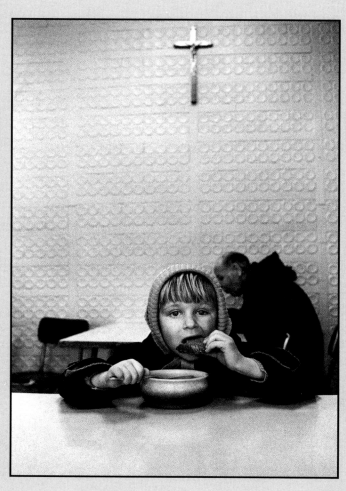

ROMUALDAS POZERSKIS - LITHUANIA

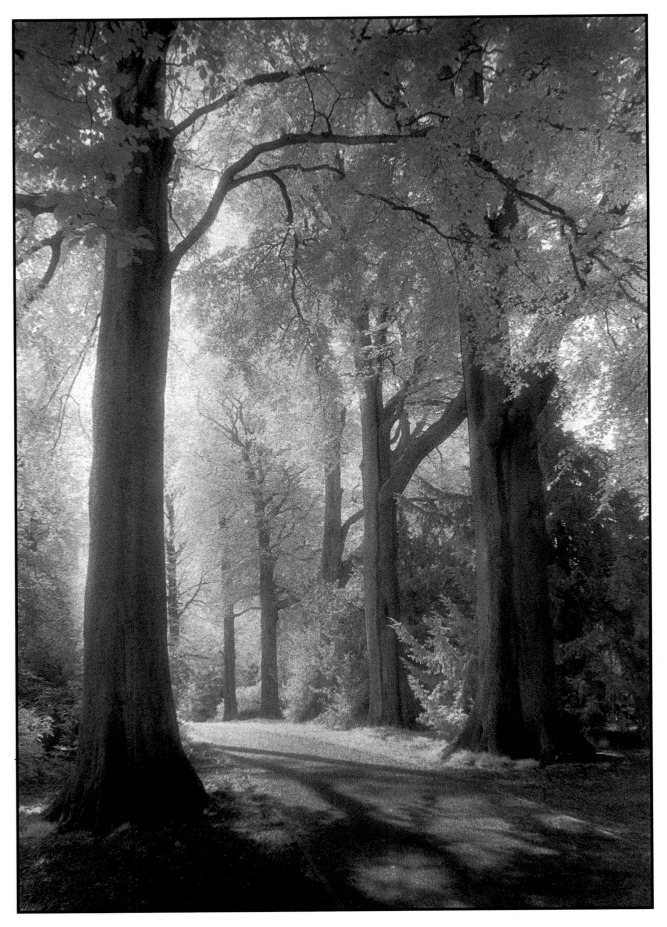

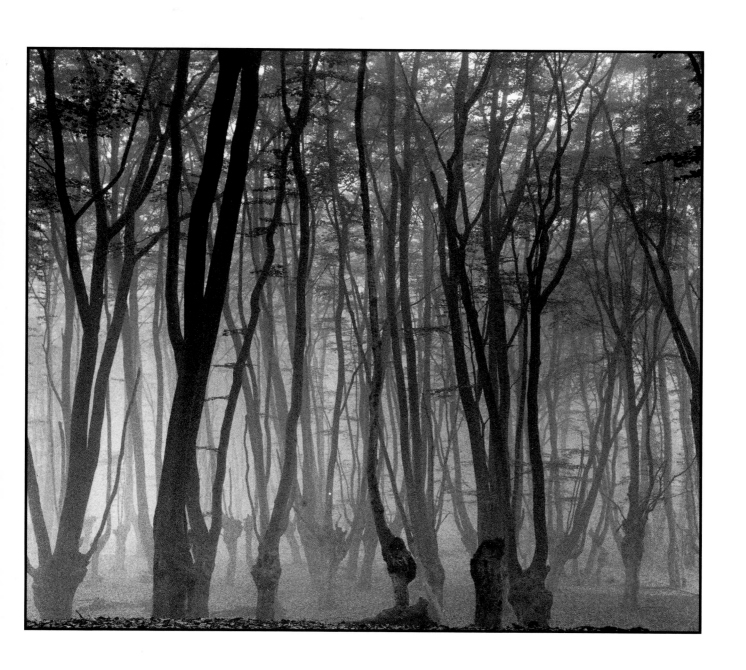

ANDY WILSON - UK

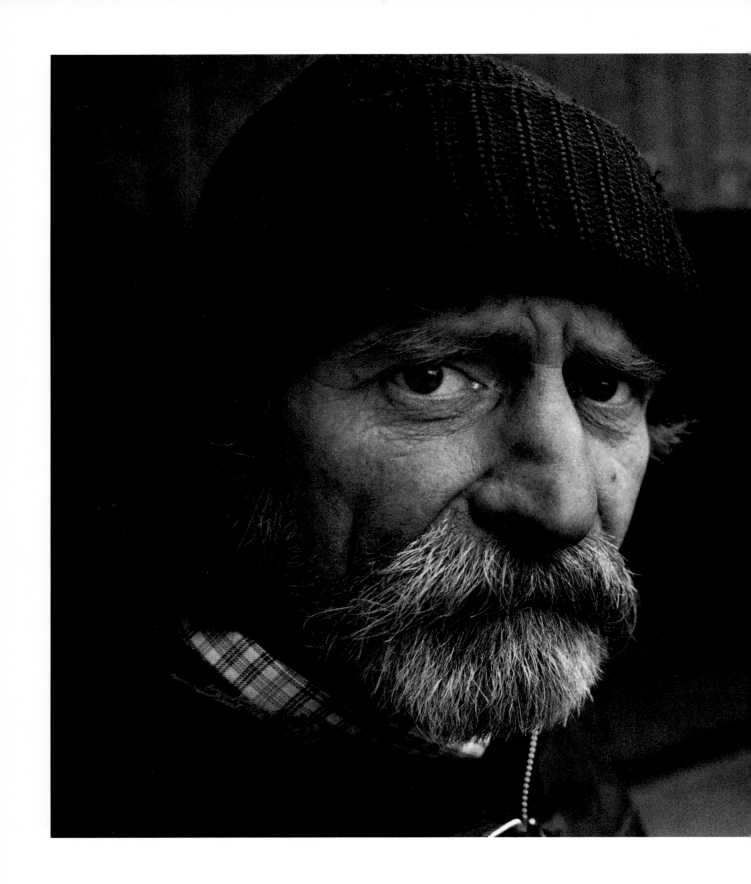

ROGER HANCE - UK

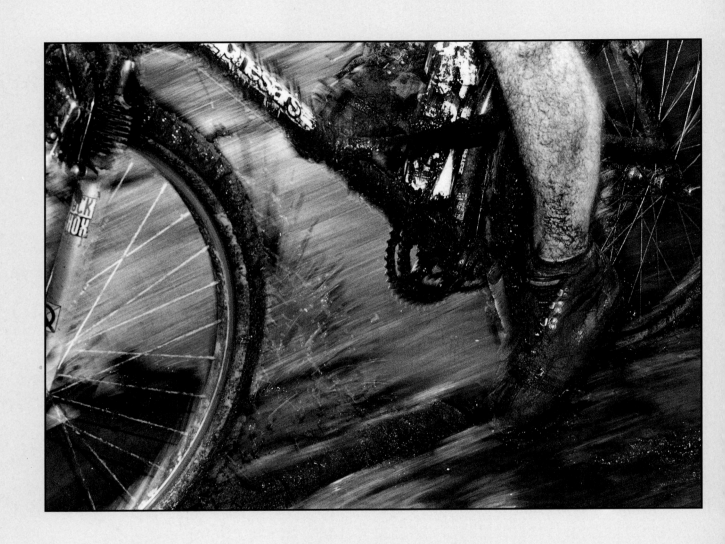

PETER STRAW - UK

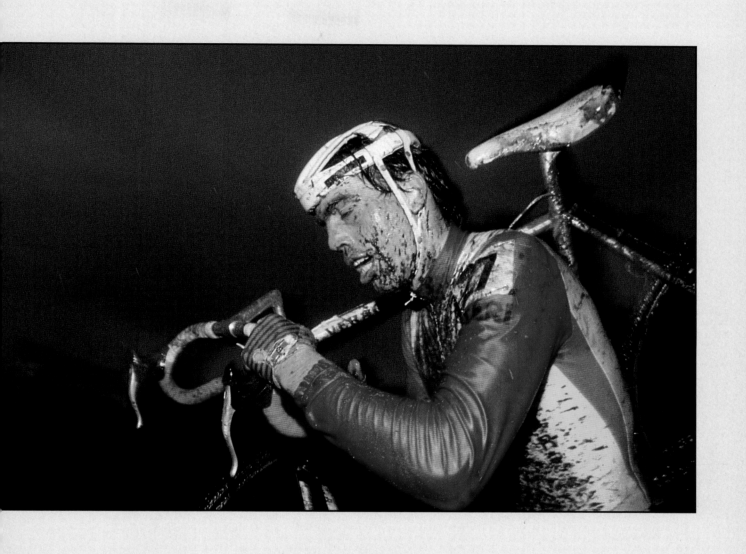

PETER HÖGERL · AUSTRIA

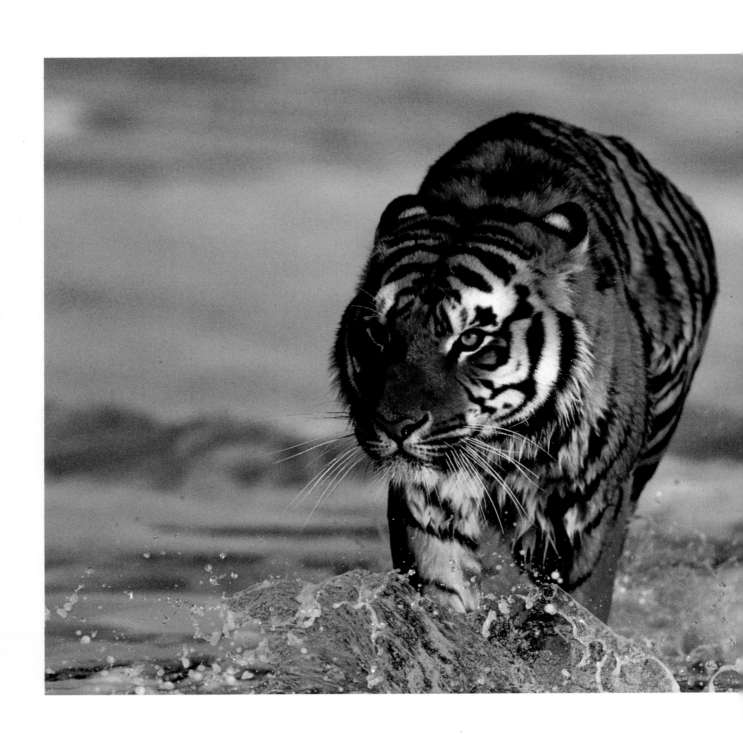

ROSEMARY CALVERT - UK

146

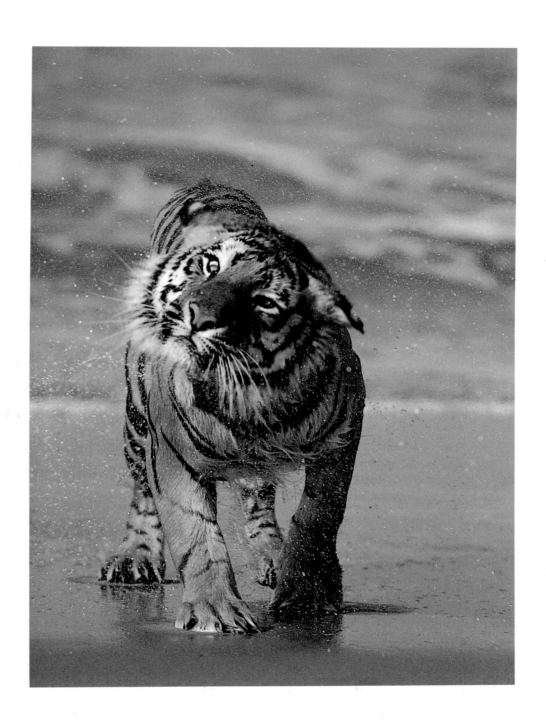

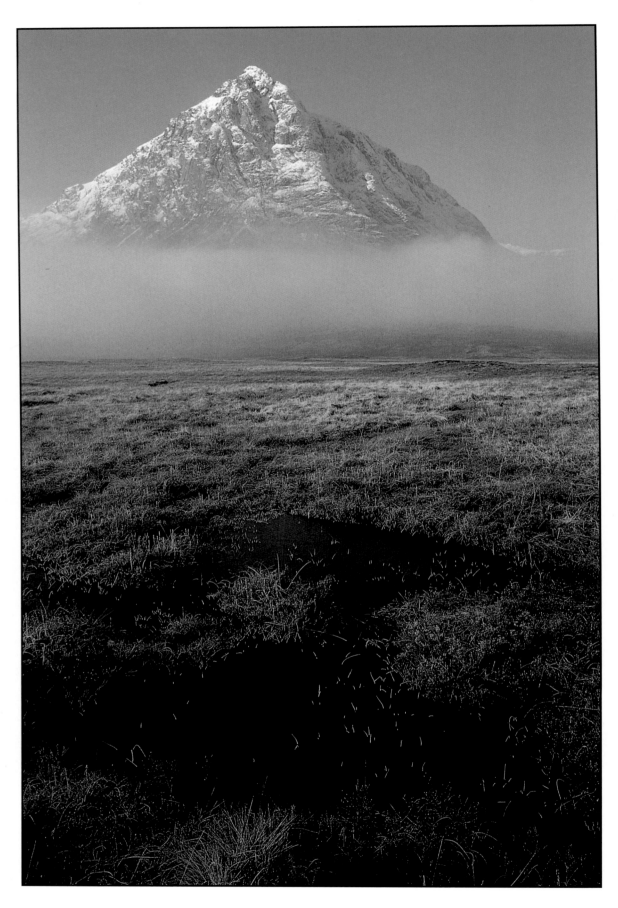

KEN BRYAN - UK

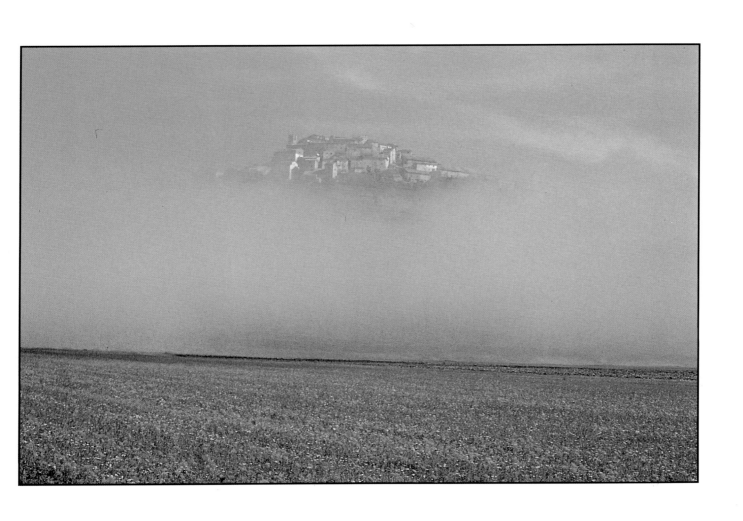

WANDA TUCCI CASELLI · ITALY

149

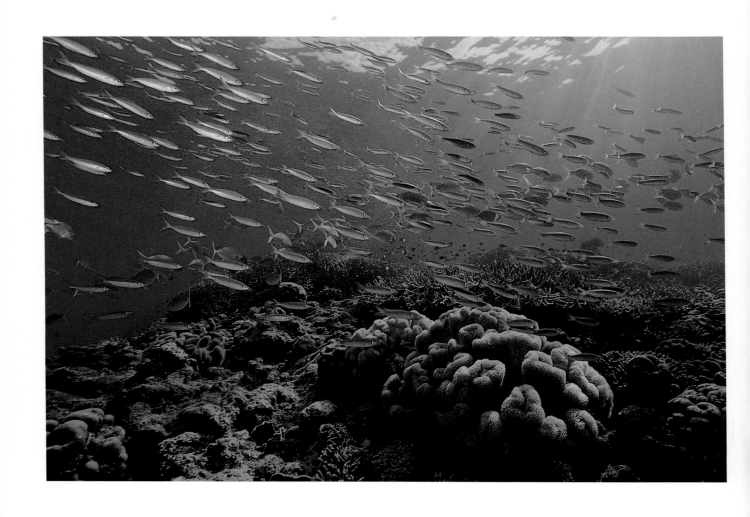

LINDA PITKIN - UK

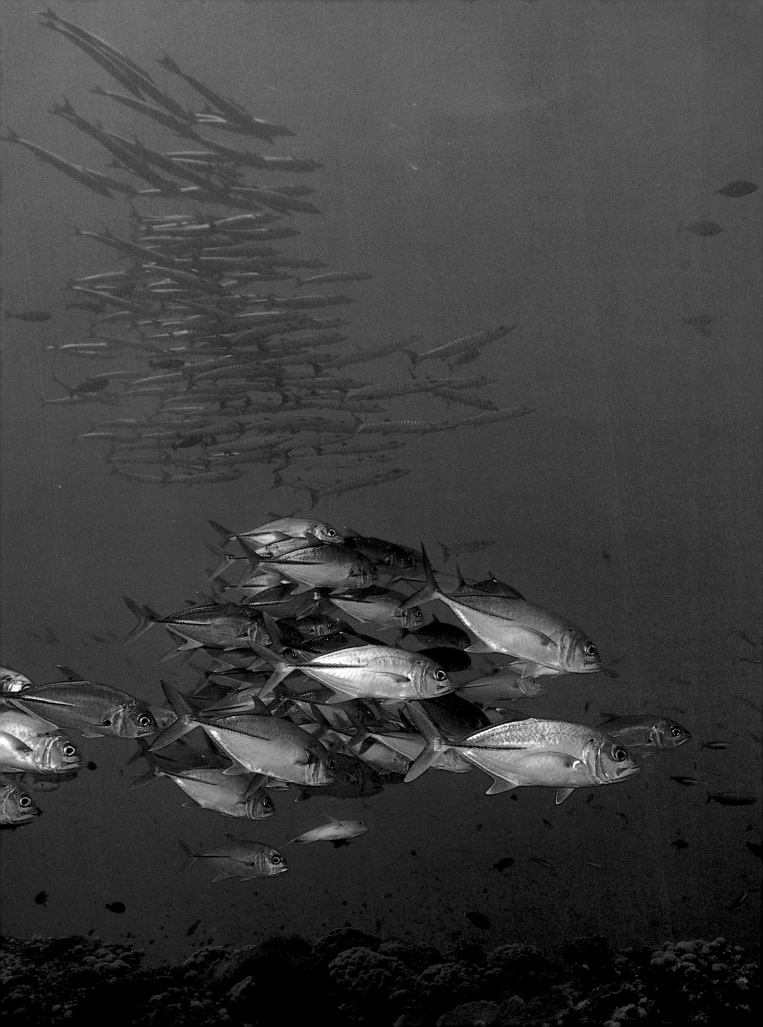

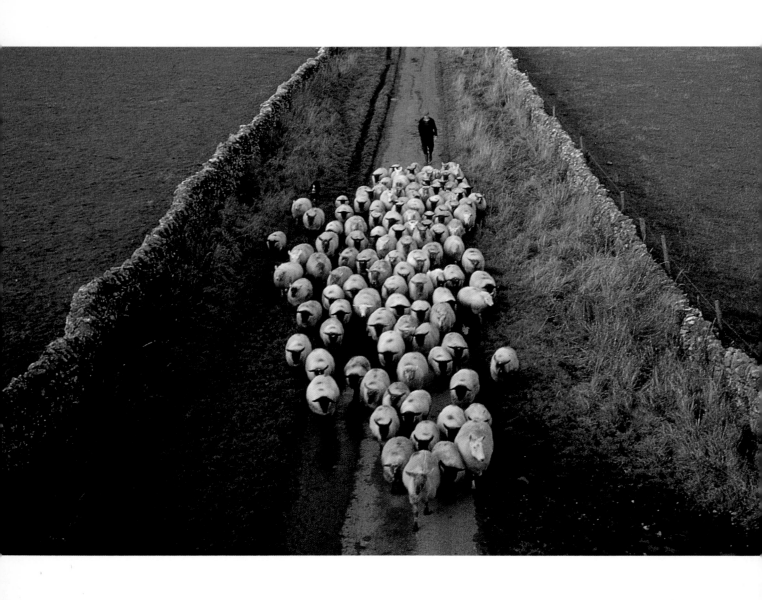

LILIAN ALSOP - UK

152

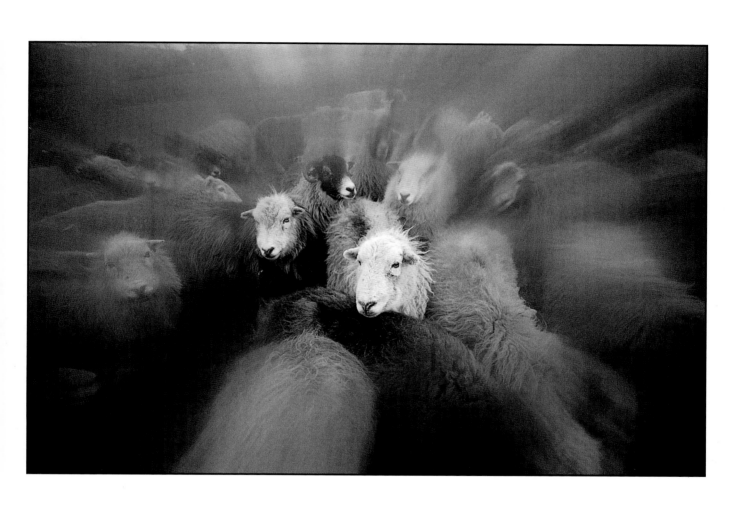

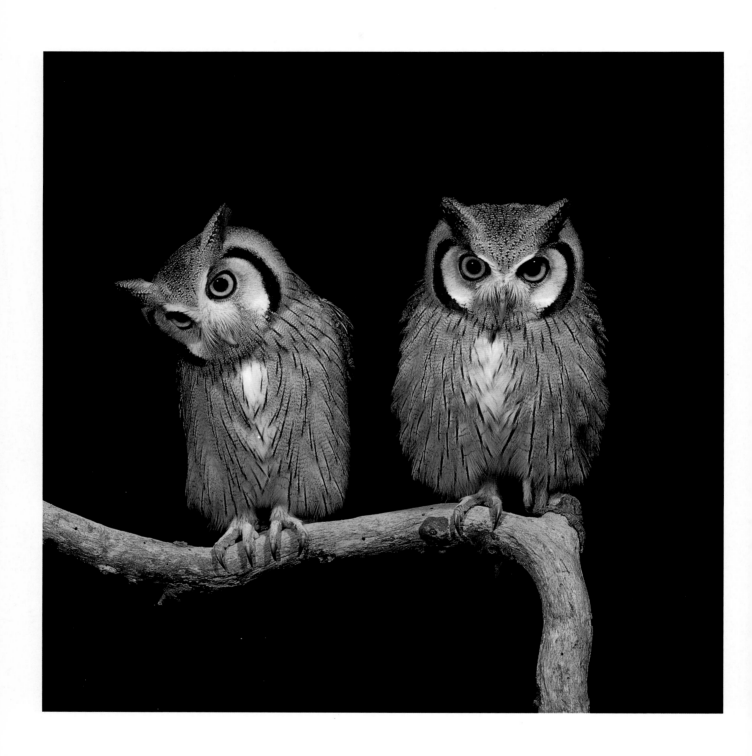

ERNIE JANES - UK

PETER BÁRDOS-DEÁK - HUNGARY

154

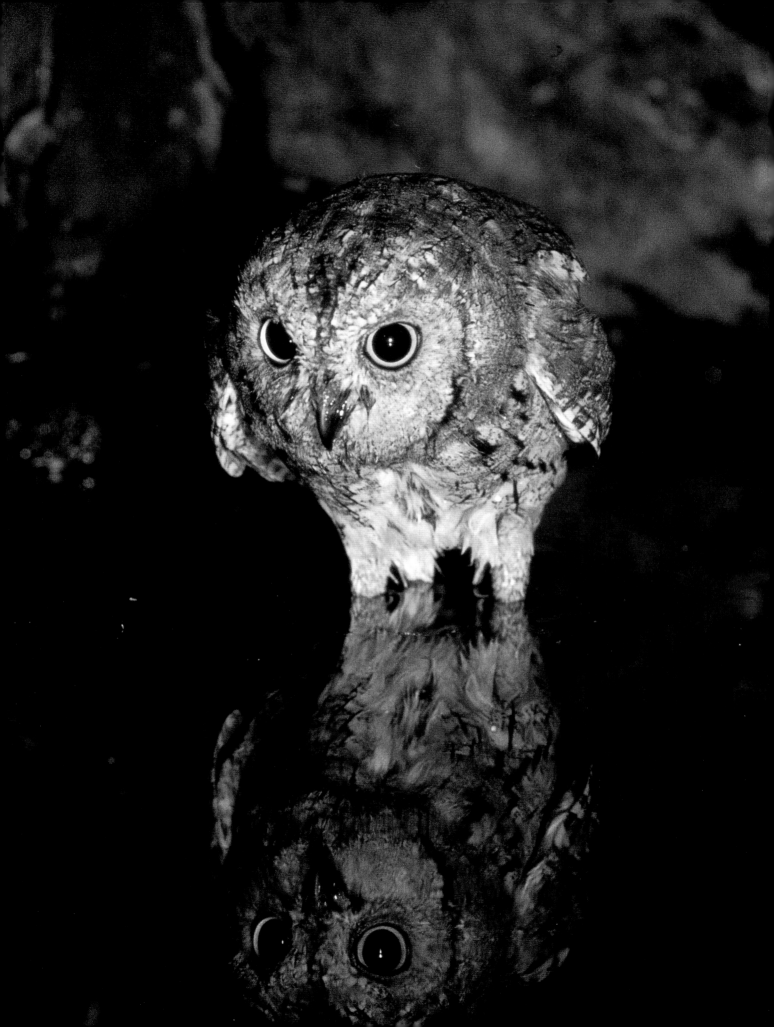

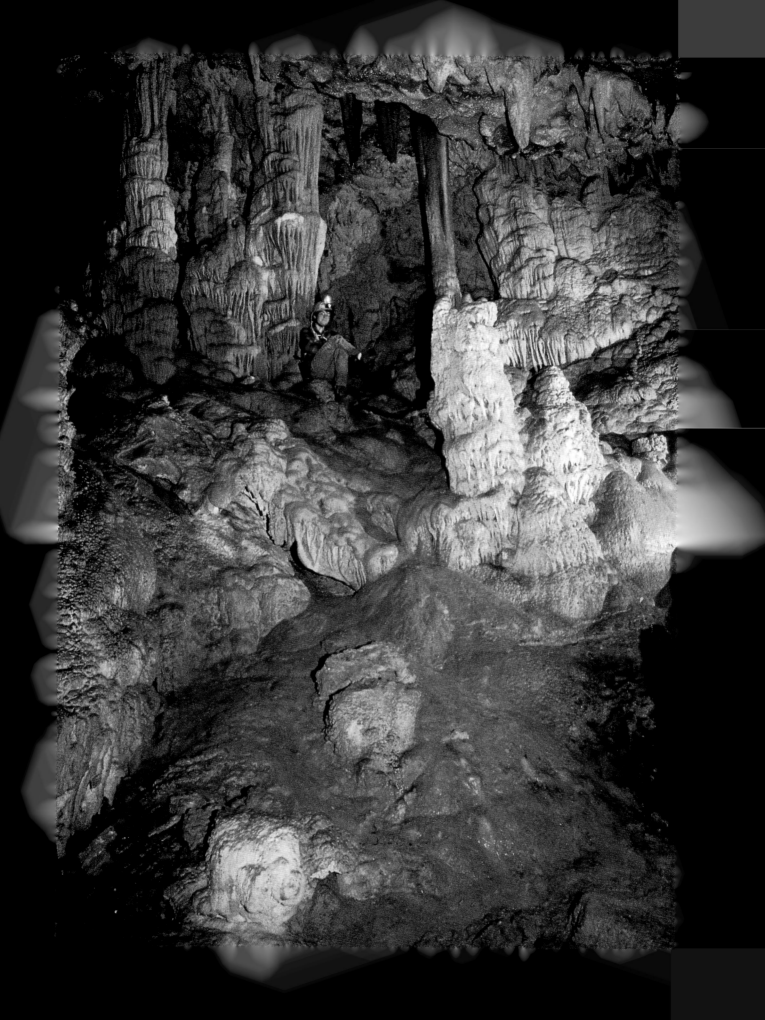

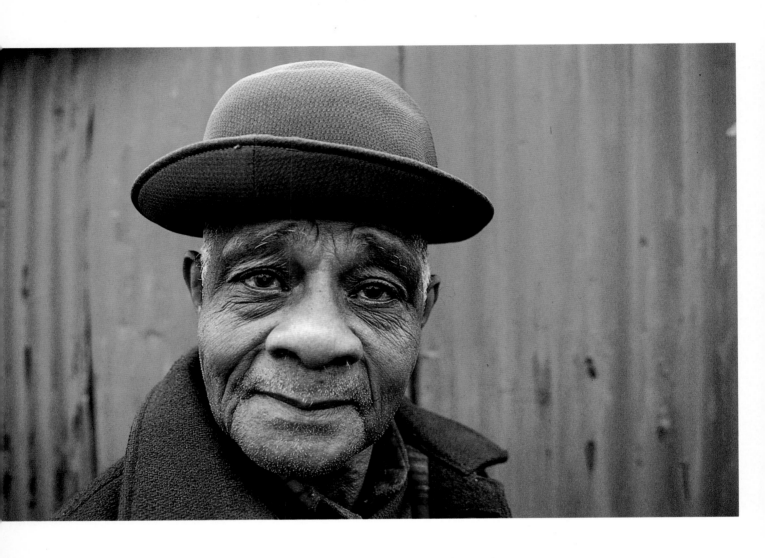

DAVID JOHNSTON - UK

158

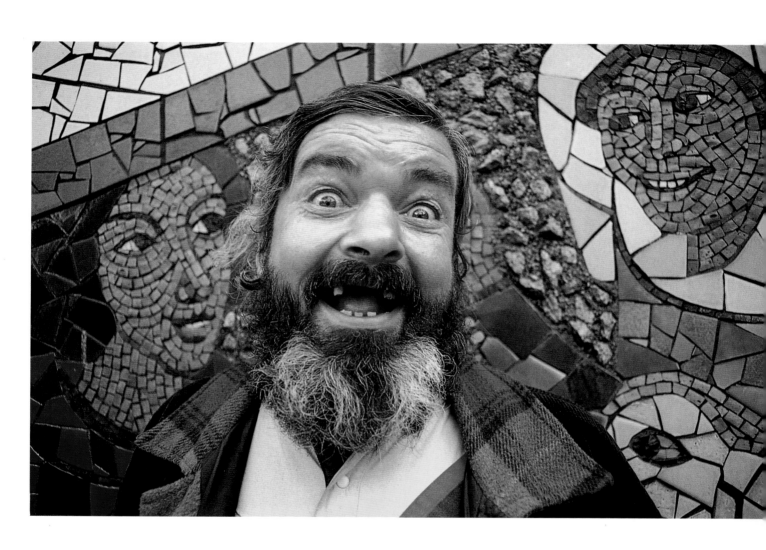

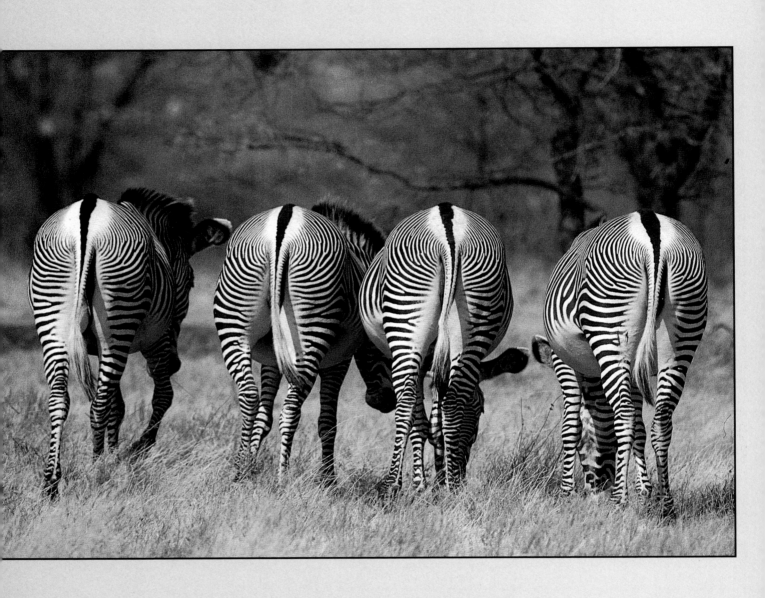

TONY WHARTON - UK

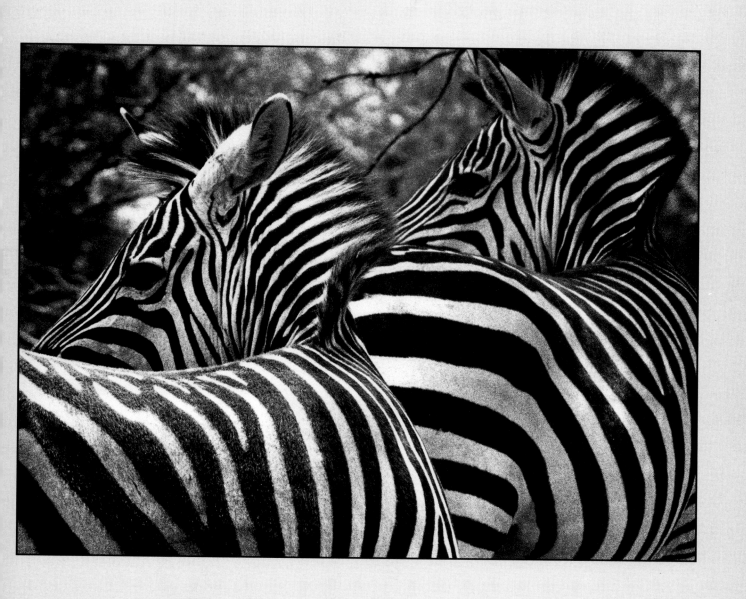

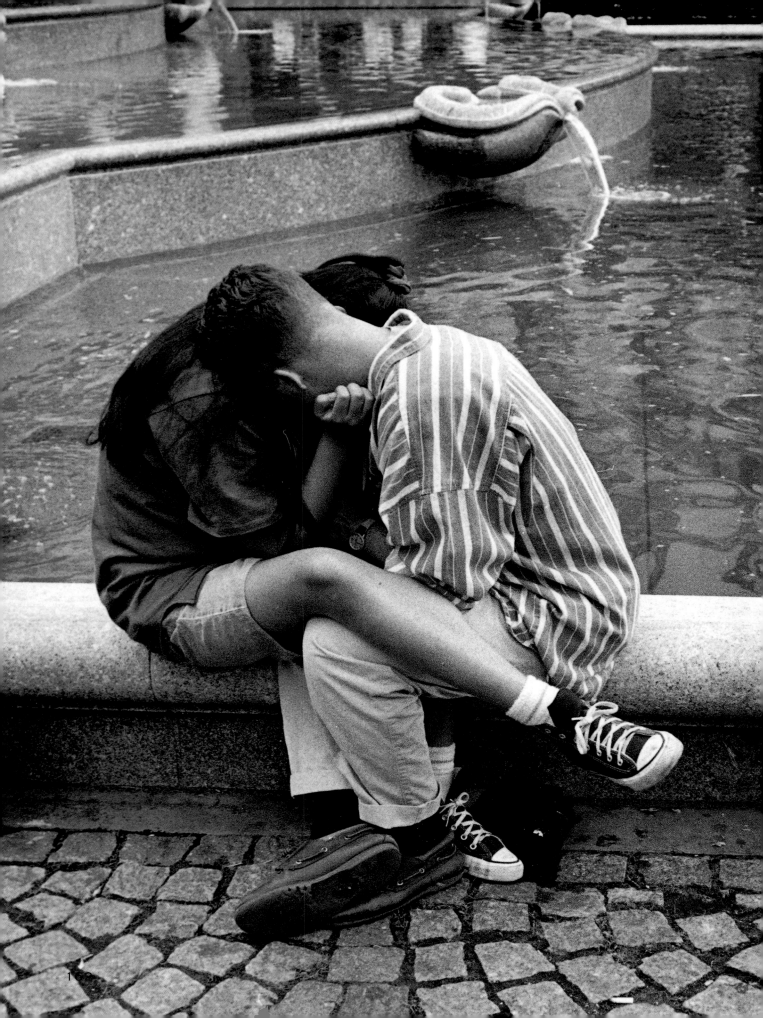

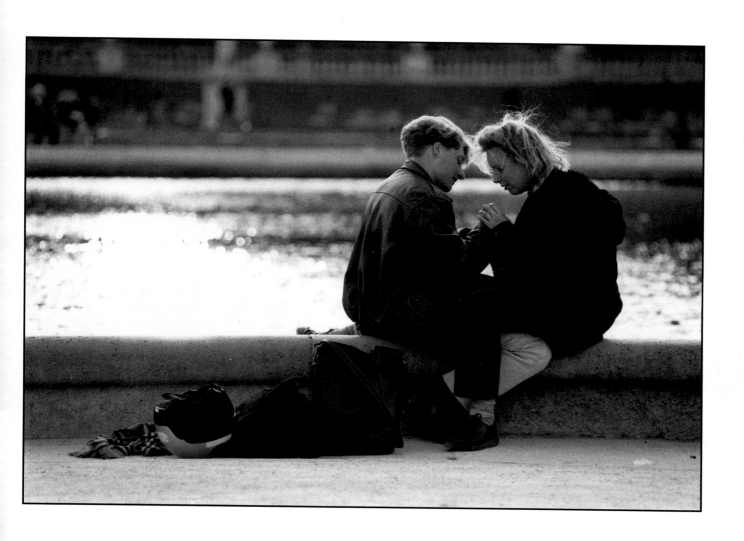

RUDY LEWIS - UK

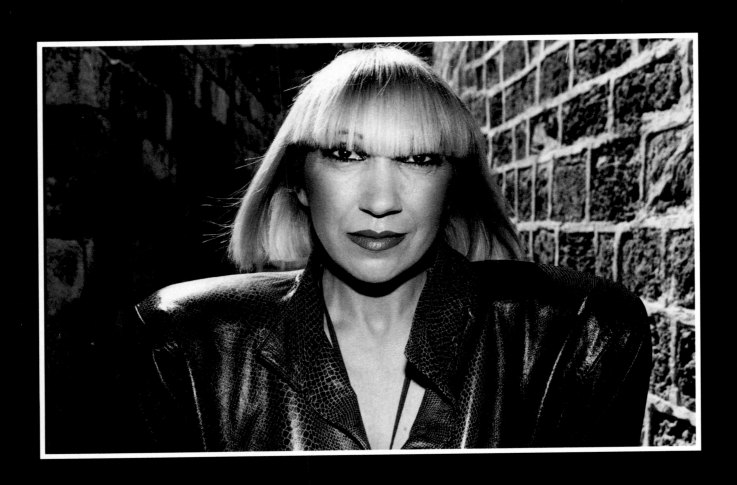

CARMEL SKUTELSKY - ISRAEL

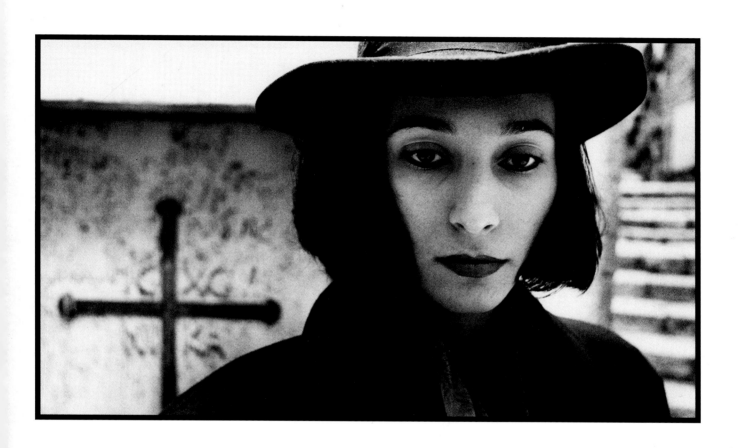

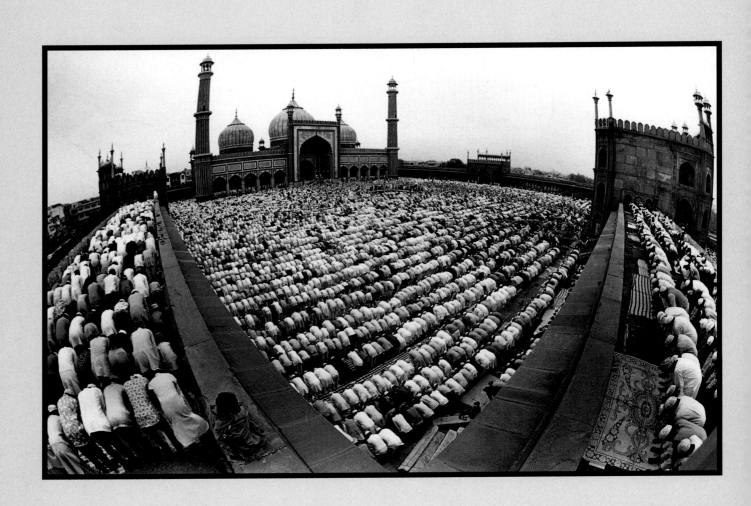

NEERAJ PAUL - INDIA

166

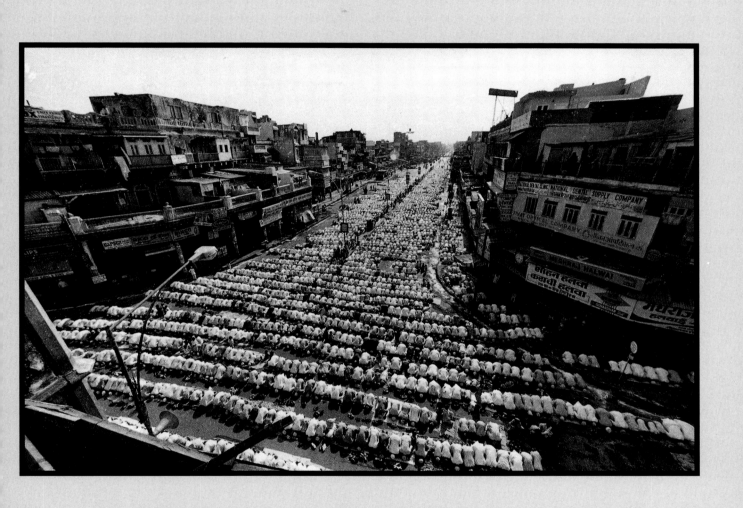

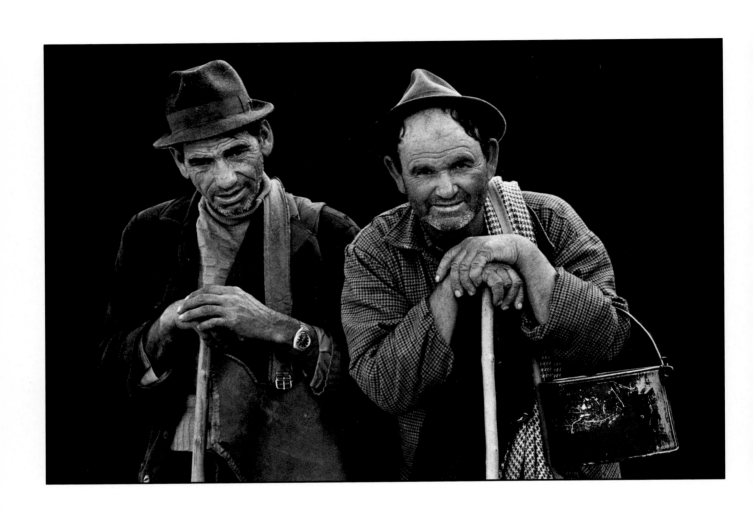

HUGO SCHÖPF · AUSTRIA

168

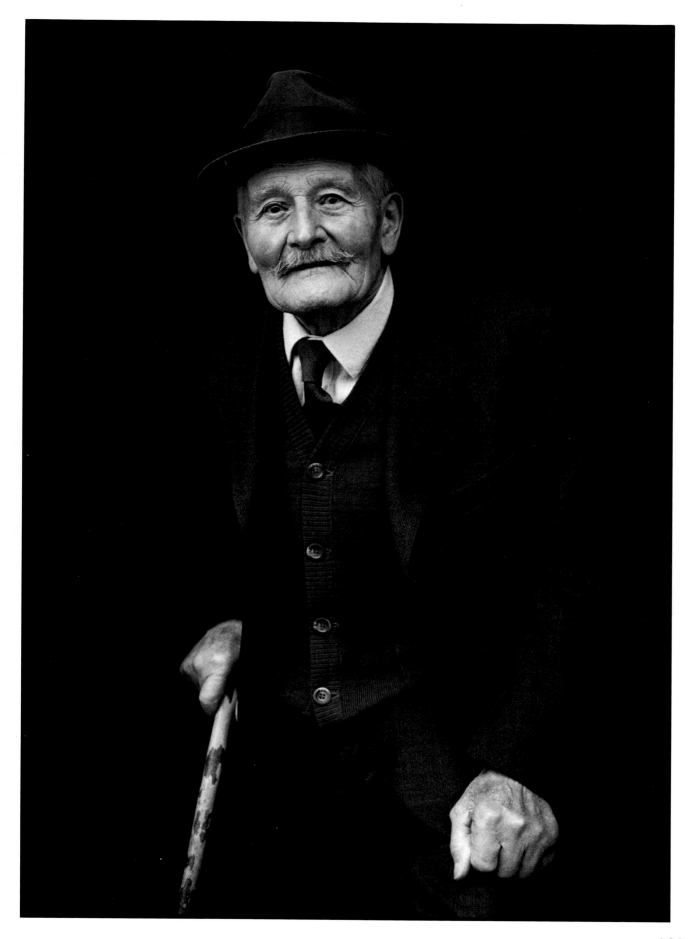

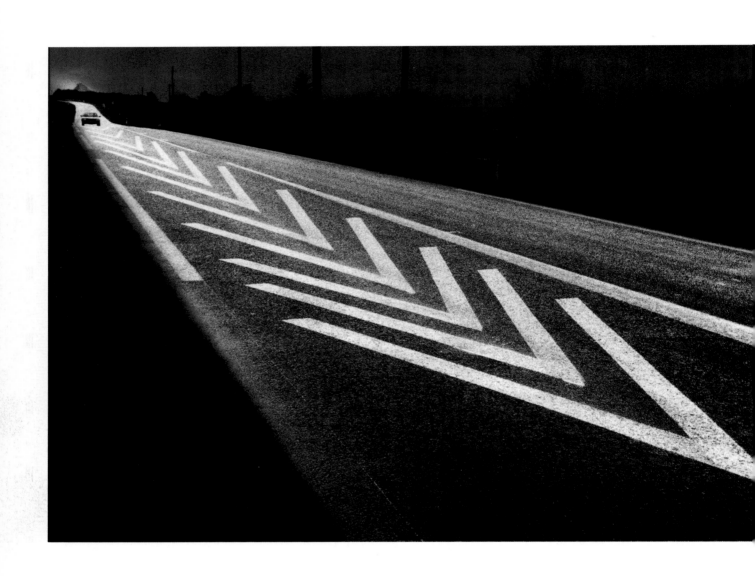

ANDY WILSON - UK

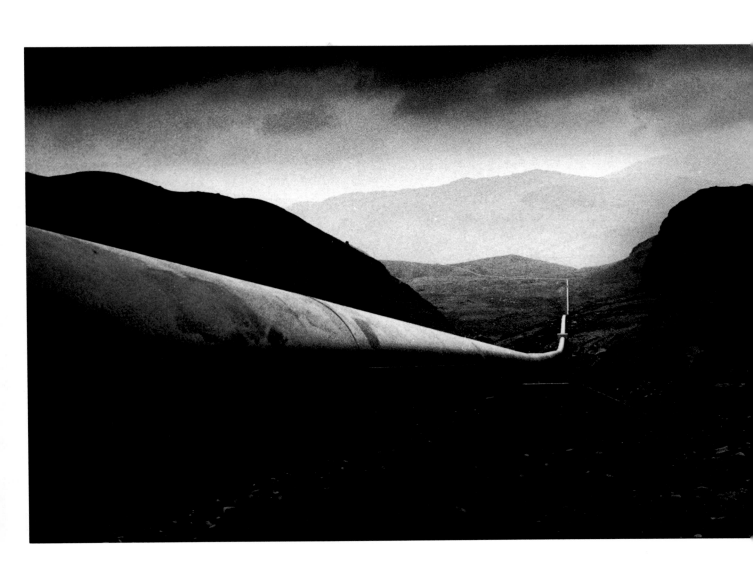

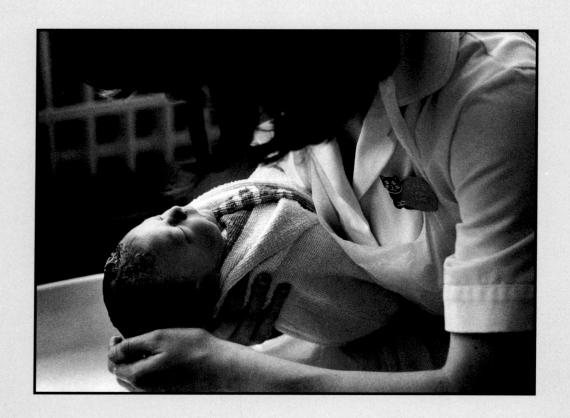

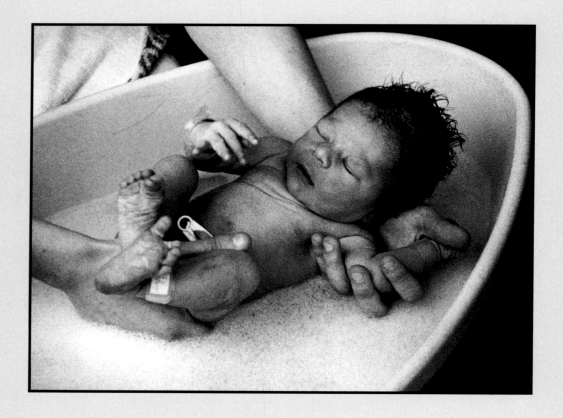

NANCYE GAULT - UK

172

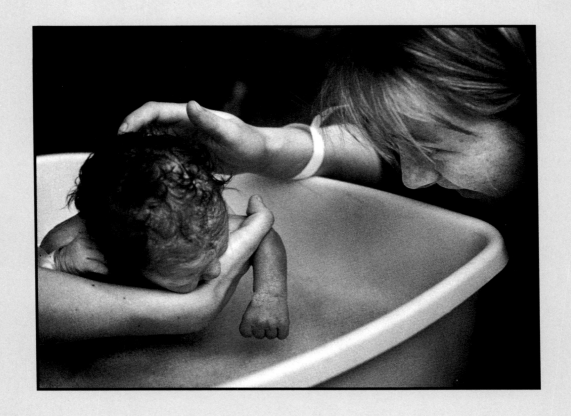

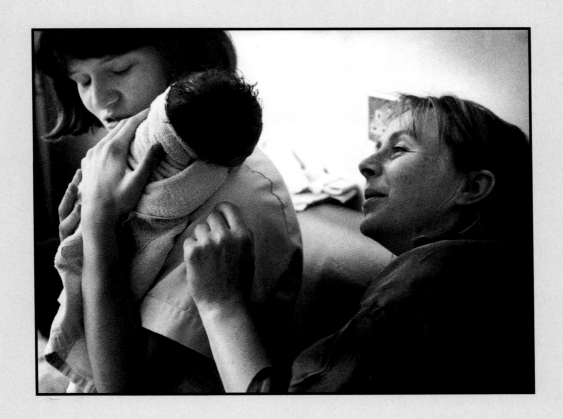

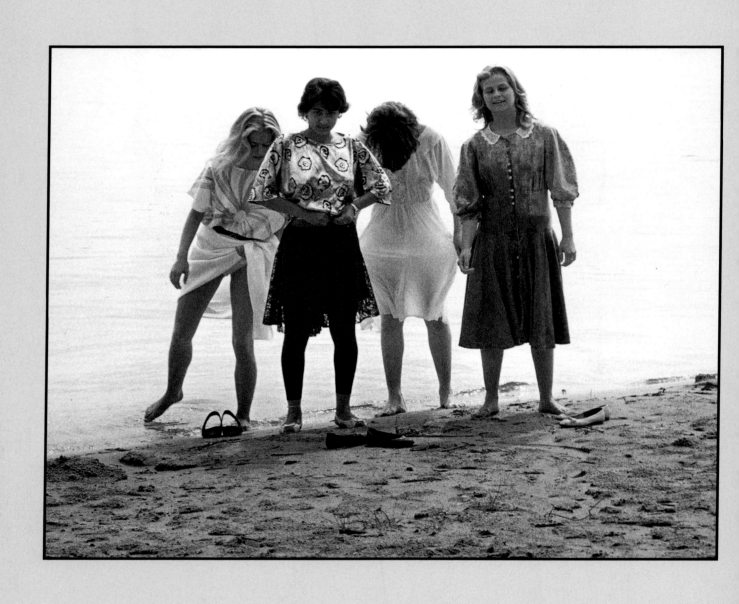

VÁCLAV LAHOVSKY - CZECH REPUBLIC

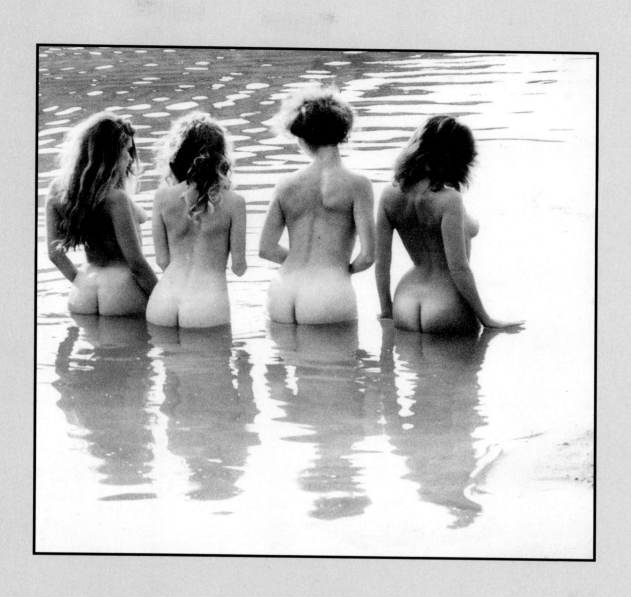

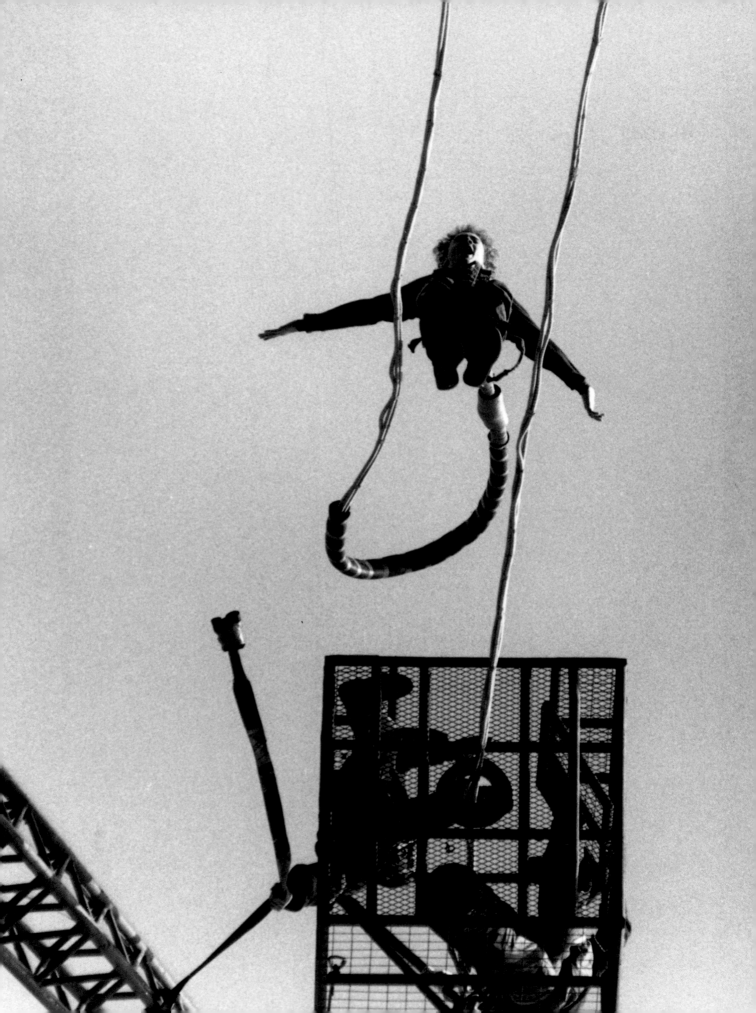

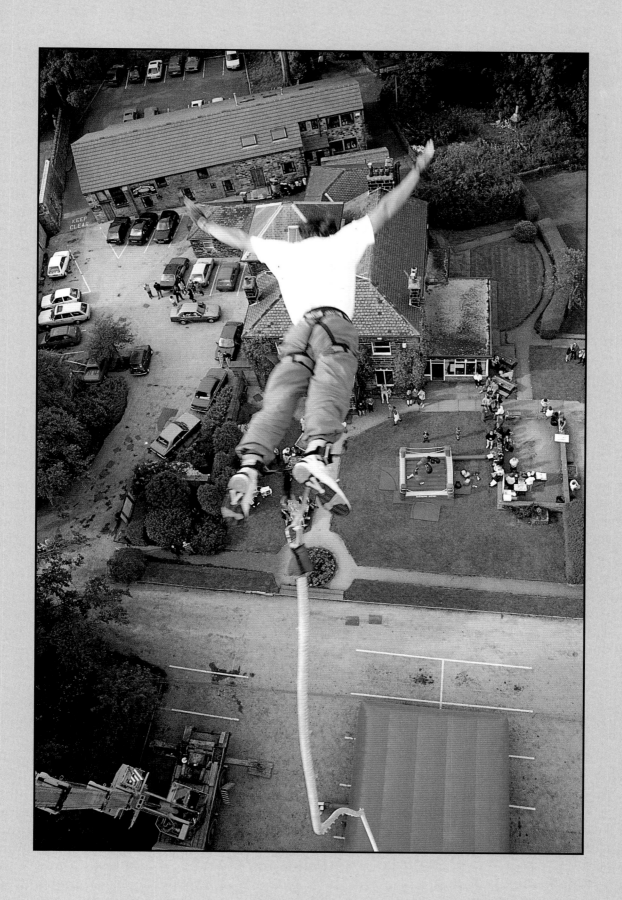

GEOFFREY GRACE - UK

NEIL RATTENBURY - UK

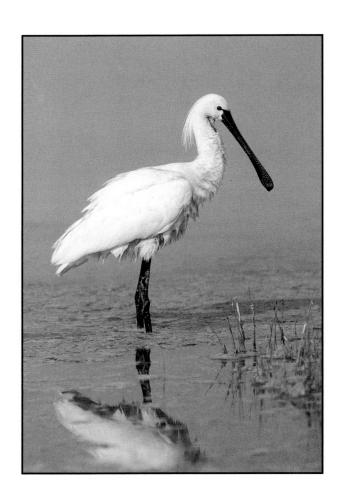

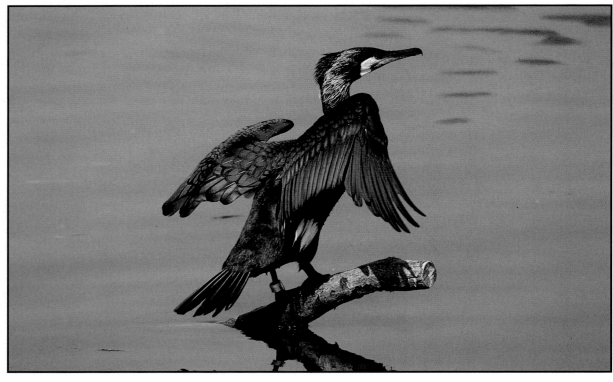

NORBERT BARANSKI - GERMANY

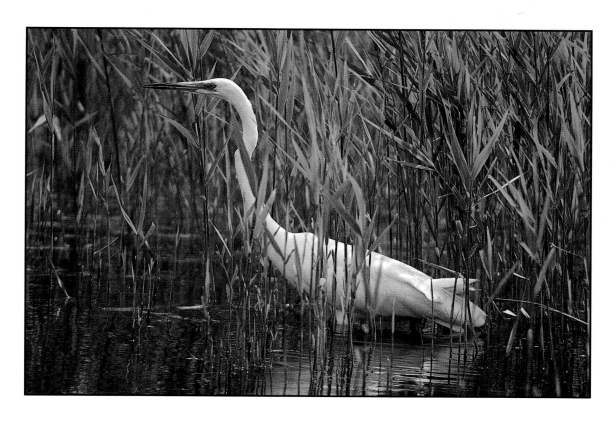

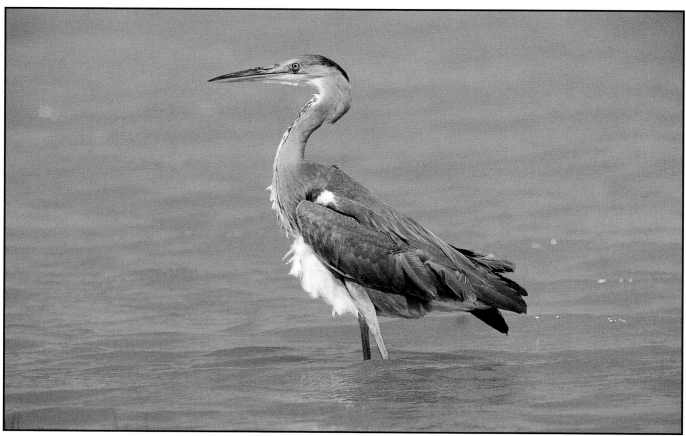

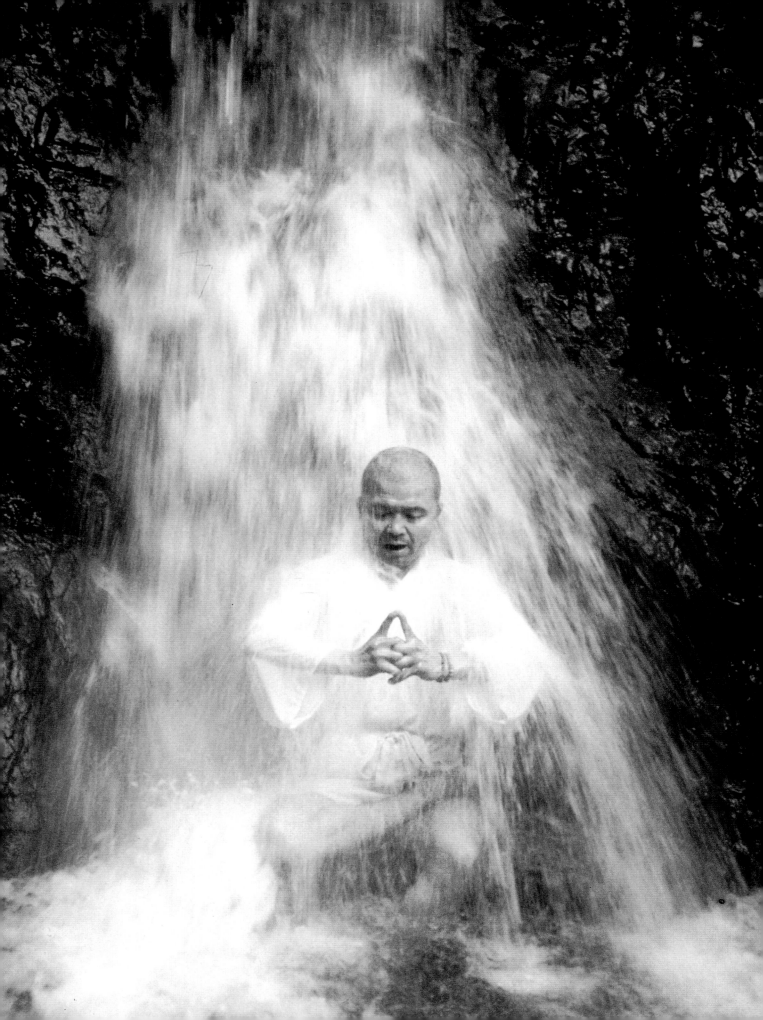

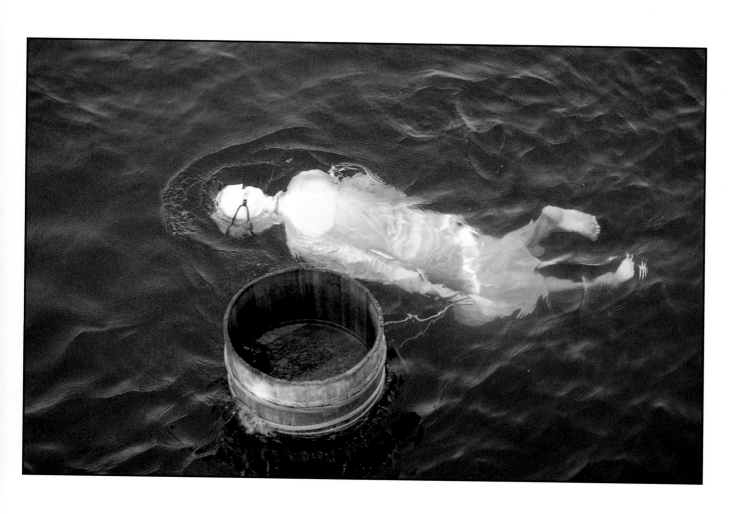

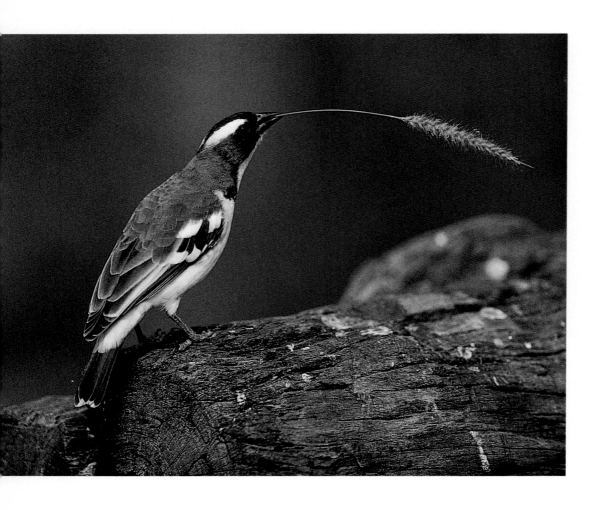

MARK HAMBLIN - UK

182

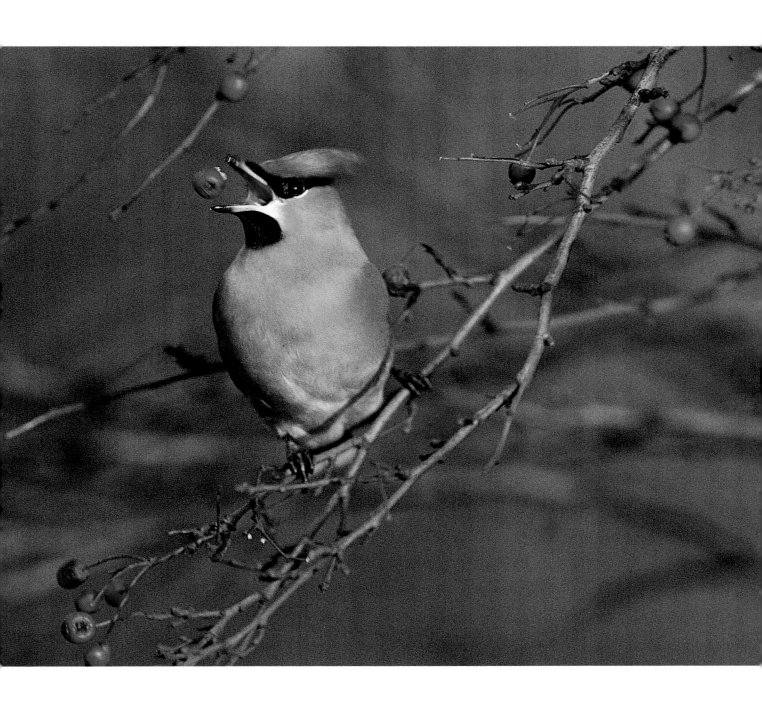

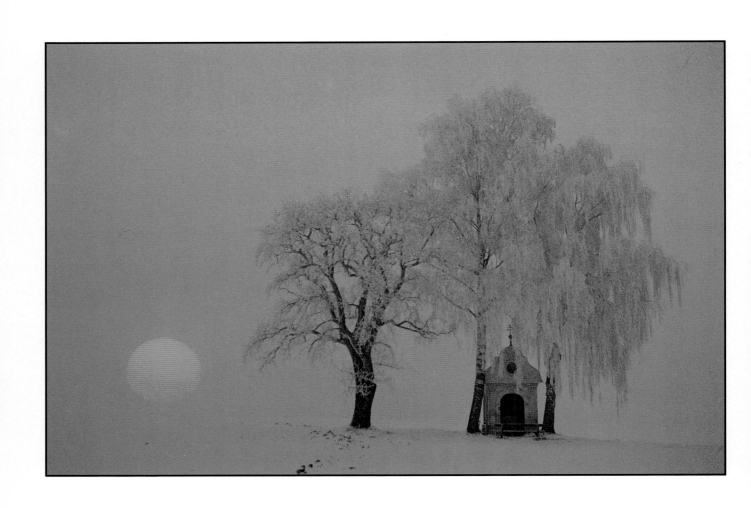

HEINRICH SPERER - AUSTRIA

184

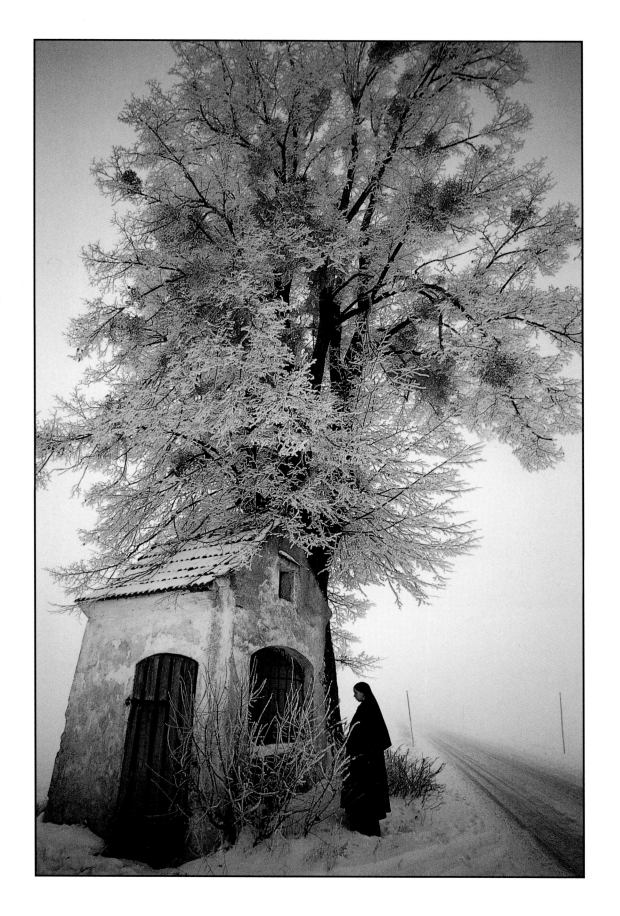

ERWIN TRAUNMÜLLER - AUSTRIA

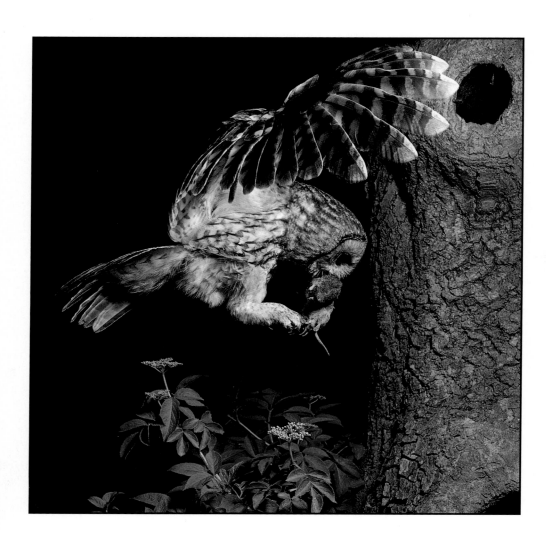

KEN LINNARD - UK

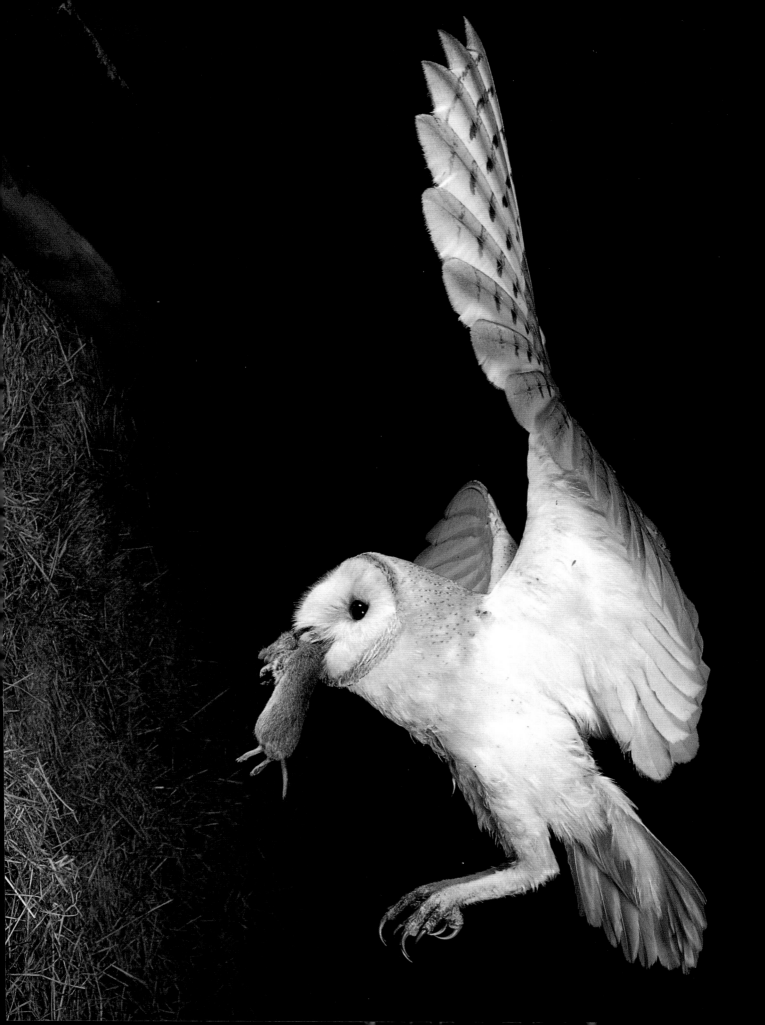

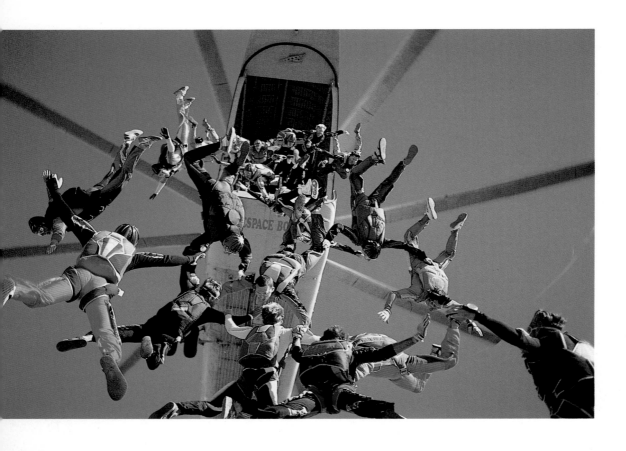

ADRIAN THORNTON - UK

188

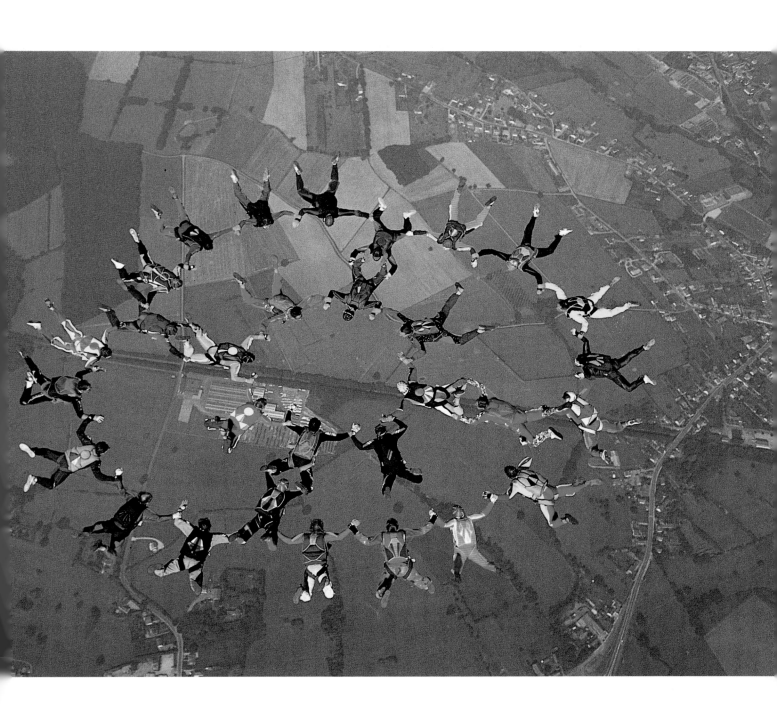

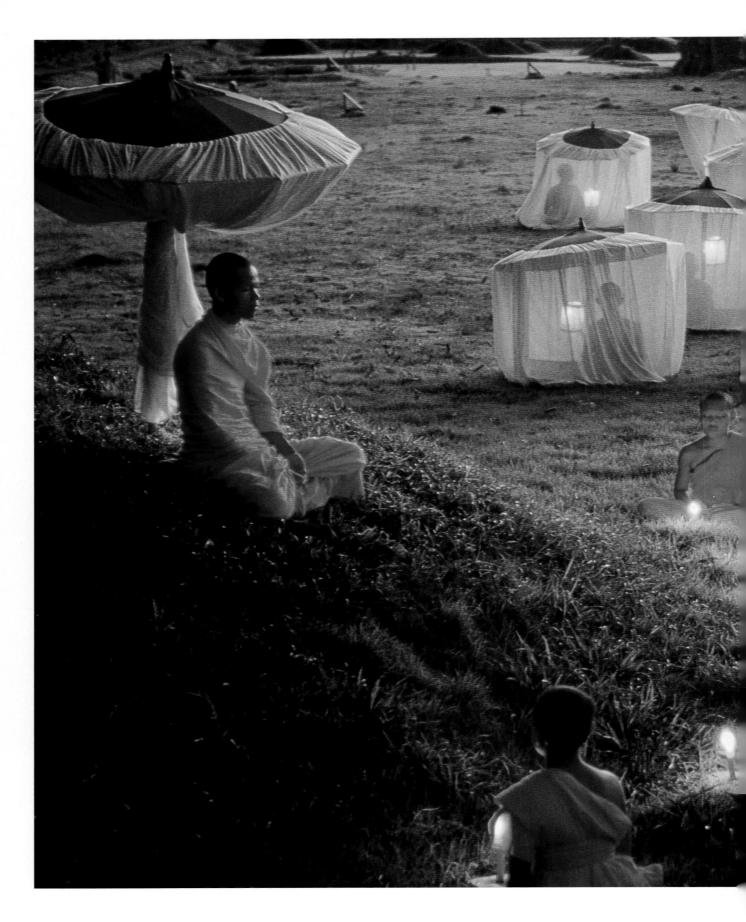

KUNBUA NOPHADOL - THAILAND

190

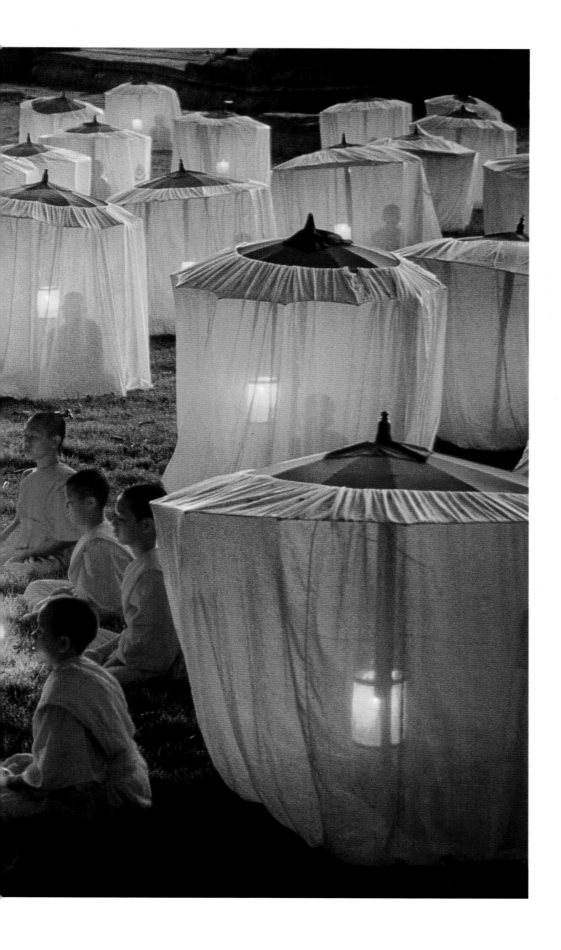

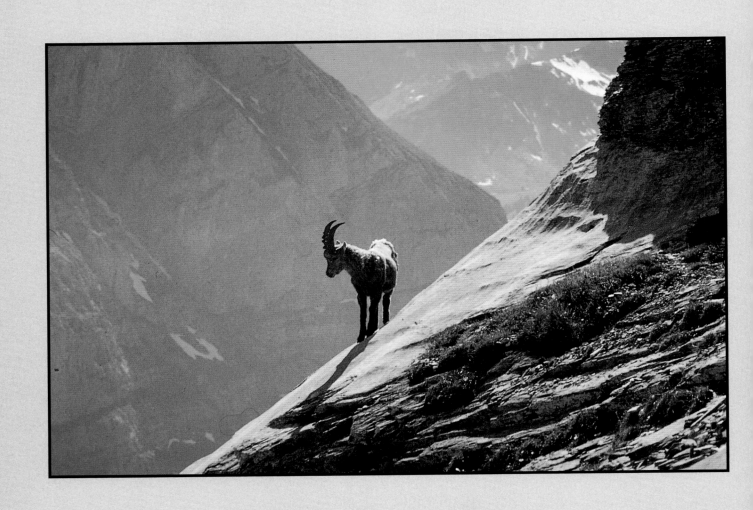

VIC ATTFIELD - UK

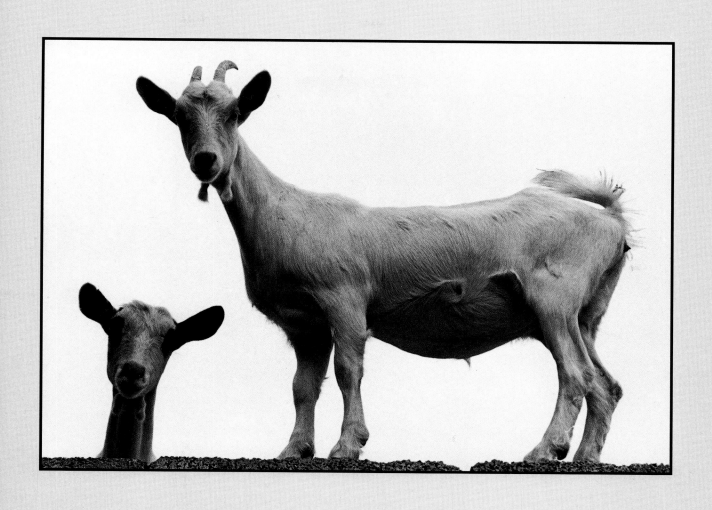

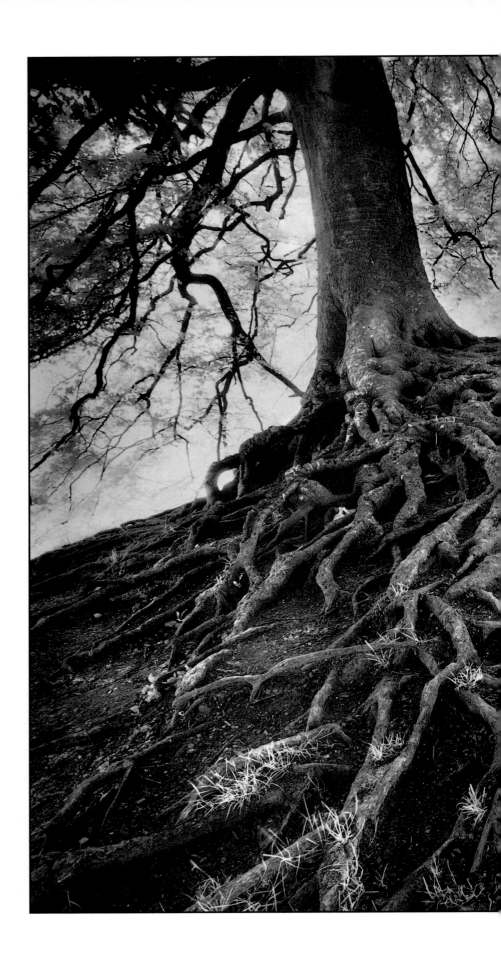

TONY WOROBIEC - UK

194

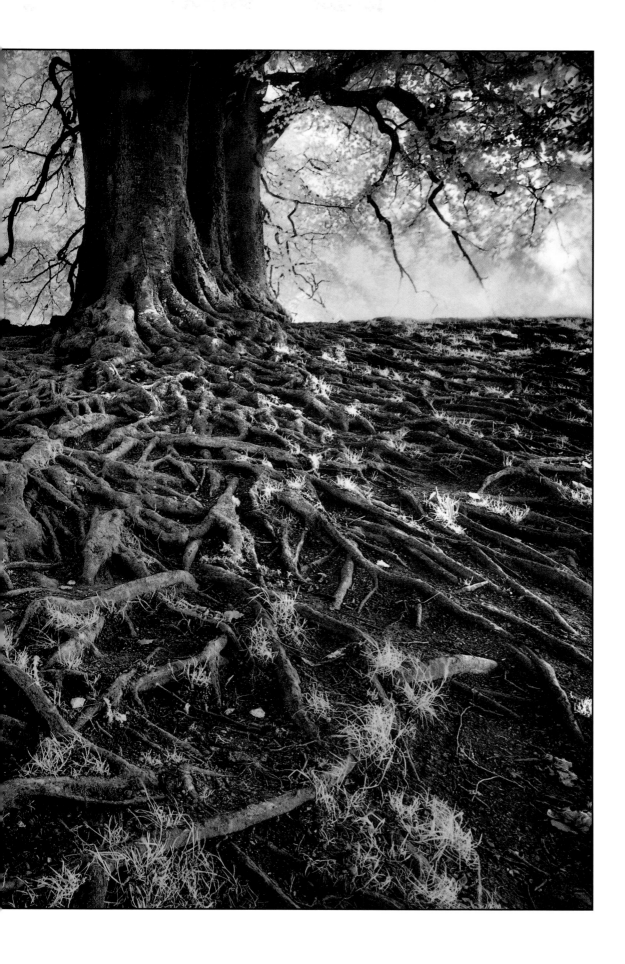

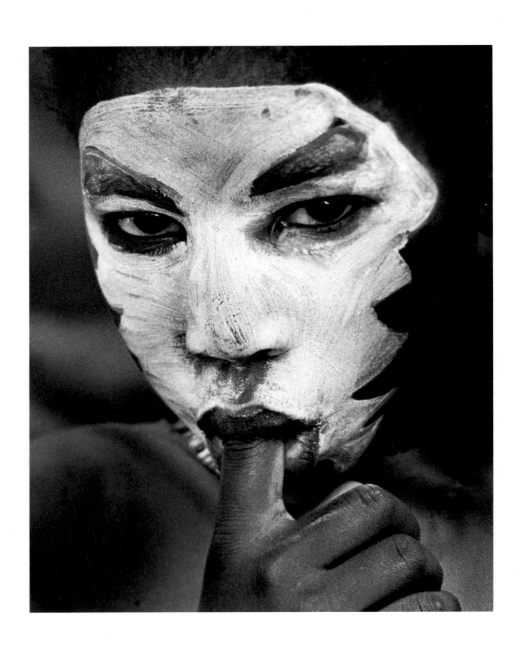

BILL CARDEN - UK

196

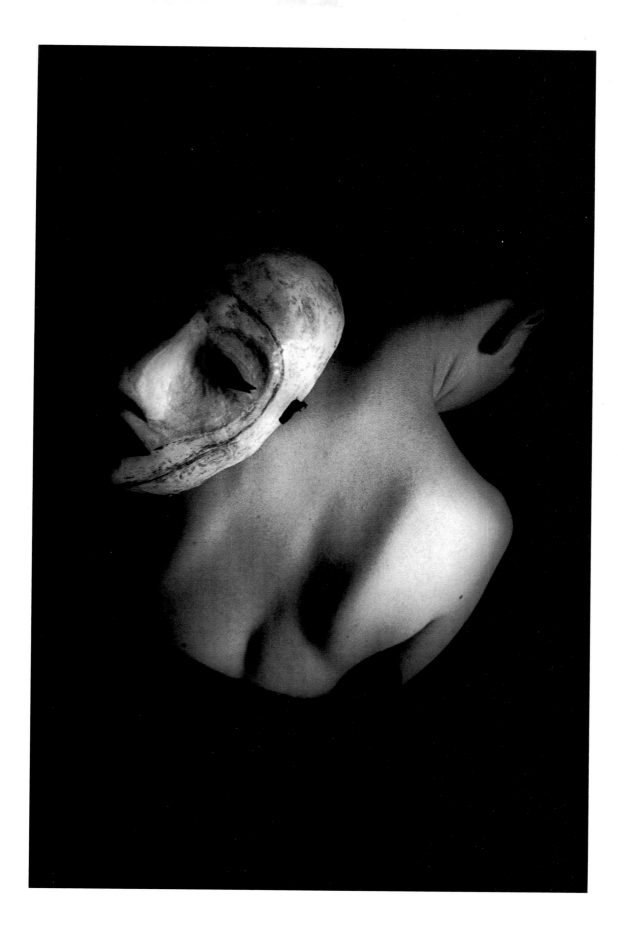

WILLIE DILLON - EIRE

197

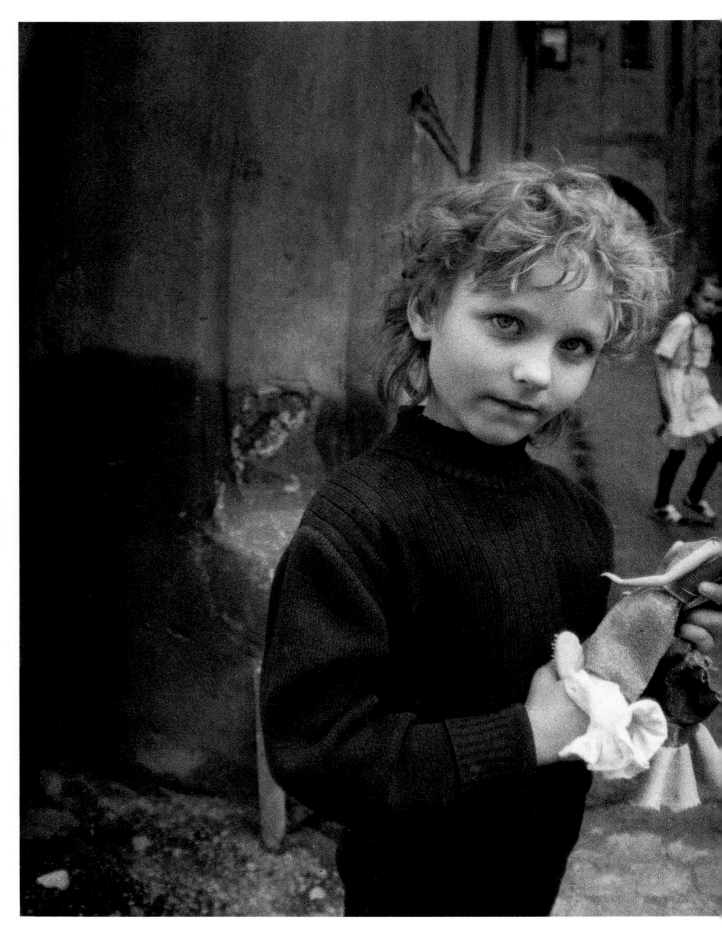

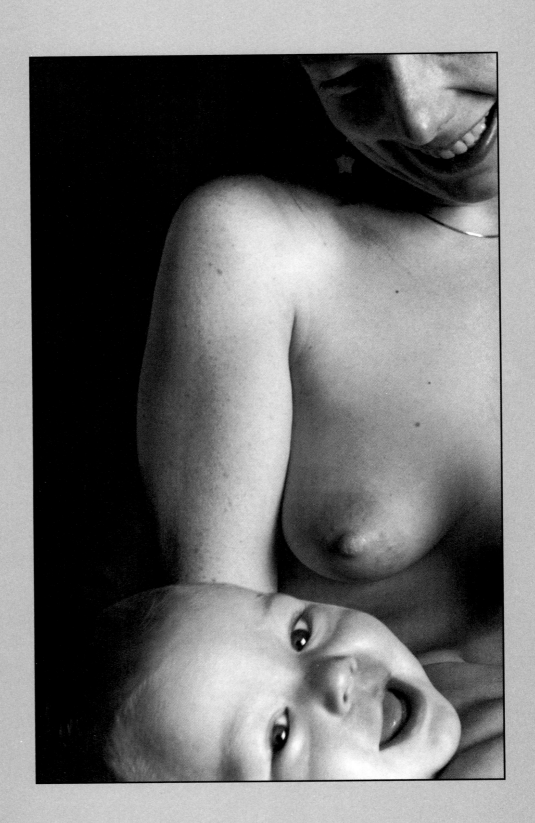

MAGGIE EATOUGH - UK

200

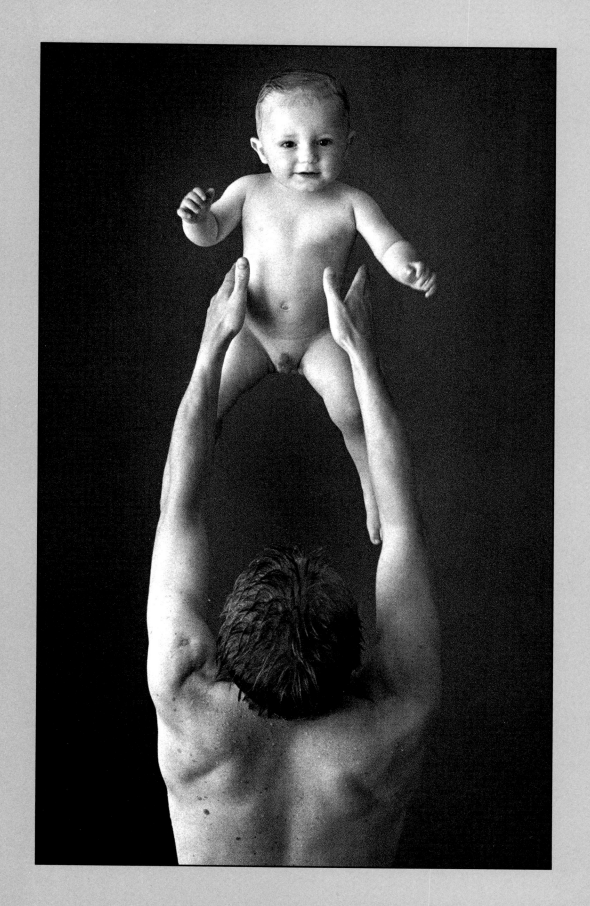

MANFRED ZWEIMÜLLER · AUSTRIA

201

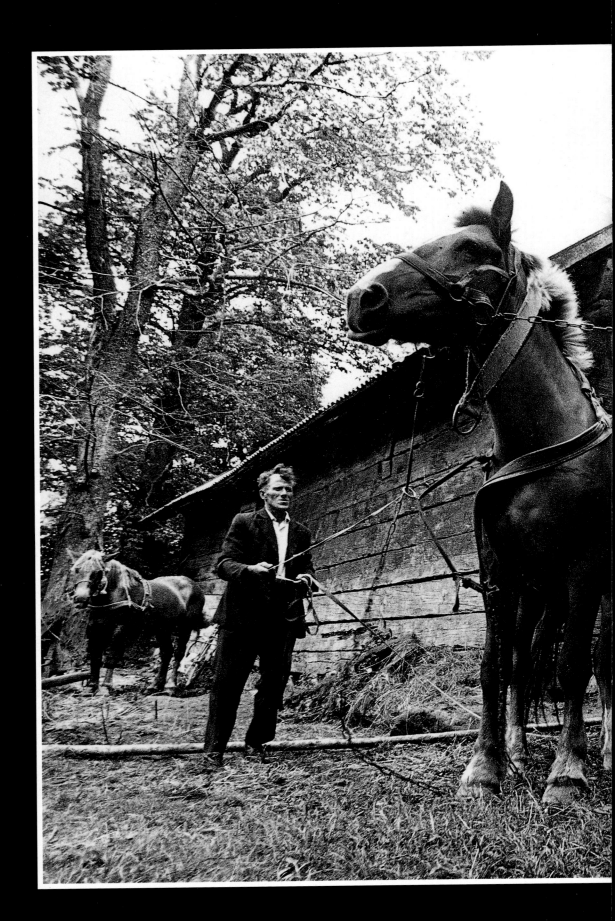

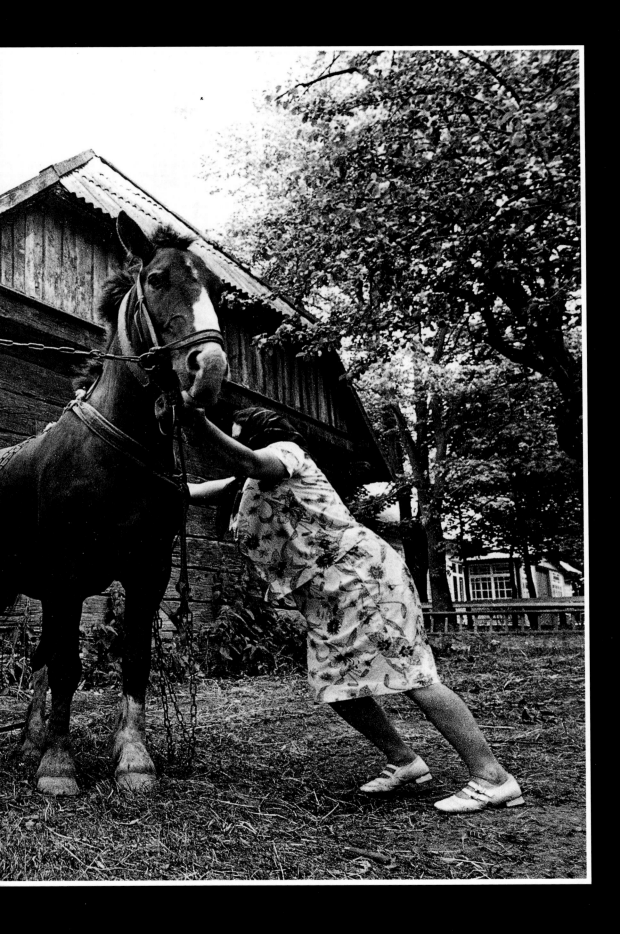

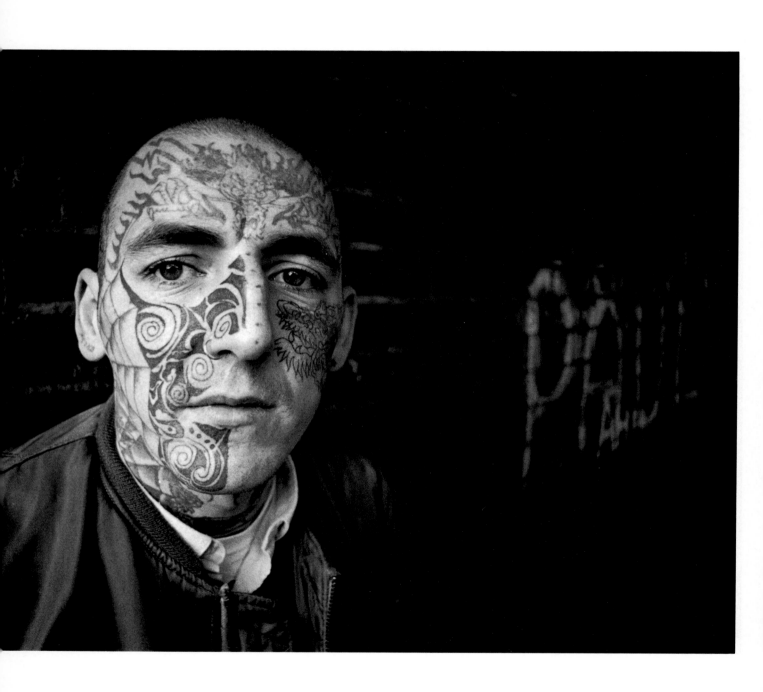

PETER GENNARD - UK

204

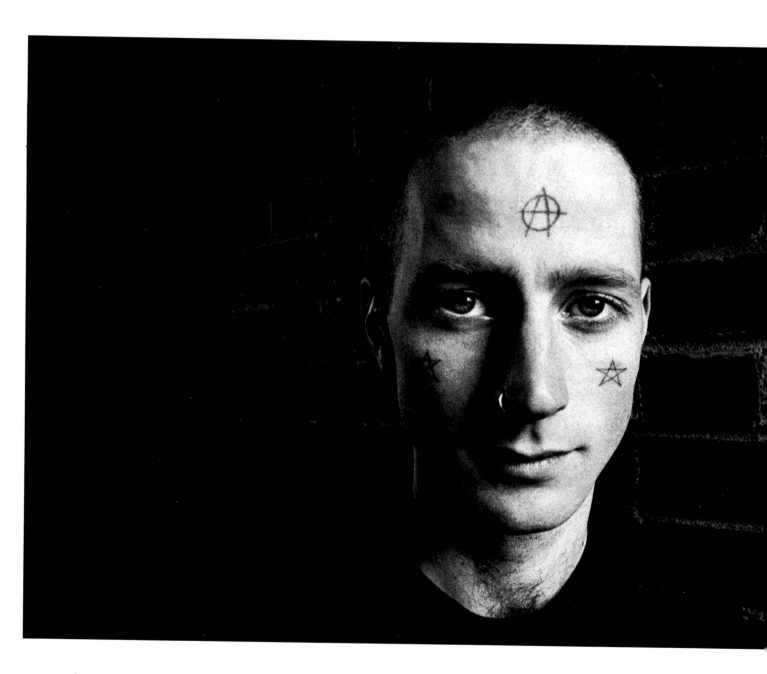

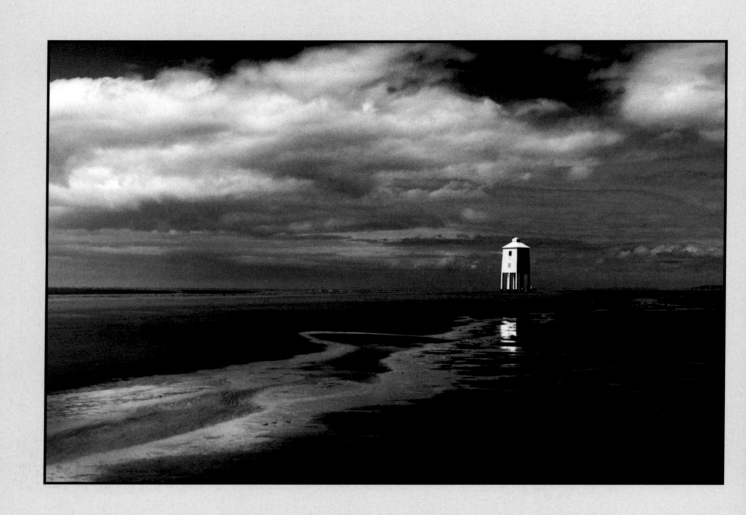

BRIAN TUFF - UK

206

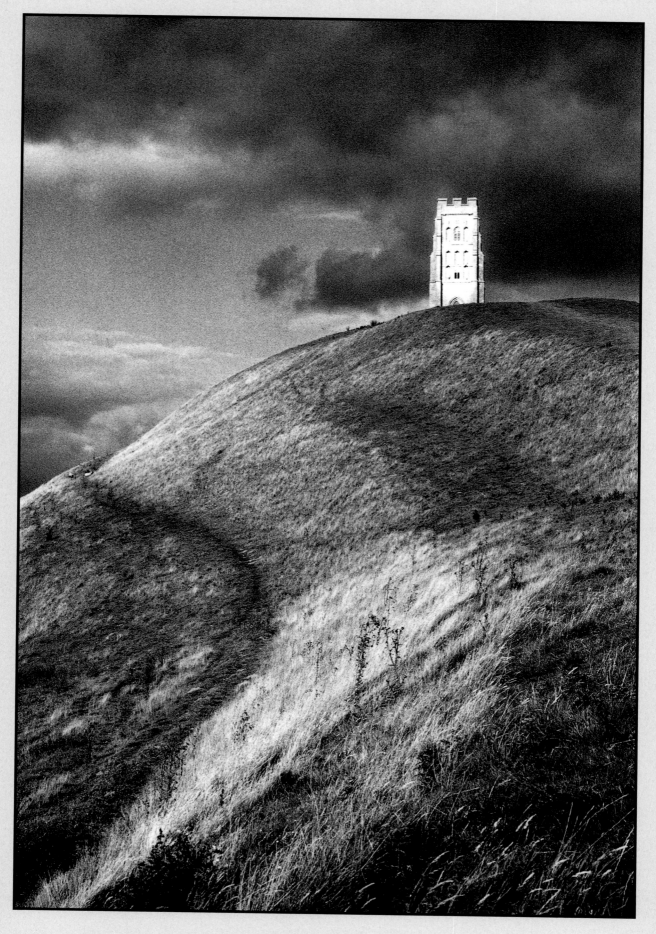

ROBERT HALLMANN - UK

208

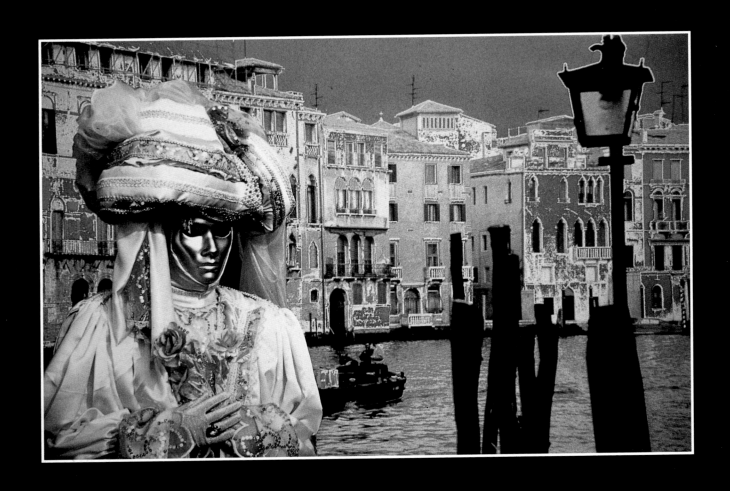

CLIFF THOMPSON - UK

210

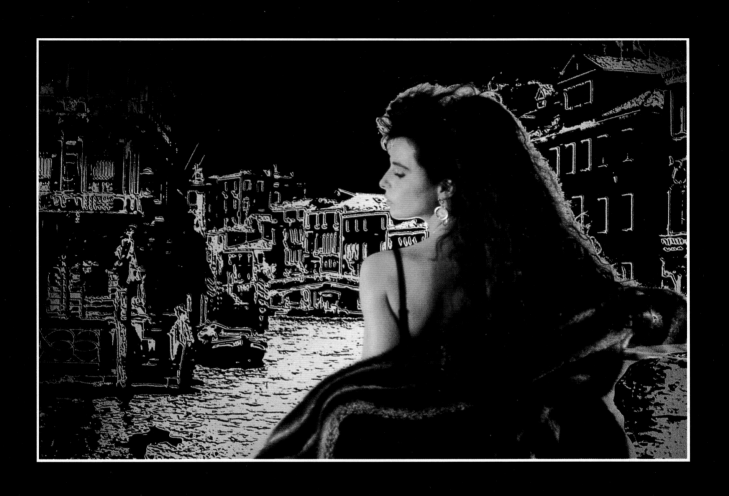

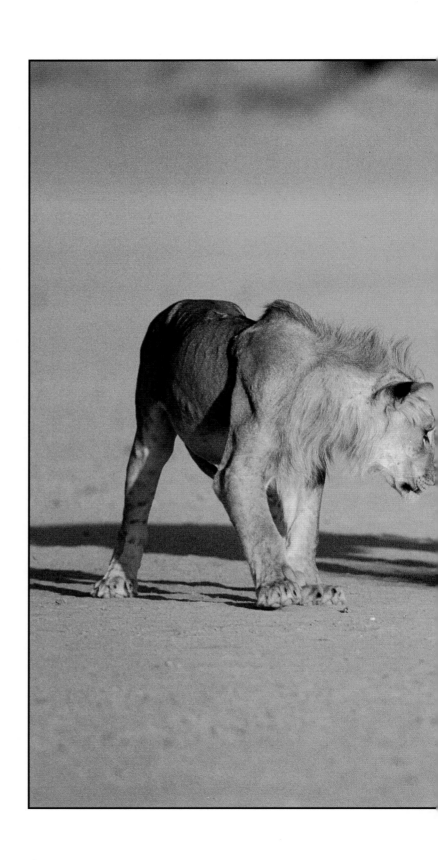

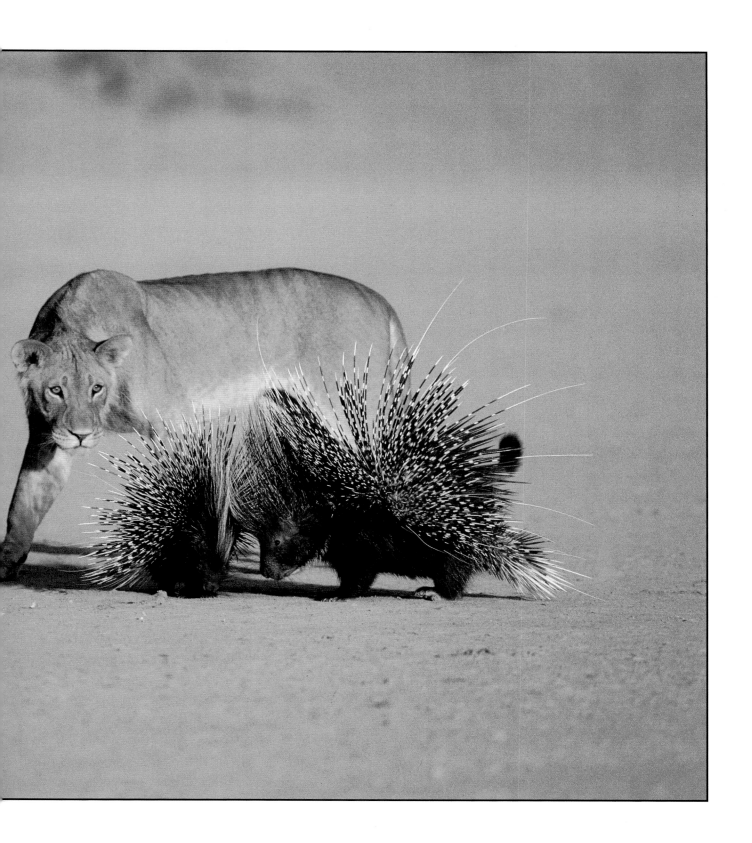

Patricia Mulkeen - Germany

214

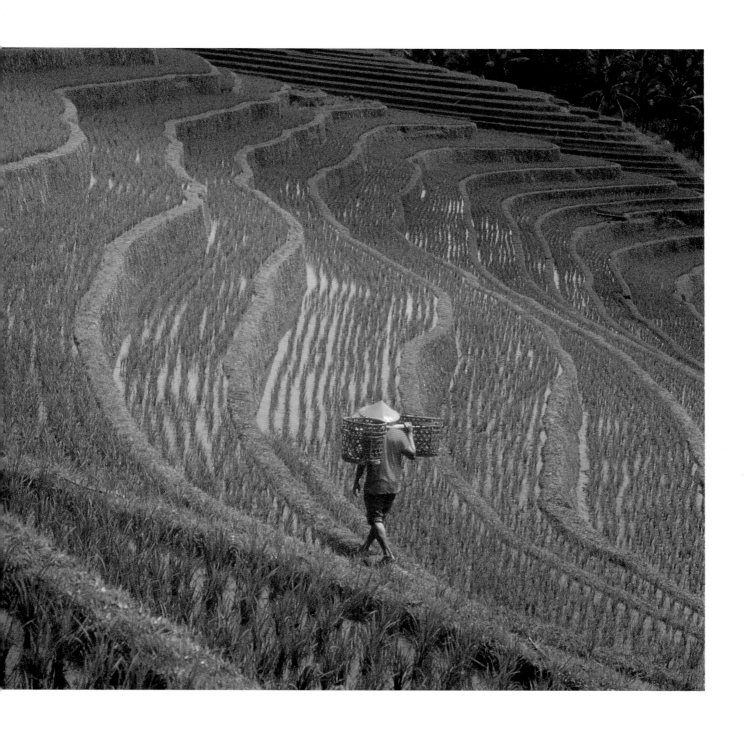

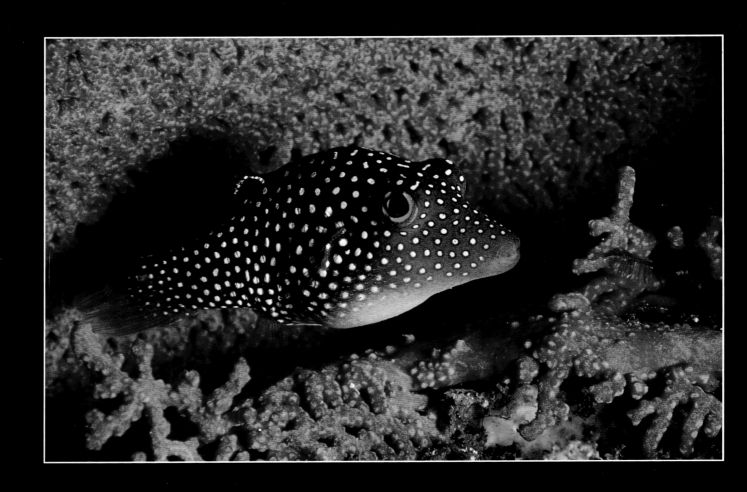

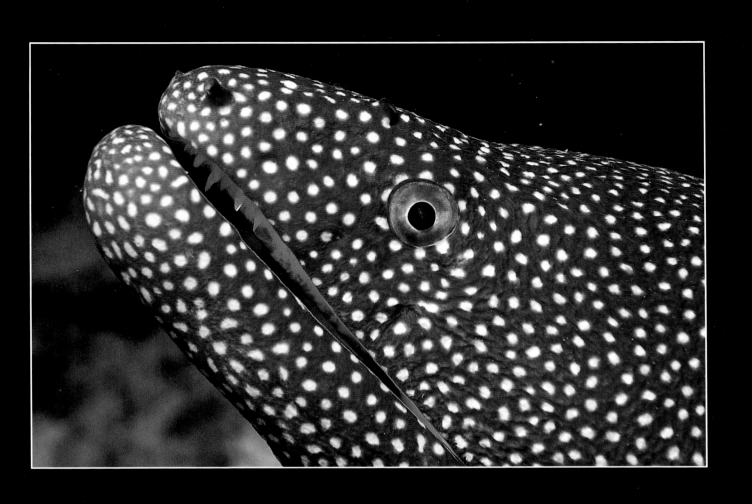

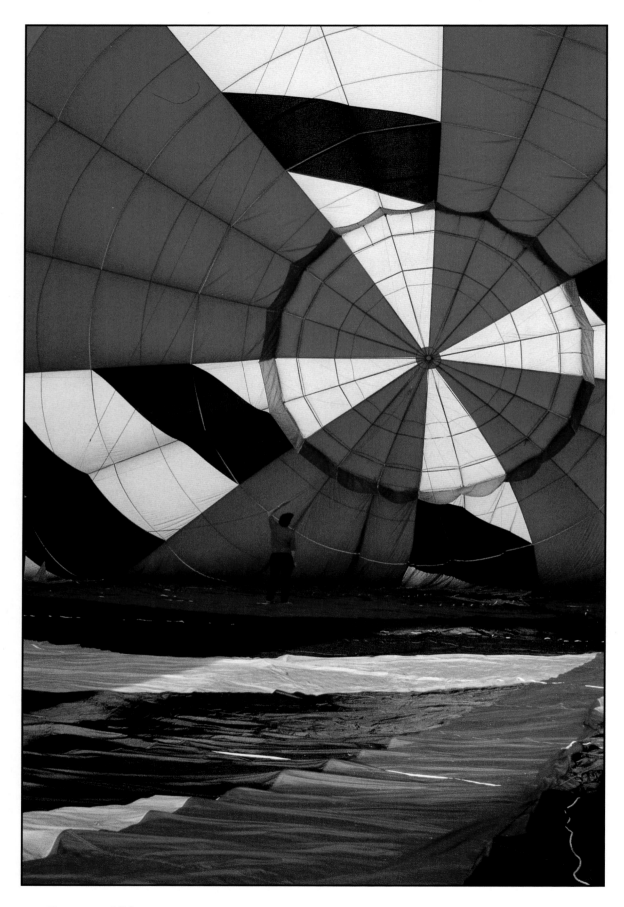

CAROLYN BATES - UK

218

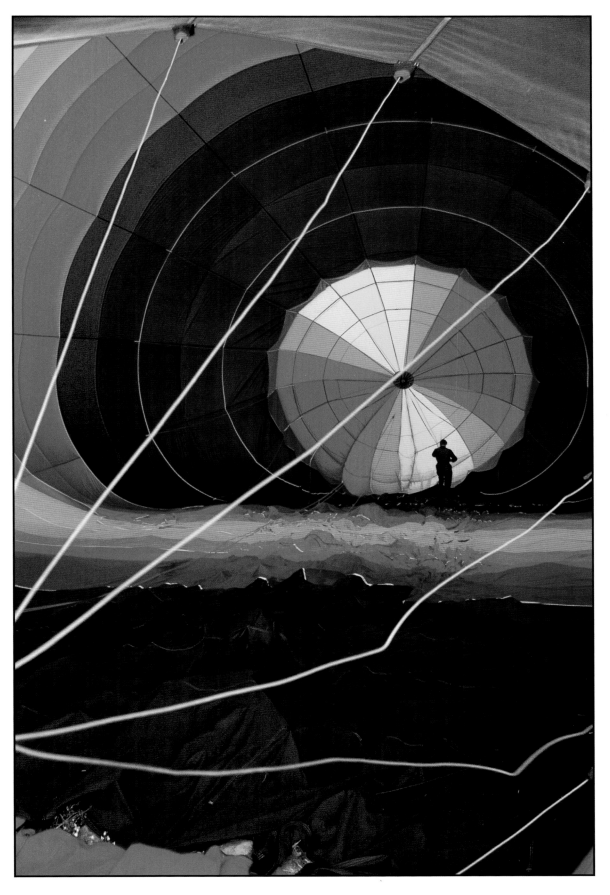

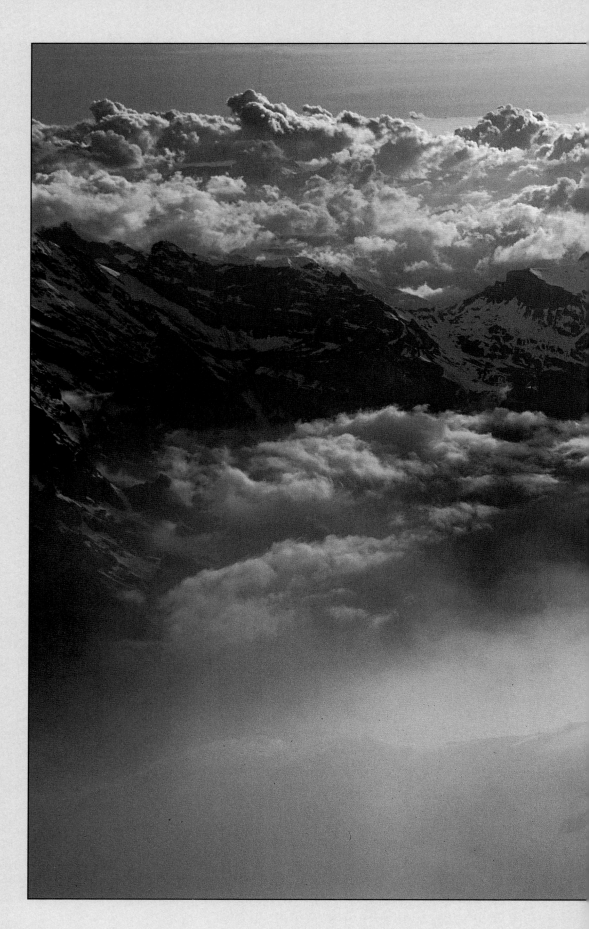

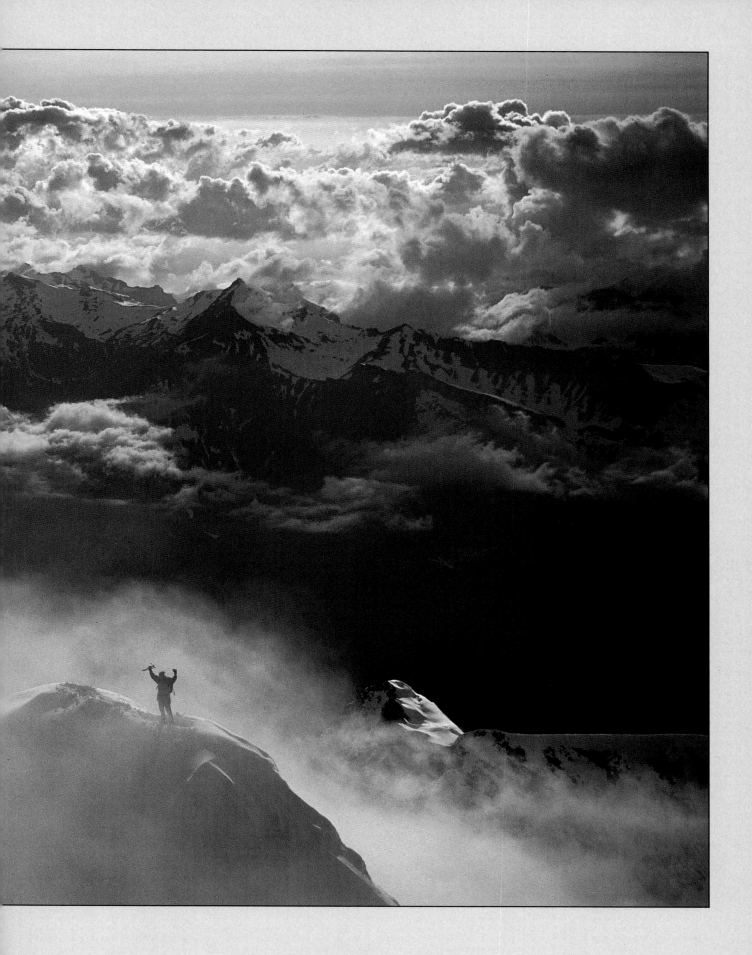

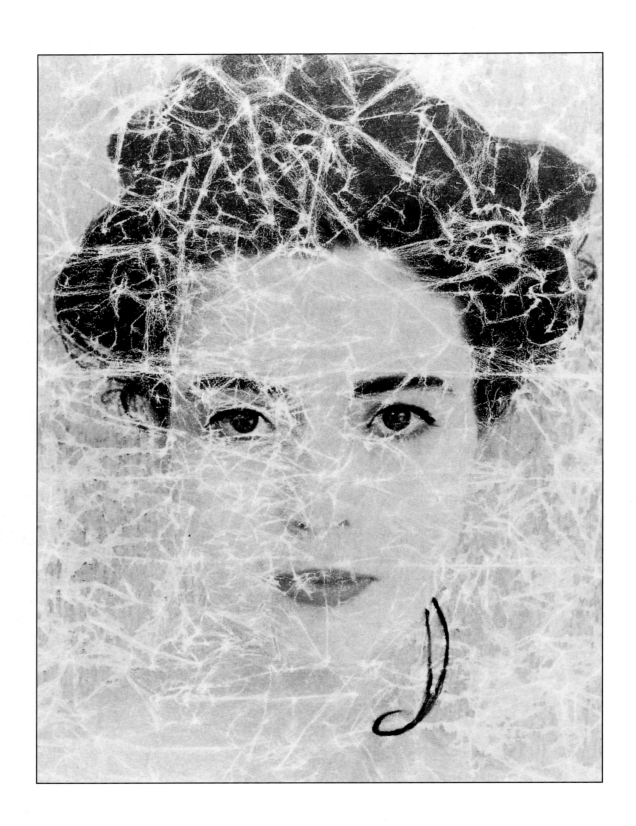

PAULA BIER - UK

DEBRA GAIL HANSON - UK

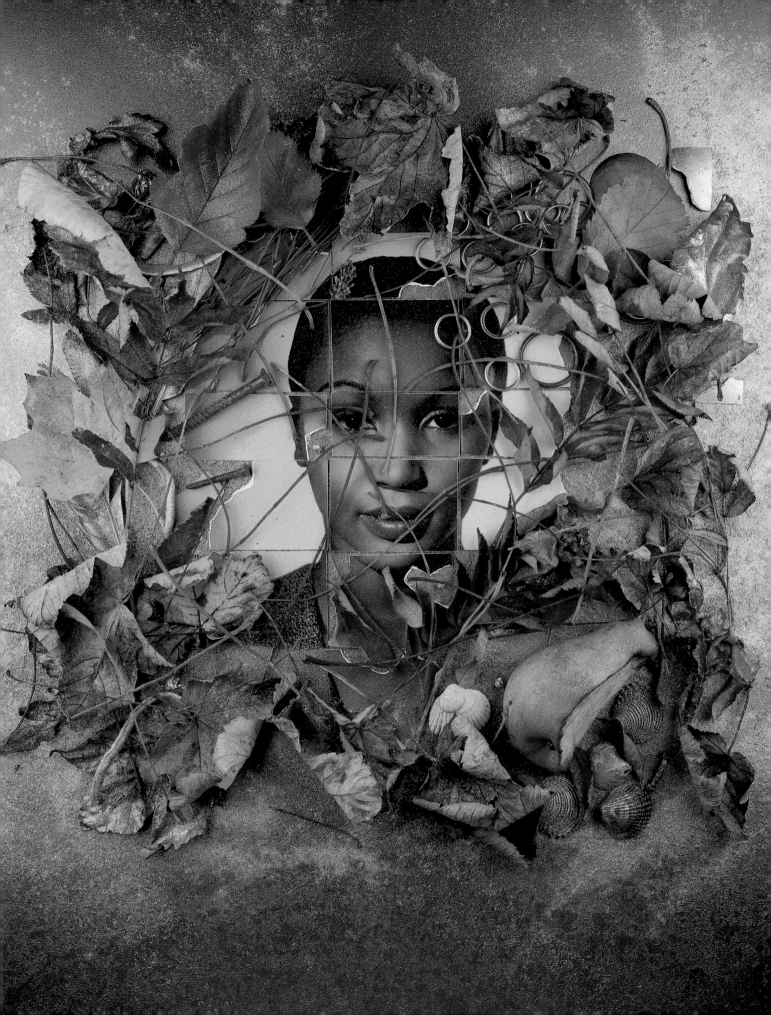

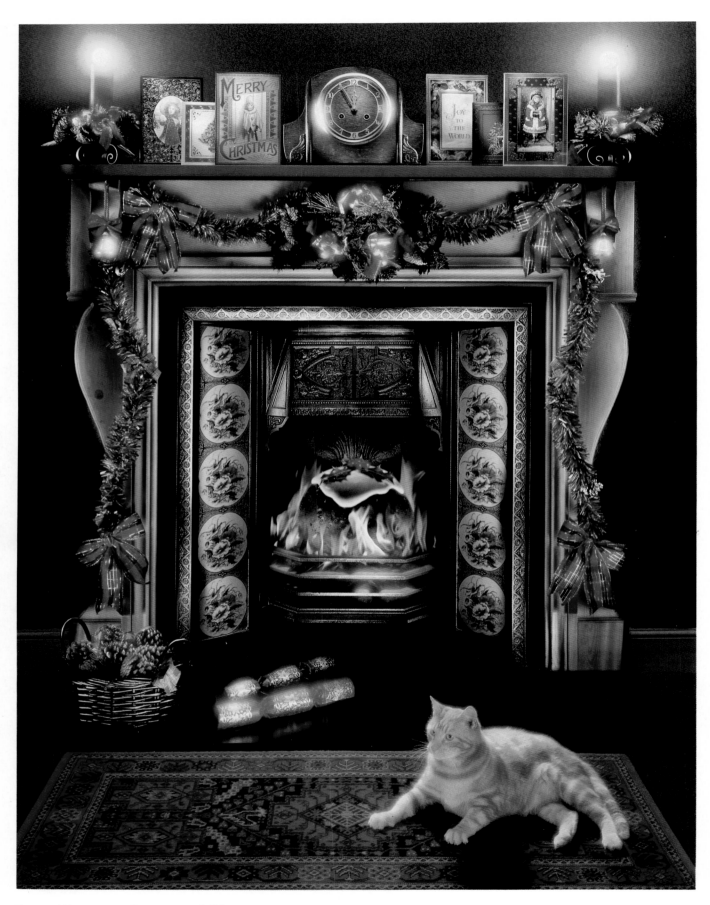

PAUL WENHAM-CLARKE - UK